In History's Wake

Also by Markham Starr

Building a Greenland Kayak

On Oceans of Grey: Portrait of a Fishing Port

Against the Tide: The Commercial Fishermen of Point Judith

The Catboat: A Photographic Album

Voices from the Waterfront: Portrait of the New Bedford Fishing Industry

Down on the Farm: The Last Dairy Farms of North Stonington

Finest Kind: The Lobstermen of Corea

End of the Line: Closing the Last Sardine Cannery in America

Barns of Connecticut

Swab Summer: Transformation at the United States Coast Guard Academy

IN HISTORY'S WAKE
THE LAST TRAP FISHERMEN OF RHODE ISLAND

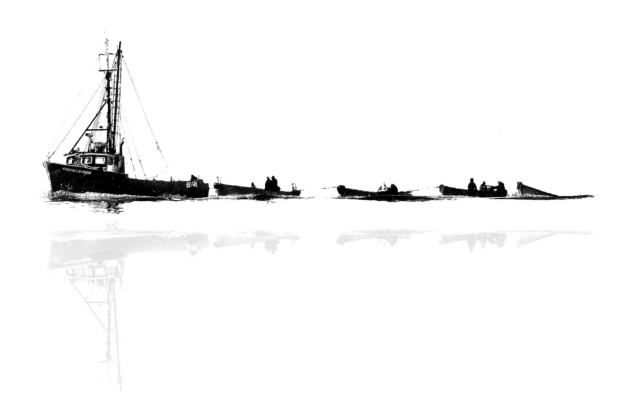

MARKHAM STARR

WESLEYAN UNIVERSITY PRESS
Middletown, Connecticut

Wesleyan University Press
Middletown, CT 06459
www.wesleyan.edu/wespress
© 2015 Markham Starr
All rights reserved
Manufactured in Canada

Library of Congress Cataloging-in-Publication Data
Starr, Markham.
In History's Wake: The Last Trap Fishermen of Rhode Island / Markham Starr.
pages cm.
Includes bibliographical references.
ISBN 978-0-8195-7561-6 (pbk. : alk. paper) — ISBN 978-0-8195-7562-3 (ebook)
1. Fish Trapping—Rhode Island—Pictorial works. 2. Fishing—Rhode Island—Pictorial works. I. Title.
SH344.6.T67S73 2015
639.209745—dc23

for Teresa & Timothy

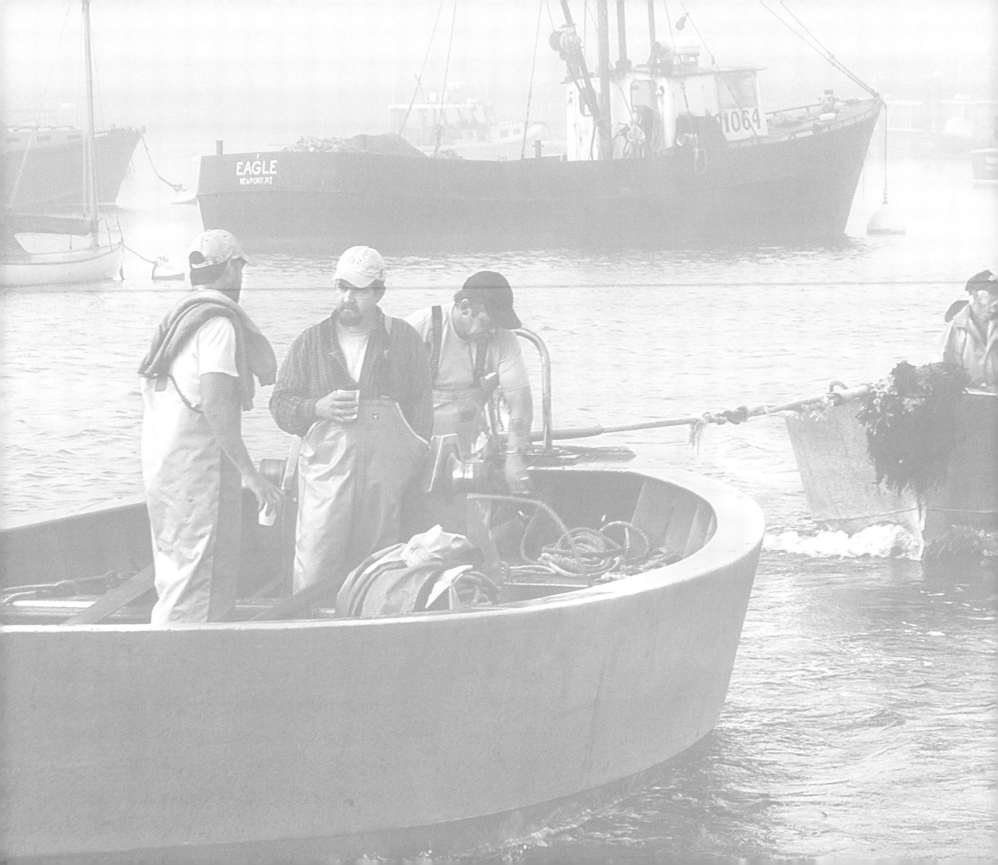

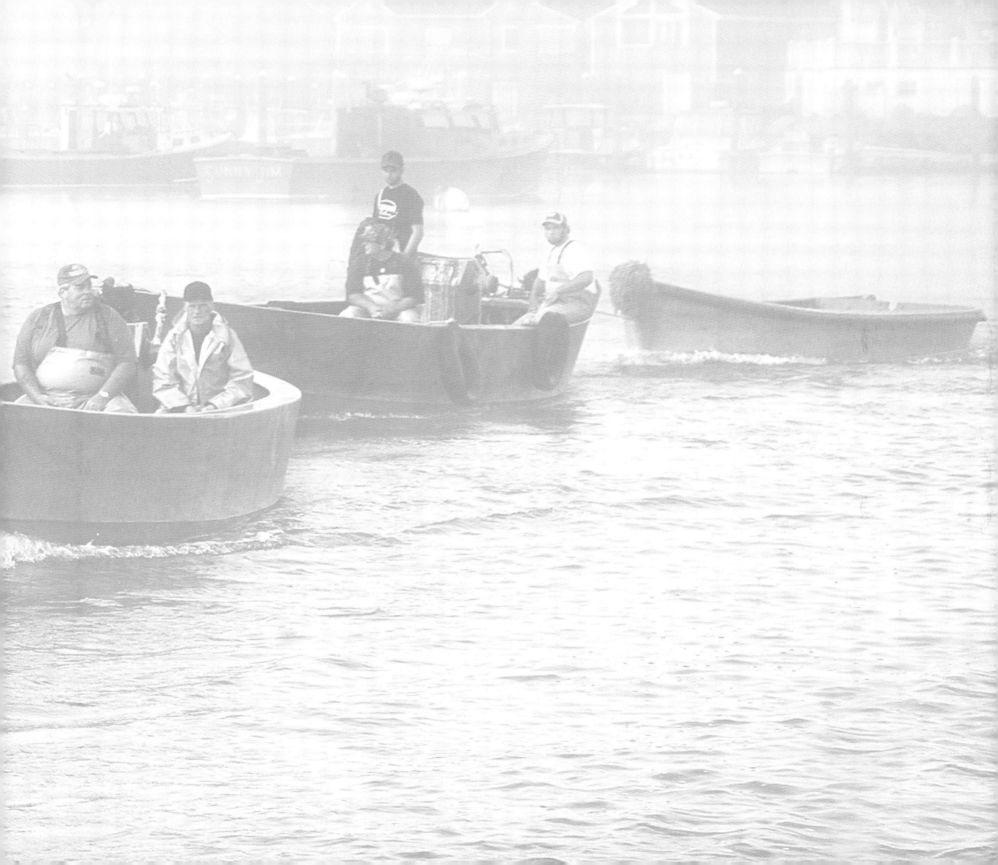

Contents

Preface	xi
The Floating Trap	xiii
In History's Wake: Introduction	1

 Rhode Island's Floating Traps ⋄ Tradition ⋄ A Trap Fisherman's Day ⋄ The Fish Trapping as a Green Fishery ⋄ Additional Problems and Work ⋄ Governmental Regulation of the Industry ⋄ Getting into the Business ⋄ Documentation of the Trap Fisheries

The Plates	45
Acknowledgements	183
Bibliography	184

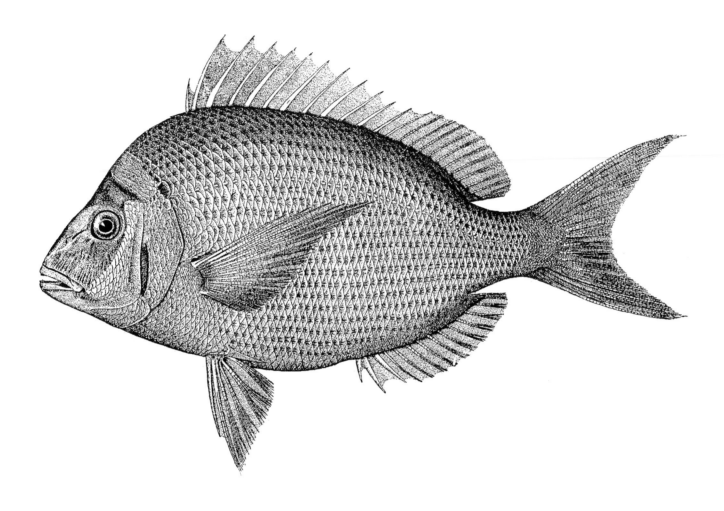

The money paid the fishermen for the catch in 1880, $33,907.50, is quite an item, yet the chief value of the catch is in giving so large an amount of good food to the laboring classes in the cities, by whom it is mostly used, at a very low cost: the first-cost value being less than three-fourths of a cent a pound. [1]

G. Brown Goode

Preface

Rhode Island's extensive shoreline has long been home to numerous trap companies. Fish traps, set along the coast, take advantage of schools of fish as they travel along their migratory paths. Trap fishing is a passive business; traps are built and the waiting begins. Fish are captured only after swimming into leader nets blocking their path. Turning to get around these ocean obstructions, they are guided into the trap proper where they remain swimming in endless circles until fishermen arrive to bail them from the nets. Trapping has faced a slow decline since the advent of the steel-hulled, offshore trawler, when fishermen began leaving their traps in favor of newer techniques. No longer willing to wait for fish to come to them, they began taking their nets to wherever schools gathered. In a state where hundreds of traps once flourished, there are now just four companies left fishing the summer season.

I made these images during the summer of 2008. Trap fishermen form a unique subculture within the larger group of commercial fishermen as a whole. Faced with an uncertain future, I thought it important to record at least some portion of this tradition for posterity. Through their generosity and desire to have others understand who they are and what they do, they allowed me to accompany them on a daily basis to photograph their work. I hope the images I captured and the conversations I had with them translate into a meaningful portrait, providing a better understanding of the work they do in a world rapidly abandoning traditional practices. It was a privilege to get to know them and an honor to have the chance to record this small slice of history.

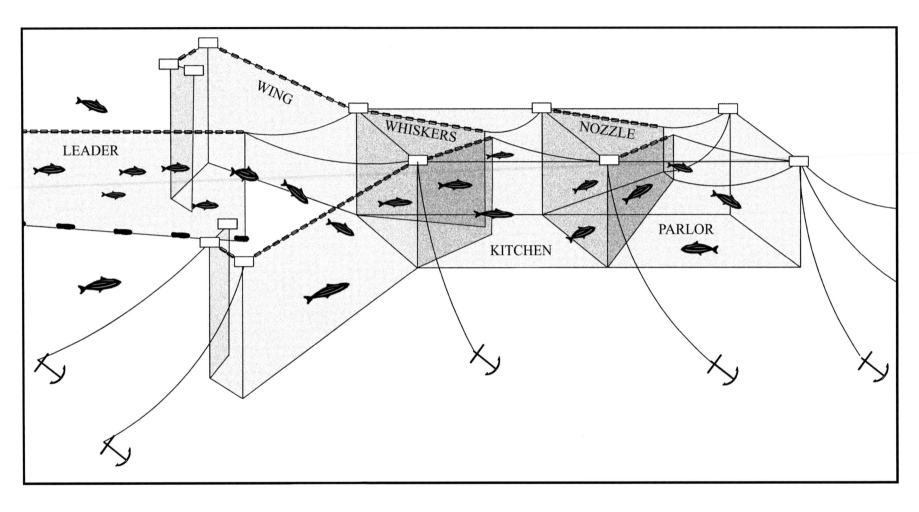

The Rhode Island Floating Trap

Note: This diagram is not to scale and does not include all anchors, floats, or weights used in the full construction of such a trap.

The Floating Trap

The traps pictured throughout this book are known as floating traps, and while small differences in their construction may exist between the companies deploying them, every trap design is governed by the same general principle. Each is constructed around what fishermen call the frame of the structure, and the trap's netting hangs from this ridged form. The frame is formed by a series of anchors, lines, and buoys. Construction begins with a leader line anchored to either the shoreline or a breakwater. The leader may be as long as 1,500 feet, depending on local conditions and the overall size of the trap itself. This line is held on the surface of the ocean by a series of large floats, either steel spheres or barrels, brightly painted to warn passing maritime traffic of their location. The leader line stretches from the shore outward to the first float, which is itself held in place by a pair of anchors stretched perpendicular to the run of the leader. The cable proceeds to the next float anchored in the same fashion, continuing on to other floats until reaching the end of the leader some 1,500 feet later.

The leader ends far from shore at the wings of the trap. The wings, set at an angle to the direction of both the leader and the trap itself, begin funneling fish into the structure. Swimming along the leader and directed by the wings, fish are then steered by the whiskers into the kitchen portion of the trap. A ramp made of netting rises from the ocean floor at the far end of the kitchen and leads them through the nozzle, the narrow entryway into the parlor. The parlor is the actual trap portion of the structure, the section from which fishermen will bail their catch.

A rectangular box of netting up to 72' in width and 90' in length, the parlor stretches from the ocean's surface to the sea floor. Like the leader, these additional structures—the wings, the kitchen, and the parlor—are constructed using the same techniques. Lines running between anchored buoys trace each individual section across the ocean's surface, held in place by up to twenty-six anchors set in opposition to one another. Fishermen add rigidity to the framework by tensioning the anchor lines at each large float.

Once the frame has been constructed, the netting, referred to as twine by fishermen, is ready to hang. The twine at the ocean's surface is strung with floats to keep fish from escaping over this edge. The bottom of the trap rests along the ocean's floor, held in place with lead, iron, or concrete weights specifically cast for this purpose. Once the entire frame is properly tensioned, fishermen hang twine from it to create the wings, the kitchen, and the parlor. Crewmen then hang twine from the leader line to complete the construction. As with the rest of the structure, the leader's twine must reach the bottom to prevent fish from merely swimming under. Because of this, the leader is tapered: narrow at the shore end and deepening as it moves offshore towards the trap. Once the twine is hung, the trap is left to soak—the fishermen's way of saying it has begun to fish.

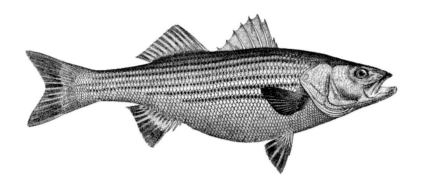

In History's Wake: Introduction

Fishermen have chased their prey for perhaps as long as we have existed. The ever-present need for food has led humankind to consider all sources, and we often pursue the easiest path to our next meal. Fish, abundant wherever large bodies of fresh or saltwater occur around the globe, have been a major source of protein for many cultures, and in almost every society, the trapping of schools rather than individual fish has become the preferred technique. Archeological evidence of a long history of this practice comes from fish traps preserved in European bogs over 9,000 years old. Traveling in large groups for both protection and procreation, fish lend themselves well to capture en masse. They act with a high degree of predictability, following the same path and yearly calendar used by their ancestors, and as predators, we have learned to take advantage of these particular traits.

Fish are caught in nearly every imaginable way. Individual fish are shot with arrows, speared, hooked, stoned, and even snatched by hand from the waters in which they swim. In several cultures, trained cormorants bring fish back to their masters. Moving beyond the capture of

any single fish, a number of ingenious methods were developed to increase the rewards of a day's work. Dams built on small streams allow fishermen to temporarily drain short sections, leaving fish high and dry for the taking. Toxins, extracted from local plants, temporarily stun fish in stagnant or slow-moving waterways, causing victims to float to the surface where they are easily collected. Even explosives are used in extreme cases. By far the most important and perhaps successful methods developed by the world's fishing communities revolved around the invention of the net. By fabricating a durable web from available materials, humankind created one of the most efficient and flexible ways to harvest this important source of food.

Despite the lack of physical evidence, the use of nets predates recorded history. Natural fibers used in their production leave no trace of their existence, degrading relatively quickly in the environments in which they were employed. It is not until relatively recently that nets have achieved a working lifespan of more than just a few years. In general, pre-World War II cotton nets in this country would typically survive only two seasons of fishing. The invention of synthetics such as nylon and polypropylene has changed this, extending twine's working life into dozens of years. While these materials came into existence during the 1930s, they were not widely used within the fishing community with any enthusiasm until after the war had ended. Problems with the suitability of the materials, as well as resistance on the part of fishermen themselves, slowed its acceptance. Once they overcame these obstacles, however, synthetic netting quickly supplanted all other natural fibers. According to George Mendonsa, a long-time trap fisherman:

Way back, say before World War II, everything was cotton. After the war I ordered cotton, like from A.M. Starr Net, R.J. Andrew Linen Thread, Hope, and all them guys. After the war I was order'n, for Tallman & Mack, about $50,000 worth of twine every year. So we had to order two brand new nets, and then we had to order two sets of one-third sections to repair the net from the year before, so in two years' time a net was gone. So here was $50,000 gone. Just after the war, that was a lot of money. Then nylon was come along because of the war, so that we was introduced, more or less, to the nylon. The nylon would fish 2-300 weeks. But if nylon hadn't come along and we had to continue with cotton, instead of our twine bill being around $50,000 a year or less, it would cost our operation close to $200,000 a year. So, if nylon had never come along, there would be no trap fishin' industry at all anywhere.

The expense of these new materials, however, kept nylon from world domination for a much longer time, with relatively poorer countries and fishermen clinging to traditional materials such as cotton, linen, and other natural fibers. Once they became affordable, synthetics quickly replaced all other materials used throughout the industry.

As with other technologies, the way in which fishermen deploy their nets varies by location. Most simply, schooling fish can be captured by throwing cast nets across them. Boats have encircled fish with twine or towed their nets directly through them. In other cases, netting is placed across streams, rivers, and the openings of small bays in efforts to trap them. Nets are anchored to the bottom of the ocean as gill nets and set loose on the surface as drift nets. In addition, large-scale traps along America's many rivers, estuaries, and coastlines are put to use in a variety of forms. Weirs or pound nets, also known as stake or pole traps, are constructed around pilings driven into the ocean floor, where woven brush and sticks or nets strung between them create barriers and guide fish into holding pens. George Mendonsa:

In the state of Rhode Island, way back in the 1800s, and probably very, very early in the 1900s, there was 300 of those stake traps in the bay. They were all inside the bay. But the floatin' traps, like where the old man started fishin' down there, the two nets that he had were 10 and 12 fathoms deep. Out there in the ocean, pole traps that high, they'd be toppled over in rough weather.

Local fishermen overcame the inherent limitations of weirs and pound nets through the creation of the Rhode Island floating trap.

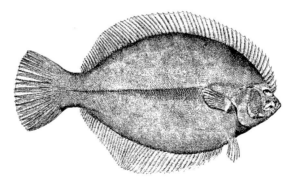

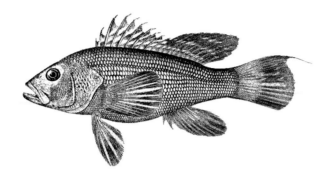

Rhode Island's Floating Traps

The design of the Rhode Island floating trap is unique when compared with the type of traps developed in other states. According to G. Brown Goode, who undertook an exhaustive study of the American fisheries in the late 1880s:

> *The pound-net fisheries of Rhode Island have certain peculiarities which are not possessed by those of any other region on our coast. We find no weirs here corresponding to those of Maine or Cape Cod. The coast is too much exposed to permit the use of such a frail apparatus. Pounds similar to those employed in Vineyard Sound are quite extensively in use, and very successfully. The characteristic form of net, however, one which seems to have originated in Rhode Island and had never been extensively employed elsewhere, is the trap. It is a very simple apparatus, but one which demands the constant care of the fisherman.* [2]

To take advantage of the great schools of fish swimming along the state's open coast, floating traps were placed in deep waters beyond the practical reach of pilings. With few exceptions, the last of the traps currently set in Rhode Island are all floating traps. Used outside the protective sanctuary of a river or bay on the open sea, their design allows the structure to withstand the destructive forces of both wind and ocean waves. With floating traps, the entire structure hangs

from floats and buoys on the ocean's surface, held in position by dozens of anchors. This allows them to remain in place for the season, although fishermen may remove netting from the frame for the largest summer storms, minimizing risk and avoiding damage to the valuable twine.

The last four trap companies that fish Rhode Island's waters operate from either Point Judith in Narragansett, or Sakonnet Point in Little Compton, the latter continuing its long history as a trap fishing center within the state. Goode describes the area in 1884:

Sakonnet Point is the spot to which numerous fishermen of Little Compton and the neighboring places come for the purpose of fishing. This point juts out into Sakonnet River, which is an arm of Narragansett Bay. Into this bay flow the Providence, Taunton, and several other rivers and streams. A great variety of fish, including shad, mackerel, bluefish, rock bass, striped bass, tautog, squeteague, Spanish mackerel, alewives, kingfish, butterfish, flounders, flatfish, cod, hake, pollock, sturgeon and scup are taken in great quantity. The Spanish mackerel, cod, hake, and pollock are rare visitors. Sturgeon are plentiful, but, like the pollock, are not considered a food fish, being classed with the dogfish, goosefish, shark, skate, and menhaden, which are sold at 25 cents a barrel for fertilizing purposes. [3]

The scale of early trap fishing in Point Judith, a late-blooming port that only expanded after the creation of the breakwater system in the 1930s, was relatively small in comparison to the operations carried out from either Newport or Sakonnet. Joe Whaley, a lifelong commercial fisherman whose father was born in the Point Judith Lighthouse, describes trapping in the early years at the Point:

My brother Babe was workin' for Charlie McKenna—he had more traps. He had where Tom Hoxsie is on the East Wall, inside, and then they had others. There was a lot of traps around then. Boy, there was probably three on the West Wall alone that belonged to people. There was a lot of trap sites, but their boats were so small. They'd take 'em out with a little power boat, although I guess Cap'n Clarke had a bigger boat when he worked. I think he had the traps on the East Wall and the West Wall, but that was probably in the '20s or early '30s. But, you know, it was just almost all family. You knew everybody and everybody helped everybody out. I was only eight when the war was over, and I can remember my brother comin' back and goin' right back trappin'.

The people who lived along the shoreline of Narragansett Bay did whatever they could to put food on the table or generate additional income. Alan Wheeler's family was no exception:

My mother's father used to cart fish from Sakonnet Point, horse and wagon, up to the train station in Tiverton. The New York boat used to stop at Sakonnet Point, and they used to put fish in sugar barrels and take it to New York. Of course everybody, years ago on the island, you know on Aquidneck Island here, were farmers or fishermen, and or both, because it was subsistence living. My father had stub traps and fykes years ago. My grandfather had fykes. A fyke is like a fish trap except they're hoops. They're big hoops, but it only takes one or two people to handle 'em. The stub traps are, instead of the floating traps like we have, the big floating traps, they were on poles, and they were up and down the Sakonnet River, and even maybe down as far as Wood's Castle down in South Middletown there. And of course they were all market gardeners; when I was a kid, where these maple trees are were all trellised tomatoes.

Around the time of the Civil War, fish from Rhode Island's traps at Sakonnet and Newport were routinely shipped to Philadelphia, New York, and Boston by train, steamship, or even on ice as bulk cargo in the holds of sailing ships. Goode discovered locals using fykes in Tiverton in the 1880s:

Fyke nets are fished to a limited extent during the fall and winter. The catch is almost entirely flounders, of little value or amount. On both sides of the river, from Tiverton to the Point, there are forty-three fyke nets set more or less of the time during the fall. The catch by heart-pounds is much less than from those used on the south and west side of Newport Island. Pounds and fyke nets are made from old, condemned purse-seines of the menhaden fleet. The catch by pounds is marketed at Newport, New York, Providence, and Boston. [4]

At Point Judith, career fishermen often employed young boys to help with trapping once the gear was set. Joe Whaley describes just such a childhood job:

In 1946 I started stringin' bait in the summertime, and then I went trappin' with Harry Champlin. Herbie Westcott and myself was his crew. We couldn't have been much help, 'cause I was only probably thirteen. Herbie might have been a year or two older than me. All I know is we used to go out and haul the trap and catch a lot of fish, but Harry had to do most of the work all himself. We had two skiffs, and that was the West Wall trap. We were up somewhere around

where Tom is now. He used to do just about everything himself—set the frame all by himself. I thought it was probably a lot of work, but since I've been goin' with Tom it's so much smaller than what Alan Glidden has to do. You know you can pick the anchors up, carry 'em around. We used to catch a lot of fish, I know that, and Harry caught all the fish for the market he ran, just about, in the trap.

The powerboat wasn't much bigger than the skiffs, but you'd never put any fish in the powerboat, so we'd put everything in the skiffs. Herbie and I would take one side, and Harry would take the other, and everything we did, once we got 'em up, was just scoopin' 'em out with a scoop net into the skiff. If you had 3,000 pounds, you know, in the skiffs, we'd go in. We'd tow the skiffs back in. Most of the fish, probably the scup back then, they didn't even bother with, they were so cheap. When they got down to two cents they used to pound up a few, but I don't think they ever got any more than a nickel for 'em back then. They just weren't popular, and most of the fish that he sold in the market was probably flounders and fluke, but they caught quite a lot of 'em, and we caught yellow eels, too, in the spring. Bluefish weren't that popular back then. When they started the rendering plant, we used to take the skates and all the other fish that he didn't want, and we'd take them up to the plant and take 'em out at half a cent a pound. They weren't worth very much back then.

The only change I can see, we used to keep the puffer fish—the blowfish. Herbie and I used to make most of our money cuttin' 'em. He sent the tails to New York back then. This was in '46, '47, and I know he was gettin' 50 cents a pound for 'em back then. A lot of mornings we'd have two trap skiffs full of blowfish, which you don't see anymore, and we used to have the old wooden fish boxes on end, and we'd drive nails up through and then we'd cut 'em across the back of the head, bend 'em over and just pull 'em off. You had a little piece, about this long, that looked like a monkfish tail in shape. We caught not as many menhaden or anything like that as they do now. He used to catch just about all the fish that he sold. He was pretty big-time back then; he supplied all the pier and he had two delivery trucks. We didn't get paid much. Herbie and I used to get coffee and toast in the mornin', but when we cleaned the blowfish or strung bait we'd get somthin'.

The Parascandolo family, who owns and operates a trap company out of Sakonnet Point, has been in the industry for more than 60 years, starting after Anthony's grandfather immigrated to the United States:

My grandfather started in the fish business in the '40s in Tiverton. There used to be, well, hundreds of trap companies all up in the rivers, and even in this harbor there were a bunch of trap companies at one time. When he came from Italy he started. He used to be a stone man in Italy. When he came to this country he started selling things, peddling, and he started peddling fish, and started buying fish. There were five brothers, and when my oldest uncle was old enough, he started to work with my grandfather. Then, as they got out of school and out of the service, they joined the business. Then all five of them were in it. The boats were smaller then. They used to do more buying fish when they first started than actual fishing themselves. My grandfather had one small dragger—name of it was the NANCY. It was named after my grandmother, but he had someone run the boat. My father didn't really get into the actual running of the fish full time, till like in the early '60s. That's when they bought the Wilcox Fish Trap Company. He used to do a lot of packing and then he used to do a lot of driving. He used to run to New York and Philadelphia, he and my youngest uncle and the middle one used to do mostly Boston runs. The older two came here, and then when we bought the trap company, my father went to running that trap company down there, and then I went there. I graduated school in 1970 and I worked here packing fish till 1980, and then I went to help him.

The Parascandolos eventually bought two operational fish trap companies:

Originally, the Wilcox family owned H.N. WILCOX, and then, when the Seal Rock Trap Company went up for sale, my family and the Wilcox family went into partnership with just the Seal Rock Trap Company, and then when Mr. Wilcox got sick and passed away, we bought out the rest of the company. The H.N. WILCOX was part of the fleet. The CHRISTINE ROBERTA we bought in 1990. It was an offshore lobster boat which we converted into a trap boat. We have twenty sites altogether: some from Wilcox, some from Seal Rock, and a couple that we applied for years ago when you could still do that, and we got permits for those. The most we'll fish is, right now, three. Three sets, because you can't keep any fish… .

Anthony further describes the basic design of the traps he fishes:

The whole set, with anchors and the whole thing, is about 1,800' long. The leader is 1,500'. It is the straight wall of twine, and it just runs from inshore to the mouth of the trap. Then you have a pair of wings that run off on an angle, and then you have what we call the kitchen. It's just an area kind of like a lobster nozzle, but it goes all the way to the bottom where the fish swim in. Then they swim from there into another area which we call the parlor, which they have

to swim up into, and then they swim down and just swim around at the bottom, and that's the end net that we haul. The kitchen section of the trap is 72' across and it's 15 fathom on the wall, so that would be 90' long. In order to swim into the final part of the trap, they have to swim up the twine. It's a little less than half the depth of the water they have to swim in. That's where it's cut down too, so it's a little over half the depth where the opening is. The way the nozzle is formed, they have to swim up and then swim over it to find the opening to come back out, and some do. A lot of fish do, but the majority of them don't. The opening is only six feet wide, so they'd have to find that one little hole.

Tradition

Over the past 150 years, the size, design, and use of the floating trap system has remained much the same. Today's fishermen would feel at home working the trap from 1887 that Goode describes, with one exception: early traps had removable sections of twine. This feature became unnecessary with the advent of winches, bull nets, and the diesel-powered vessels built by trap companies over the course of the following century:

The fishing is carried on chiefly by traps that are set for several miles along the river, commencing just north of the Point. The net and leader are floated by means of corks strung together. The following are the dimensions of the traps used here: Leader, 100-200 fathoms long, of 5" mesh; the trap itself is of box shape, 10 fathoms wide, 15 fathoms long, from 4 to 7 fathoms deep, and of 2 ½" square mesh. They cost, when new, from $1,000-$1,200 each. They are put down between April 2 and May 10, and taken up about June 15, during which the scup are

running along the shore. In lifting a net of this kind, three boats, called working boats, pointed at each end and capable of holding forty barrels of fish, enter the mouth of the net. Each of the buoy lines is raised by the occupants of one boat, the fish retreating to the farther end of the net. The pockets attached at the sides and end and are movable, and when filled with fish can be detached and brought singly into harbor. The use of these pockets will readily be understood when it is learned that from a single one, 3,000 barrels of fish were landed. The end pocket is mostly used, those at the sides only coming into play after the end one has been filled. In 1879, many of the nets had the three pockets full at once. These traps are set so as to catch the fish when they are traveling eastward, the reverse being the case on the east shore of Rhode Island. [5]

Building a trap system ashore calls for uniquely skilled workers, as does properly setting the enormous structure into place where it can then begin to fish. This is a dangerous task, given the size and weight of the gear that fishermen must accurately position from the deck of a rolling ship. Finding and retaining a proficient labor pool is becoming more difficult as regulations governing the industry continue reducing threadbare profit margins. As hurdles mount within the fishing community, crews once employed year-round now find themselves cast adrift for the long winter months. The spring of each year now brings anxious moments for trap owners as they wait to see who will return to work the new fishing season. Anthony Parascandolo describes the process of setting the trap's framework from which they will hang their twine:

They had huge trap gangs in those days, and everyone who worked there, pretty much, would work on the lot, work on the gear. That all changed. Practically none of the guys that work on the crews now know how to even mend a hole. You need a certain number of men that know what they're doing. When you're setting gear or taking gear out, people have to know what's going on—it could be dangerous if they don't. When you're setting frames, setting the anchors and things, I'll only take the people that know what's going on. The whole thing is set up on the deck of the boat. You drop an anchor on one end, and you run the whole thing out. The whole running line, then the frame, and the whole thing all comes out, all the barrels, all at one time, and when you get to the other end you drop it—the bridal anchor on the other end—and the whole frame is off the boat. So it all has to be set up on the deck of the boat first. They have to know, as it's going off, what barrels to throw, what to get ready. And then, as I said, setting the trap is the next step. It has to be winched out to the corners and has to be tied off right. The nozzle lines have to be a certain tension to hold the nozzle open, but if you pull it too tight, then

you close the nozzle off. It's been where we could keep a certain number of guys on all year—the guys that you needed for the next year. This past year, it got to a point where we really couldn't. So, hopefully, we'll get those few people back that you know we really depend on. We kept them as long as we possibly could, and hopefully they'll be around in the spring.

He goes on to explain another major difference in today's labor requirements as compared with those of the past:

You needed a lot more people to pack the fish then because we were allowed to bring in such a volume, and now you can't. A lot of the work was done at the dock. We used to go with two boats. We could put, say 50,000 or 60,000 pounds on the CHRISTINE ROBERTA, and you could pack over 100,000 or a 110,000 in a day, but you'd go out in the morning at 6:00 and you'd be in about 9:30, but then you'd be there until 8:00 or 9:00 o'clock at night packing the fish. So you needed a big crew to do that. As I said before, we used all wooden boxes, and everything was done with the hand trucks. Boxes had to be nailed. Now you can't bring in any fish to begin with, and everything is put in cardboard cartons, so there's no nailing; you just slide the cover on. Nothing is done by hand truck and everything is on pallets. The buyers don't want to deal with anything that's not on pallets, so everything has to be put on pallets and wrapped. So it takes a lot less people to pack the fish due to the decrease in volume and work.

Each trap company owns many more sites than they fish. While there are fish at each location, none of the four companies sets more than three traps at once. Anthony explains why:

As I said, we would do 100,000 pounds of scup a day. Now the first day we could go out, I had to sew the trap up because we already had enough fish in the trap for the whole season. So the very first day we went out, May 1st, I sewed the nozzle of the trap up so that no more fish can come in and fish wouldn't swim out. It's crazy. Back then we would set four traps. Now we're down to just three, and you can't set certain traps because you know they're going to catch fish, so you don't. You know you can't catch blackfish. We used to set one trap that caught squid but also caught blackfish, so we can't set that trap because we're only allowed ten blackfish a day, and you know you're going to be over. We have a trap off Cormorant Rock that we haven't set in a couple of years because it catches too many fluke and sea bass.

The men working for George Mendonsa's father built most of the traps still in use today:

There was no trap made by industry. Every trap, the fishermen had to make 'em. You could

order twine. You ordered yards and yards of material, and they'd make it up. You specified the size of the mesh, the strength of the twine, 1,000 meshes long and the depth of the water. You had all of the figures and we figured it out and we'd make one web, say 1,000' long—all depends on the size of the mesh—and we could tell how many meshes we needed. So they made up the side of the trap. It was all made up a certain size mesh: the number of meshes across the top, the bottom, and the size of the mesh. We gave the twine people all the specifications. So when it came you had thirteen webs of nettin' to make a trap. And of course then we had to tar it, and then we put it together. It would take a complete trap to fish, like in these recent years, say four men a good month to make one whole complete unit, and they had to be good men at it. As a matter of fact, my father died in 1977, and the nets they're usin' down Sakonnet, my father made 'em, out of nylon, and the nets over at Point Jude. They bought that boat, the AMELIA BUCOLO over there, and the nets that we had for fishin' over Narragansett. My father made all them nets.

Joe Whaley describes other differences between his early years and now:

The traps weren't like they are now. We had cotton traps and we had to tar 'em. We were allowed to pull the traps up on Little Comfort Island to dry them. We'd just put 'em in the skiff and take them up there and pull them out right on the end of Little Comfort. We'd dry 'em out and then put them back. Back in those days they had a law that you could pull them up on the beach and let 'em dry, you know, without loadin' in a truck and taking 'em off.

Long gone are the days of fishermen spreading their nets on local beaches within view of the public. Tom Hoxsie, who builds and repairs his own traps, describes the complexity of the older and larger traps built by Mendonsa's operation:

The back funnels are different, everything is different. Mine taper up from the bottom much more than the others. The Breakwater Village trap starts out at 24' in the mouth of the kitchen end, and then it goes to 16' where the back funnel is, and then the back funnel is a three-piece funnel. I did that for five years with the big traps that Mendonsa built, and I never understood how those back nozzles went together right. I could do 'em, and we could copy what was there, but I never understood totally how he built them, 'cause they made that out of a square piece of web; put a piece in it to give it more depth to make a funnel. But his are much more deep and narrow, with a little bit of a bottom. Mine are a distinct three-piece triangle. The bottom piece comes up like this and then the sides come in. It's a much more distinct setup—all of it is.

The guy that used to work with me forever had a farm, had a ten-acre field, and if we put in it a couple of traps and a leader we could fill the field. We had three traps in there one time and we had the field completely full, and it was ten-acres. With the wings attached and spread out, they would take up a ten-acre field, and that was without the leader, which was draped back and forth up against the stone wall in the far end. And you got it all there in the fall, then you spent the rest of the friggin' year mendin' that crap. I don't miss those big traps at all… .

Of course, the process of setting or tending traps was much different in the early part of the last century as well. George Mendonsa describes how his father built and fished them:

When my father fished, first started down there, they lived on the island. They rowed to the nets; they didn't have a propeller, any kind of a propeller. They rowed out to those nets, and there was no winches. As a matter of fact, they rowed out and set an anchor. They used to row the 32' boat, double-ender—you've seen them—they throw the line to the barrel and they'd row that boat out till the line ran out which was 50 fathom long, and drop the anchor and they'd come back and get in the skiff and pull it tight. That's how they stretched them out. But after a while, when they got a boat with power, you threw the line and then we'd run out and with the engine, tow everything out tight. When we quit, the anchors we had were a 1,000 pounds each and we put 26 of 'em on each fishin' trap. There was no lobster fishin' and no settin' of fish traps through January, February, and March; there was a closed season. Even the lobstermen had a closed season.

Despite the fact Tom Hoxsie began fishing long after the days when men rowed their longboats to trap sites, his early years in the business were far from easy:

You'd start haulin' the trap at just about daylight, and you could bail those fish faster by hand. That, and you were 25 years younger. You were only fishin' one trap at the time. You couldn't physically, well, physically you could not do more. The first week we went fishing, I lost 15 pounds. Finish up in the mornin', go home and go to bed and get up whenever it was you had to get up, and just sleep. I never did anything. I remember the first month, that first May, you'd get done at the end of the day, go home and go to bed. But the money was good for a 25-year-old guy there.

A rather inauspicious start almost ended Tom's involvement permanently:

We started from nothing, honestly. The spring that we put the trap in the water, I had somewhere around $100 when we finally got the anchors set. The guy that worked for me had two kids and a house and he had 250 bucks. We got the twine set, and it was a miserable day, and I said, "John, we gotta wait another day," and he says "I got $250 to my name right now. We gotta get this goin', 'cause we need to make money." It was horrible. The first week I'd have given the whole thing to anybody that come along. Free. You can have it all—take it. We almost died the first time we went, the first day we went back to haul out. We set the anchors and all that stuff in like four or five days, and then we finally got to settin' the twine. It took us all day long to set the twine, the two of us. I mean we started at six in the mornin' and I finished up almost dark, and it was blowin' and it was horrible, and we got the trap and the thing all set. The next mornin' I get up and it's blowin' southeast about 30 miles an hour with a huge, giant sea on. Go down to the beach with the skiffs, towin' everything. I'd never done this by myself before, but I'd been with my brother about four times. The guy that was with me, he'd been a few times. We got down over where Sand Hill Cove is, where they go surfin', and that's before I was surfin' and I didn't realize how far out that broke. I'm goin' across the beach in the lee, out of the wind, and I look out and there's three beauties comin'. They're like ten-foot face waves comin' and we're inside of that. I'm towin' two 16' skiffs behind me. I turn the thing around it, so we're pointing into that, and I was like "John—hang on!" and he turns around and he goes "Holy Shit!" And we went up, poked through the lip of the first wave, and the skiff free-fell down. Put it wide open through the face of the next one, and it fell down, and the face of the third one, and it fell down, and I said, "Screw this! I'm the boss, I'm the captain. We're goin' home." And we turned the thing around and went back.

The Mendonsas' first powered vessel was not acquired until the 1930s, and like many other waterfront stories, its acquisition makes a colorful tale. George Mendonsa:

A couple of old Portagee friends of my father, they came down to the house one day, and they was talkin' to my father about my father financin' a little boat. These guys were two brothers—their name was Cruz. So anyway, this had to be in the '30s. So the old man bought the little boat and they took it down to Stonington to the Lathrop Marine down there and they put an engine in her and they went fishin'—a couple of years draggin' with it. And finally, one day they come to Newport with the little boat and they tie it up down the docks there in Newport. Well, one day the

two brothers got in a fight. And there's the boat tied to the dock, and I guess afterwards, the way it was explained to the old man, they got in an argument. So the one brother grabbed the other guy and he's got him half goin' over the rail, and the guy that's goin' over the rail caught the other guy's thumb in his teeth, and he god-damned near chewed it off. So when the guy was under pain, from the guy chewin' on his thumb, he grabbed a hammer and he clonked his brother right over the head. So that was the answer. Then the old man took possession of that boat and then he started usin' it in the fish company. That little boat went in the '38 hurricane—it got busted up. We built the first steel boats, me and my brothers, I guess in 1962. We had wooden boats before them. The wooden boat up there on the wall, the CHESTER B. TALLMAN, she was the last of the wooden boats. We built the MARIA MENDONSA down there, then we built the AMELIA BUCOLO.

A Trap Fisherman's Day

A fisherman's day is always something of an adventure, never knowing what awaits him over the horizon. As with all fishermen, the day starts early and the crew begins to assemble on the docks near sunrise. As the fishing season runs from early spring to early fall, the start time varies with the rise of the sun. The first man to arrive is usually the captain, who starts the diesel engine, giving it the necessary time to warm. The crew arrives and quickly checks the day's gear as they swallow the last of their coffee. There is little fuss or bother, as the morning's preparations are second nature to all. Just before departure, they sort their longboats into the order in which they are towed to the traps. Crewmen fishing from Sakonnet prefer riding to the traps in the longboats, while the Point Judith men generally remain on the deck of the larger ship until they arrive. Both crews pass the time in conversation or lost in thought under the thrum of the diesel, quietly enjoying the view of the sun rising above the horizon. The longest trip lasts between thirty and forty minutes, depending on the weather and the condition of the

sea, while *North Star's* ten-minute trips are the shortest. Tom Hoxsie's traps are set within and around the Harbor of Refuge protecting Point Judith. All commutes are relatively short when compared with the twenty-four hour voyages offshore trawlers make to reach Georges Bank.

Upon arrival at the first of the sites, the longboats and skiffs break free of the ship and begin coasting towards their working position on the trap itself. With proper timing and speed, little rowing is required to get them into place, as the heavy boat's momentum is generally enough to carry them to the side of the parlor for which they are responsible. Should wind and waves prevent this, each boat is equipped with several long oars, allowing the crew to propel it a short distance. Once within reach of the floats, fishermen use boathooks to align their craft with the sides of the trap. Each workboat takes a position on one of three sides of the trap—one at the nozzle end and two on the long sides of the parlor—although *North Star's* traps are small enough in size that Tom has perfected a system whereby he and his crew can empty them with the use of a single skiff.

Once in position, the next step fishermen take is to close the nozzle. This is the gateway fish use to enter the parlor, the actual trap portion of the structure. After closing it, fish are no longer able to escape the parlor's confines. Next, the mother ship approaches the head-end of the parlor and maneuvers parallel to it. Using the onboard winch, the deck crew hoists the twine of this fourth side of the trap to the height of the ship's rails. Not only does this hold the vessel in position until the trap is emptied, it also prevents fish from overrunning this edge of the net as the trap is hardened.

After the vessel is secured, the crew still on deck enter their workboats to help with the "hardening" of the catch. To harden the catch, each boat's crew begins hauling twine on their side of the trap into the boat in which they stand, thereby reducing the volume of the parlor available to their catch. As they harden the net, they simultaneously pull themselves closer to the mother ship at the head-end of the trap. As this continues, the schooling fish are driven into smaller and smaller portions of the parlor. At numerous points throughout the hauling process, the excess twine piling aboard each workboat is dropped back overboard behind the portion of the net the crewmen hold. With few fish in the twine, crews easily harden the trap, but there are days where tens of thousands of pounds of fish swimming towards the sea's floor within the trap make the work nearly impossible. Alan Wheeler describes such a day:

I can remember seven vortices of mackerel in a trap: long day! Lots and lots of real pulling, you know. Pull by hand—you're pulling your guts out. This year we had those false albacore tunas. I think we had probably around 40-50,000 pounds of these false albacores—we couldn't pull the trap. They were too heavy; I mean they were all swimming down. You know 40,000 beats ten men at 200 pounds both ways goin', and that was an interesting day. The next day we went out and had 15,000, and we didn't have eight guys; I took twenty with me the next day. We've had squid like that where we couldn't pull the trap.

George Mendonsa describes similar days:

My father talks, way, way back, that when he started fishin', I don't know, probably in 1910 to 1920 or '30, that they used to be hauling the net and if they had squid in it they'd just roll it right out of the net and let 'em go. They couldn't get a cent a pound, but in recent years, squid got valuable. I can remember one day we went out, after the scup run in late May, and we're catchin' squid. The scup had already migrated. So we haul one trap one day, and the squid is heavy. We haul 'em by hand. So we made a rig to haul that weight by power in the net. And I'm tellin' you, it was heavy. We caught a lot of squid day in and day out, but one day we brought in 50,000 pounds of squid on that one net, and no way would we ever get that net up without riggin' this power thing we had. And the next day, we come back to that very same net, because we figured well, Jesus Christ, we'll probably get another load of squid here, no sense goin' to the other nets. We come back to that same net and we're haulin' it, and we could feel the weight, you know, like 25 men pullin'. When we're getting to the end of haulin' the net, them seine boats, they're layin' over. Then we put this power rig to it, and we're comin' up nice and slow with it, and that power rig is bringin' that net up, and all of a sudden the whole trap just split right across the whole middle, and the squid went all right to the bottom. So we had 50,000 pounds a day before on this same net, and the day before the net handled the 50,000, but the next day we never got nothin' out of it. I say there's probably 40 or $50,000 worth of fish in that net that went that day, easy.

Goode reports that his contemporaries also captured record amounts of fish in the very same locations:

In 1867, Mr. Benjamin Tallman, of Portsmouth, caught in six traps in nine days $18,000 worth of fish. Estimating the value of the fish at $5 per box, which is not too great a sum, the

number of boxes secured was about 3,600, representing 1,260,000 pounds of fish. The average catch to a trap each day was about 23,300 pounds. [6]

A look at the totals he lists for the year of 1877 for the 30 traps in operation provides a feeling for the early productivity of the fishery:

In 1877 the yield of three traps was as follows [In Pounds]:
Flounders 17,225
Tautog 15,675
Scup 112,750
Weakfish 29,325
Sea Bass 10,500
Bluefish 23,625
Total 269,100
Average to the trap: 89,700
Estimated yield of 30 traps in use in 1877: 2,091,000 [7]

Anthony Parascandolo recalls one of the most amazing sights he ever saw at a trap:

We'd go out and haul, you know, bring in some scup, and then stop at the squid trap and bring in some squid. So we did that, and we stopped at the squid trap and we couldn't haul it. It was just so hard we couldn't even budge it. So we cut it open and let all the squid out, and then sewed it back up, and then, the next morning we had it open I think for an hour. On the way out, we opened the trap, we went out, hauled the scup trap, came back, and we couldn't haul it again. We had to cut it open again. I think we left it open for a half-hour, and we couldn't haul it all the way, but we had the skiffs almost sunk and the workboats were almost sunk. They were tipped over, so we had Alan Wheeler's crew come over. They put their boat on the backside of our nozzle boat. We had the two whole crews there, and we had the long workboat oar lashed to the bull net handle, and we bailed some squid out of it, and then ended up cutting it open again. And then on the following day, we went there and left it open for five minutes, and almost filled the WILCOX. Then we were doing like a seven-minute thing. We'd go there, and in seven minutes, just watch your watch, leave it open for seven minutes, close up the nozzle, and haul the trap and load the boat right up with squid. It was amazing—it really was amazing. You'd

look down and you'd see all these squid, just all lined up waiting to go into the trap. You'd open the thing and it was just—sheew! It was like ladies in a department store—they couldn't get in there fast enough.

Anthony, along with Alan Wheeler and George Mendonsa, all remember days when they removed more than 100,000 pounds of scup from a single trap. George recalls one of the most remarkable summers trapping this one species:

But I'll tell ya somethin', me and my brothers, what we unloaded ain't nobody will ever come close to equalin'. Nobody. I don't give a goddam who they are, they'll never come close. The most fish we ever unloaded in one day, I can show ya this, was 163,000 pounds. That's goin' out and catchin' the fish, bringing it in, unloadin' it, and puttin' it in seven trailers loaded to the roof. One year there, during the month of May, we unloaded 3,000,000 pounds of scup alone. That's 100,000 pounds a day average, and we had days that was rough weather that we didn't work, but we still averaged 100,000 pounds a day for the month of May in scup. There was one year that we'd go to one net and load up over 100,000 pounds of scup out of one net, and I remember there was one year that we didn't go to the second net for two weeks. We kept goin' to the same net, loadin' the two boats, and we'd go by the second net out there, and we could see the whole trap all a-boil, like the waters boilin' on top of the stove from scup that's in there.

Squid inundated Tom Hoxsie on his most memorable day trapping:

That spring I went to the East Wall trap, the first year we ever did it, and we pulled up to where the trap was supposed to be and there was about six inches of six barrels stickin' up. It was so full of squid that it had sunk the whole trap. When we pulled up there I went "Holy mackerel—the trap's gone!" And then you looked and it was full of fish. I mean it was so full of squid that it had sunk the whole thing—corks, everything. The corks were six feet under water between the barrels. And then you looked down, and the kitchen end of it was floatin' some, and there was squid squirtin' like fountains, the whole way down, all the way around inside of the wing. We only had one wing at that time, and then halfway down the leader, out probably 50 yards out from the cork line up to the east side there, was squid, squirtin'. It was solid fish. There was nothin' we could do with it. I finally got a long gaff, we pulled up the side, cut a big hole in the side of the trap and let the whole mess go. I don't know what there was in there for weight. I've never seen anything like that ever again. So that was the beginning of our trapping career, and since then it's gone up and everything you can imagine has changed.

On the typical day, however, fish find themselves quickly packed into a small section of twine alongside the ship itself. At this point, the ocean's surface is literally boiling with fish desperately trying to escape. The deck crew transfers back to the ship from which they will bail the catch, while others remain in their longboats to keep their prey tightly penned against the hull. Deckhands remove fish from the trap with a bull net. Except for its size, the bull net is similar to the small dip nets used in home aquariums. Fishermen use the ship's winch to lift the net, as fish are scooped from the trap at nearly 1,000 pounds a pass.

When required, fishermen compartmentalize the ship's deck into "pens" by dropping planks into a series of posts and slots designed to receive them. This not only keeps fish from sliding across the deck in heavy seas, but is occasionally used to roughly sort them as they are dumped on deck. Fish brought aboard are evenly distributed to keep the ship level, helping to maintain stability for the return trip. Next, they are sorted by species and size where appropriate. Species not specifically targeted are quickly thrown overboard where they swim away, essentially eliminating the bycatch common to other commercial operations. Because this entire process is relatively gentle, trap fishermen are called upon to provide specimens for the country's aquariums or for scientists wishing to study live animals. The targeted fish are simply taken from the deck and dropped into barrels of circulating seawater until ready for transport to their new homes.

Once the twine has been emptied, the ship pulls away from the parlor and the men in the workboats reset the trap for the next day's fishing. Crewmen open the nozzle and the boats fall back in line behind the ship. Except for days when large schools of a single species inundate the traps, fish are sorted into totes, or plastic tubs, holding roughly 100 pounds of fish. A few shovels of crushed ice are dumped into the totes for the return trip on the hottest days of the summer. If the day's catch is large—in the tens of thousands of pounds—fish are simply left in pens on deck to be off-loaded by conveyor and sorted by size and species when the vessel returns home. Once landed, fish are packed into waxed cardboard boxes and covered with crushed ice. If not immediately trucked away, the catch is placed in refrigerated trailers until sold. In earlier times, the way they shipped fish was handled differently. Alan Wheeler:

We used to put mackerel and squid in barrels—wooden barrels. We'd put a shovel of ice in the bottom, 75 pounds of either mackerel or squid, a half a shovel of ice, and then another 75 pounds of mackerel or squid. Butterfish I think we used to put in barrels too, and then you put

water in, and it was a beautiful package. They used to say that they'd put blackfish, you know tautaug, in barrels, with the ice and water like that, and when they get to New York and they dump 'em out on the floor, the fish would still be alive. If you were loadin' a trailer for New York, you would lift one barrel—two guys would lift one barrel—and put it on top of the other barrel. I don't know, there's not much left of me. I've topped thousands of barrels in my short life. Same with boxes, you know, seven or eight high in a trailer in iced boxes—wood boxes. They'd go to Fulton Fish Market to the different dealers. I think that's all changed too, you know?

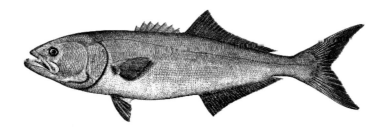

The Fish

Trap fishermen make the majority of their profits from a few species of fish: scup, striped bass, and squid. This often varies from year to year, as some fish may not appear in great quantities during any individual season, making it a difficult business in which to predict the future. Many other species of fish swim into the trap, of course, and each day brings new surprises. Anthony Parascandolo notes the cyclical nature of fish arriving in New England's waters:

We've had years where we hadn't seen any weakfish in a long time, and then just go haul the trap and it would be just loaded with weakfish. Mackerel are the same thing, squid are the same thing. They're pretty predictable, as far as that goes. You can't really tell what's coming, but what usually comes, usually comes at a certain time. If they come at all, they'll be there at that time. We have to have the nets in by May 1. The fish could come earlier, but that's when our quota begins for the year, so if we're not ready when that happens, then we're out of business for the year. When the water is still cold you'll get herring, and then mackerel, then scup, then squid. And then when the water warms up you get bluefish, weakfish, and things like that.

And then later on, at the end of the summer, you get striped bass and sea bass, usually, like the middle of May. The problem is they only let us have a hundred pounds. When we're able to catch them, the quota is only at a hundred pounds. Later they'll bring it up. Like the sea bass, they bring up to 500 pounds, a 1,000 pounds, or 1,500 pounds when we can't catch them.

Although fishermen take advantage of all species they can keep, some have higher market values than others. Those with the lowest value are fish such as skate, pogies, or sea robins, which are all used as bait by local lobstermen. These fish are dumped into barrels, salted to prevent rapid spoilage, and brought to docks where fishermen can purchase them.

As was the case 150 years ago, scup are the most important species today. A blunt-headed fish, highly prized for its flavor, their migratory timetable brings them to the Rhode Island coastline in the early spring, a timetable that can be predicted to within a few weeks. Fishermen hurry to get their traps in place before they arrive, as their passing is over in less than a month's time. When scup do arrive, trappers bring them to the dock by the tens of thousands of pounds. Like all commercial fishing industries, there is a limit imposed upon trap fishermen as a group. The federal government allots each state a portion of the total catch allowed nationwide for each species based on historic landings. Trap fishermen receive a portion of the state's quota, and once reached, all scup subsequently captured are returned to the sea. During this year, the floating trap quota for scup was 583,811 pounds. As a measure of how fast and drastically things can change for fishermen, the previous year's floating trap quota was 1,535,543 pounds, a drop of 62 percent for the 2008 season. Likewise, the striped bass quota for this season was 750,000 pounds, only half the number allowed in the previous year. It is not hard to imagine how these swings in governmental regulations make it difficult for fishermen to earn their living.

Along with scup, bass, and squid, exotic fish seldom seen in Rhode Island's waters occasionally find their way into traps during the warm summer months. Accidentally carried north by the Gulf Stream, the number caught are few, but of interest nonetheless to fishermen as curiosities. While somewhat invasive, scientists do not believe they survive the harsh winter temperatures they encounter in New England's waters. Other unusual species, typically found further offshore, also make their way into traps, such as ocean sunfish, tilefish, sharks, and even tuna.

During this particular summer, one unusual species came aboard in shocking numbers: the American torpedo. Of no commercial value, fishermen toss them overboard. Looking some-

thing like a blubbery skate and weighing up to several hundred pounds, they can deliver an electrical charge said to be over 200 volts. This shock can knock a person to the deck or jolt a pile of fish when discharged, and fishermen carefully throw them back into the sea before dealing with the rest of the catch. During the summer of 2008, Alan Glidden saved specimens in barrels of seawater for a New Hampshire scientist studying the way in which torpedoes generate this electrical current.

On another occasion, Alan Wheeler pulled one of the strangest looking of all fishes to be found in Rhode Island waters from his trap—an ocean sunfish. Also known as mola mola, these animals can easily exceed 1,000 pounds in weight, and the *Mendonsa's* crew had to hoist it from the trap using a rope sling and the ship's winch. As seen in the illustration below, the sunfish appears to consist of just a head and tail, as if its body was pinched off just aft of the dorsal fin. The large, vertical fin on top of the fish flops from side to side on the ocean's surface when the animal rises to absorb warmth on bright summer days, and boaters often mistake these harmless fish for sharks. Far less dangerous, sunfish dine on jellyfish, making their great bulk seem all the more unlikely. While there is no commercial use today for them in Rhode Island, sunfish were once harpooned by whalers and rendered for their oils in the days of spermaceti candles and whale oil lamps. Unscrupulously, they used the oil to increase their profit margins, as it was one of the few oils that could be added to whale oil and escape detection.

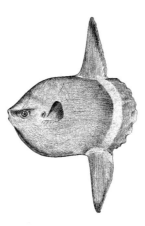

Trapping as a Green Fishery

Trap fishing is relatively passive—fishermen set their traps and wait for fish to swim into them. Trawlers, the predominant technology now used in Rhode Island's waters, are free to chase fish wherever they may roam. After the end of World War II, when powerful engines became widely available and less costly, fishermen began building larger vessels capable of venturing further from shore. Waiting for fish was no longer necessary, and as a result, the number of trap sites in operation declined. Despite this change, there are inherent advantages to trap fishing from which our modern world benefits. Primarily, the fishing is all done locally. Most of the large trawlers from Rhode Island head far to sea to reach productive grounds. Georges Bank, an important fishing area for the state's dragger fleet, is some 200 miles distant, and trawlers must steam for 24 hours just to reach the spot where they first begin to fish. Fuel, once relatively cheap, skyrocketed during this season, adding to the many other troubles these fishermen face. Trawlers can spend tens of thousands of dollars on fuel alone on a single trip. It

was not uncommon, at this point in time, for an offshore boat to come home from a trip where few fish were caught at a financial loss. This makes the advantage of fishing a few miles from home all the more apparent. Added to this is the fact that much of a trap fisherman's engine time is spent idling while fish are brought aboard, further reducing fuel consumption.

The offshore trawler also contends with the problem of properly storing fish for the duration of the voyage. While there are a few local freezer boats—vessels that freeze and package their catch at sea—most of the fleet must carry ice or provide chilled water tanks to preserve their catch until they return. A typical dragger may load 40,000 pounds of ice for an offshore trip. Trap fishermen have their catch at the dock within a few hours, avoiding this added expense. In fact, most of a trap fisherman's workday runs between 5:30 and 10:00 in the morning, from start to finish. (It should be noted that for most, this is just the first job of the day. Many will then go to work on their own boats lobstering, day trawling, or gillnetting. Others may work at unrelated jobs ashore for the rest of the day.) While this represented a typical day's work trapping during the 2008 season, this was not always the case. George Mendonsa:

We'd leave the dock at probably 5:30 every morning, and out to the nets would take about an hour, runnin' to the nets, and most of the season we'd have two or three nets fishin'. And of course, other than May, we could haul all the nets, where there was three of them. And say by ten, eleven o'clock, we'd be back at the dock, you know, during the slow season, and even during the heavy season. When we were catchin' over 100,000 pounds of scup, we'd be back by ten o'clock 'cause we'd only haul one net. One time we went out, had to be in June, that's when the butterfish ran. All species have their season, when they migrate north. Well anyway, middle of June, we went out, we're haulin' the net, and she's loaded with butterfish, and of course butterfish, when you start haulin' the net and crowdin' 'em, they die quick, and they are heavy. Well, we had never seen a bunch of butterfish like that before this. Well, we're out, we're haulin' that net out there, and finally we got the fish aboard the boat and we come into the dock, and we're unloadin' butterfish, and of course we're cullin' 'em out—jumbos, mediums, different prices. And here it gets five o'clock the next mornin' and we're still there unloadin' fish. And the other fish company was just a couple of docks over, and of course they're gettin' ready to go out, so they look across and they see us workin' and they says, "Holy Christ! Them guys are already in!" We worked one day on them goddamn butterfish. We started five o'clock one mornin' and we got through ten o'clock the next mornin', and we were dead... .

While trap fishing seems labor intensive because of the number of crew required to haul the net, trap labor is only required for a short period each day. During a trawler's commute, crew members are idle for two of a typical five-day trip to and from the grounds. Rough weather far at sea can also idle a ship, extending the voyage and raising labor, food, and fuel costs, not to mention the added toll on the vessel and her crew. On rough weather days, trap boats simply never leave the dock. The fish will patiently swim in the trap until the storm passes. To Alan Glidden, there is another important difference between trapping and trawling:

The one thing is, you just can't touch the quality of the product, and that's the fun part about it. It's great dealing with a live product. From a green standpoint, you can't do more than the trap. You're not burning any fuel catching the fish, and anything you're not keeping you just watch swim away, so it's really an ideal fishery from that point of view. Other than having the fixed gear, you have a very small footprint.

Additional Problems and Work

While the actual trap may fish all on its own, it is not entirely self-tending. The twine from which the trap is constructed must be removed periodically over the course of the summer, as traps fish poorly when covered with weeds. Fishermen remove the twine and bring it ashore to allow this inevitable growth to die before returning it to the trap's framework. This is, of course, done in the relatively quiet period in the middle of the summer, after the scup run has passed and before the striped bass migrate through in the fall. If needed, the netting is also repaired at this time, as it is not uncommon for holes to be created by the fish themselves. In the worst of cases, huge sections of netting may be damaged by schools of voracious bluefish, notorious for the destruction they can cause with their razor-sharp teeth.

Other tears of a sizable nature can occur when the trap's nets ensnare larger objects. All trap fishermen comment on the catch and release game they play with local maritime traffic. Although well marked on charts and highly visible on the water, the large orange buoys, flags, and radar reflectors decorating the trap often fail to keep inexperienced boaters from blundering into them. Once tangled, these hapless mariners do extensive damage with their knives as they work their escape, and fishermen must check their traps daily for signs of their handiwork.

Alan Wheeler reported capturing speedboats, sailboats, large power yachts, and even one vessel belonging to the United States Navy, which caused some $60,000 worth of damage.

Anthony Parascandolo has also trapped both large and small vessels, and describes the worst day he and his crew experienced on the water:

We had a Coast Guard boat, a few years ago, go right into the trap. You couldn't imagine the damage they did to that trap. It was unbelievable. It was a 175' boat, or something like that. The IDA LEWIS—a buoy tender. Went right into the trap, and then split the whole thing wide open. Anchors moved, the whole corner of the trap was cut off, and it was done for. Two years. It took us two years to repair that.

Despite governmental tracking of the cutter's movements by its own satellites and eyewitness accounts confirming them, the Coast Guard denied wrongdoing and the trap company lost a full fishing season at that one site.

General wear and tear affects the twine as well, and large sections of netting are replaced when required. Once cleansed of marine growth and repaired, nets are returned to the frame to resume fishing. As insurance, trap companies generally have spare nets waiting in storage to cover the catastrophic loss of any particular one. The twine is taken to hay fields where it can be spread and repaired by experienced hands. Fishermen do all of this work manually, as there are no mechanical substitutes for the knowledge and skill required to build and maintain the twine. Requiring more experience than brawn, repair work is generally carried out by older fishermen, leaving younger men to do the heavy work hauling traps entails. Left to work alone on twine for hours on end in distant fields, these fishermen often joke they feel like old workhorses put to pasture.

Of course the twine used in the trap is not the only gear in need of attention. All commercial fishermen have boats that must be maintained. Trap fishermen's ships, longboats, and skiffs all require scraping and painting, as well as work to keep engines, winches, and numerous other mechanical/electrical systems running. Gear such as the anchors, buoys, and line that make up the framework of the trap also get an annual overhaul during the winter months or before the beginning of each new season. While synthetic materials have certainly reduced maintenance costs, they have not eliminated them entirely. As with much of Rhode Island's fishing industry, the heavy gear in use today is approaching the end of its working life. In fact, the entire fishing

fleet in Rhode Island is showing signs of its age. Operating in a harsh, saltwater environment, oxidation takes its toll on nearly every piece of gear in use. Beyond that, most of the vessels are nearly 50 years old and now show signs of the heavy work they have done. The trying economic conditions the industry faces force fishermen to delay routine maintenance procedures once done on a yearly basis. This lack of funding creates a downward spiral for the equipment that can be difficult to escape. Beyond that, there are unexpected repairs that may rise on any working day, as Anthony Parascandolo relates:

Years ago, we had three tuna fish in the trap at one time, and the biggest one dressed out at 650 pounds. That big one we put on the deck of the boat. We had two-inch thick penboards on the boat, and tried to set it in the penboards, and he slapped the penboard with his tail and just splintered it, just wood flying all over the place. One shot just splintered that two-inch penboard.

Governmental Regulation of the Industry

Fishing has changed from its beginnings in many other ways, with governmental oversight now playing a major role in the life of every commercial fisherman. How, where, and when they fish, as well as what they may catch are all determined by forces well beyond their personal control. These regulations usually evolve on a yearly basis, and with some fisheries, weekly changes are all too common. This adds to the individual fisherman's difficulties in managing his or her business. The design of the traps themselves has been regulated in terms of size for hundreds of years, as has their location. Each trap must have a governmental license and be positioned exactly where prescribed. Locations and licenses for traps are also limited to those that have never gone out of service. There are no new trap sites being created, and all existing traps must pass to another fisherman or be permanently lost. Where once hundreds of stake and fyke traps lined Narragansett Bay, now only a handful of floating traps exist. Added to that, the

federal government sets annual quotas for each species of fish. Anthony Parascandolo outlines the system in place in 2008:

> *The federal government regulates the state, and then the state regulates us. So the state gets a percentage of the federal quota, and then the state divides the state quota however they see fit. We have a portion of the state quota for striped bass and for scup—everything else is the same as the state. When they divided it up, they figured historical landings, and the reason why the state got as big a percentage of the quota, the federal quota, as it did, was because of the traps. Traps had a history of catching scup, and they gave us 60 percent of state quota because they knew that we could catch the whole thing in a few months—in a few weeks, actually. The rest is just what they call "general category"—it's not really divided. The draggers, the pot guys, rod and reelers and everyone else gets the rest.*

These quotas are by far the most difficult of the regulations imposed upon fishermen. The total landings allowed for any individual species is spread across all trap fishermen as an industry. For example, the striped bass totals for the year of 2008 was 750,000 pounds. A running tally is kept by the government on all striped bass landings by trap fishermen, and once they reach this quota, the species is closed to them and bass found in the trap thereafter are simply released back into the wild. After filling the striper quota, traps are often pulled for the remainder of the season because very little can be made from the remaining fish they are allowed to keep. Should one trap company do well with bass at their sites, another may lose a significant portion of their yearly income. As previously mentioned, the totals for this season for bass were also halved, making it even more difficult for trap fishermen to keep afloat in difficult economic times.

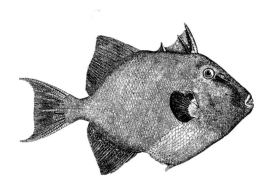

Getting Into the Business

Most fishermen involved in trapping seem to have gotten an early start to their careers on the water. Many had fathers and grandfathers who worked along the waterfront, exposing them to a lifestyle they found attractive. Alan Wheeler's story is somewhat typical:

The first money I ever made on the water, I was ten years old, scallopin' in Nanawauket Pond out of a skiff. A little tongin', a little bullrakin', you know, and I was ten years old. I mean I didn't fish from the time I was ten right straight through, but that was the first time that I ever made any money. A classic case of a fisherman getting fished. "Oh—look at this! Money!" I was a deckhand on various different types of boats. I was on a couple of dredge boats, and went on an offshore lobster boat in the hay-day of offshore lobsterin'. Then I got married and I was still on the offshore lobster boat, but I bought myself a skiff and 50 lobster pots. My wife's cousin's husband had a little sawmill and used to make lobster pot stock, so I'd work in his sawmill and I'd get the second laths and I built my own pots. Knitted my own nozzles—not that I wanted to do that—it's just that's the way I had to do it because I didn't have any money. I built that boat. The boat carpenter put the planks up and I nailed them. Layin' on his floor in his boat shop, there was frost and there was sawdust goin' in my eyes from the dam skiff, ya know? It was a beautiful skiff, twenty foot, and then I built a big flat bottom skiff next. I built the CORY B in the backyard over there, and layed them up, and had a lot of fun. No, not really. When you start to

build a boat, about halfway through the project you say, "This really isn't that much fun," but the product that you get in the end is better than something you would have bought.

Then I bought a 36' wood boat off Don Crawford from Stonington, Connecticut, and that boat was built by Don Wilcox in Aponaug, Rhode Island. She was a strip-planked boat, and we went cod fishin' with that, gill nettin'. We used to haul the cod nets by hand. It was funny; I bought the boat and the engine was junk. I used to run at 1,100 rpm with the cap off. I had a blown head and one piston was bad, and as long as I idled I could go anywhere with it, but as soon as I put it up she'd overheat. I couldn't even afford to buy an alternator for it. I'd come in, I'd hook it up to a little trickle charger, I'd leave the boat, I'd get my start in the morning: good to go! Honest to goodness. I didn't have a Loran—all line of site. The codfish were all close by. I used to have the 45-minute ground. I pulled twelve nets on the 45-minute ground. There used to be a Texas Tower, and I used to put that on Cutty Hunk. That was my north and south, and my east to west bearin' was the lighthouse on Church's Point. And that was 45 minutes off the beach, so if it was a little hazy or anything like that, you spent a long time looking for your gear. I would do everything time and compass. We made a lot of money just doin' that. At the time I only had twelve, 50 fathom shots, and one day we came in with 3,600 pounds of cod. We were pullin' by hand, and the cod would float up, because they would blow up, and they'd be everywhere. They'd be floating up behind the boat and we'd be pullin' the nets in. One guy would be taking the fish. It was fun—it was a lot of fun. And then we got haulers, you know. I rebuilt the engine in the boat. Then James Blades passed away and I bought the SHIRLEY ANN from his family, and Luke ended up with that. Eleven years ago I said that I was not going to fish winters when I bought Tallman & Mack. I said I don't care if I make five cents, I'm not going to fish the winters, and I made a lot of money fishin' the winters.

Tom Hoxsie's experience within a fishing family was similar. Growing up just a stone's throw from the salt pond and the ocean into which it empties, the Point Judith waterfront became both a playground and a workplace. Having neighbors who also fished for a living was just part of normal life at the Point:

When we grew up here as kids, the guy next-door had fish traps. They had stuff spread out in that backyard next-door; you'd work on leaders in the backyard. The people two houses over were like family friends, and everybody was back and forth all the time and you had to be careful walking from one house to the other at night 'cause you'd get wound up in the twine. As a

matter of fact, the woman two houses down there broke her leg trippin' in the twine one night, and it wasn't, "Oh my god, I'm goin' to sue my neighbor!" Nobody even gave a damn at the time, it was just like, "Well, that happened—get a cast on it, get it off, and get on with life."

My father did the fish trap thing when he was a kid. That was kid's work. He was born in 1925, so, what? Thirties? I mean like, twelve, fifteen years old? That vintage. They got people there, men to work for 'em, and then as it kind of tapered off, then they got kids. Joe Whaley, the guy that helps me mend twine, he's 73 or 74, and that was what they did when he was a kid. They used to steal the trap skiffs and scull 'em back and forth across the breachway. It was a whole different thing—probably was a lot of fun at the time. Nobody had any money, but it didn't matter. You didn't have to buy expensive toys to entertain yourself. You could entertain yourself with what was available: the world.

Tom's introduction to fishing was essentially the same:

I worked for my father. We always, always did boats and stuff and begged to go fishin', that is, until you had to! And when I was twelve or thirteen years old we burned the woods down over there and that was the end of my free time. My father came home and said, "You have far too much free time: you need a job." And that was how I got to go. I worked on the boat in summers for five dollars a day. Big money! At the time it was good kid-money, and then when I was in high school he said, "Well, do you want to go fishin'? You're goin' to have to do somethin'." The guy that was workin' for him didn't want to go. He'd got somethin' else goin' on, so I ended up workin' for him for a while.

Anthony Parascandolo's father and five uncles all work at the family's fishing company, as do seven of his cousins:

We all lived in Johnston, on the same street, a dead-end street, and we had the trucks there and did the mechanic work there. We would get out of school and go up into the garage and mess with the trucks. We had wooden boxes, and my father was running to New York, and my Uncle would run New York, and they'd go to New York, deliver, then go to Philadelphia. They'd come back to New York and pick up the wooden boxes and we'd have to repair them. This was when we were in grade school, you know. With my grandfather, my cousins and I would go into the garage and repair the used boxes. In the summertime, we'd be down here and we weren't even big enough to pick up a box, but we'd be nailing boxes or whatever we could do. Dumping

baskets of fish on a table: I remember standing on a fish box and then two stacks of covers on top just to be high enough to reach the basket when they came in. There'd be one of us on each side of the table.

Alan Glidden, of the Black Point Fish Trap Company, is the one owner of a trap company not raised in a fishing family. On their way to Texas, two friends of his stopped to work on fishing vessels from Point Judith rather than continuing south. Enjoying the work, they called and invited Alan down from New Hampshire to join them. He began by working on an offshore lobster boat, the *Miss Phyllis*:

I worked a little bit on that boat, and then did some work on small inshore draggers and then got into airfreighting seafood. We were sending fish out to the West Coast just when airfreight stuff started, before they had the special seafood rates and all of that. We probably started that in '75 I think, and we still ship stuff out there, but now everybody and their brother started airfreighting seafood. It got to be a very competitive field. While we were doing that, I bought a small lobster boat, a thirty-two foot Holland, which was a great boat. I did that for four seasons, and during that time we were unloading Tom Hoxsie's fish trap and marketing Tom's fish. It was such tremendous quality fish—you can't get a better quality product, and so I got interested in that way.

Then, the opportunity to enter the trap business himself came along:

George Mendonsa was breaking up his company. He had Tallman & Mack, and Tom asked if we wanted to get involved in the Black Point Trap Company, and we got into that together and that was, I guess, nine years ago. The larger portion of the company went over to Alan Wheeler and his partners there, and Tom and I ended up taking one of the boats and six sites. We've got four over here and one over in Price's Neck, off of Newport. And then Tom, you know he's got the great setup with the smaller traps there, decided to go back and do that exclusively, and I kept going with this.

There are a few significant differences between the two companies fishing out of Sakonnet Point and those from Point Judith, as Alan goes on to explain:

The fishing over on the east side of Aquidneck Island is a lot larger scale, because they get the scup early, and they do volume, volume, volume. Over here we get our handful of scup and the stripers, and it's sort of a mix, but it is a nice striper set over here. For volume, they're the

productive traps over there, but it works out. You have good days and bad days. Our main thing over here are stripers, and that's been pretty consistent. We usually get the scup a lot later than they do over there. We usually have, in July, a little two-week period. Last year it didn't happen with all that rain we had. Everything got driven off the beach and the bay got all fouled up. We got a few last year early. You really can't plan. Squid's been terrible the past couple of years for us. Maybe after a really cold winter like this one we'll have some squid again in the spring.

Fishing represents much more than a weekly paycheck to most of the people involved. It is a passion—something that they both love and seemingly must do, despite the hardship, risk, and financial uncertainty it often entails. Alan jokingly traces his interest to a memorable book from his childhood:

I like the trapping though, because I grew up on the Dr. Seuss philosophy. Remember that Dr. Seuss book McElligot's Pool*? It's a kid sitting out on a little muddy hole about this big in the middle of a field out in Ohio. "Well, you're never going to catch anything there." "Yeah, but I might!" And there's whimsical creatures swimming up. That's like trapping. You know it's dry as a bone for three weeks, and then "Wow! Where did these come from?" and then, "Wow! Where did they go?" I love it from that point of view; that's why trapping is great to me. You never know what can happen. With lobstering you have a pretty good idea of what's going to happen, and you know what your top end can be, but here, you're just rolling the dice, and you can convince yourself that anything can happen.*

Like the little boy in the Midwestern field, it is nearly impossible to keep a fisherman from fishing, regardless of where he finds himself, as this story of Tom Hoxsie's father illustrates:

My father owned a bunch of draggers and stuff before World War II, when he was like 20 years old and you could make a lot of money doin' that, but it was the most boring thing you could ever hope to do in your life. And then, during World War II, he got in the Army and was a military policeman. He guarded Hirohito at the end of the war after they signed the truce—my father and several other guys. I've got pictures of him fishing in the Emperor's moat catchin' carp. He'd buy onions and he'd have fish and onions. I know there was a woman that used to be up around Saunderstown that came from Japan and she said "No one was allowed to ever even look at the Emperor. If he came by, you looked at your feet. You weren't allowed to look at him." Well, my father saw him daily, for, I don't know, maybe nine months.

Returning from the war, Tom's father went back to fishing. Then, as now, adaptability was the key to survival for Rhode Islanders hoping to make a living along the waterfront:

When he got back from the war he couldn't make money doin' anything, 'cause it was like damn near a depression, so he ended up going quahoggin' and did some lobsterin', but you couldn't make money lobsterin'; you couldn't sell it. In the summertime you could sell lobsters if you were really lucky for a while, and then as soon as it slowed down no one would buy 'em. He didn't like fishing, fishing, fishing, so he went quohoggin'. He did that for quite a while, and then, like 1960, he was quohoggin', and they were makin' pretty good money quohoggin', and he said, "What the hell, I'll try lobsterin' one more time. If this doesn't work, I'll just keep quohoggin'." He fiddled around with the lobsterin' and did pretty well, and bought another boat in '67 or '68. That was a 42' boat, a real boat, and he did that for the whole rest of his life. He had a few more lobster boats. We've been doin' this forever, I mean, we always knew the trap was there.

Tom's brother also fished for a living, and bought the traps Tom now owns:

It might have been like '76 when my brother got the traps. Pete Sprague sold those trap sites to the son of the guy that owns Breakwater Village. They put the stuff in the water and they never picked it up; they just left it abandoned. My brother got it from them, bits and pieces of it that were scattered around, and put it back together. I think it might have been '76 or '77. He got it goin' and he died in '82, and I bought it from my sister-in-law, so I've been doin' this since 1982. They had two sites. They had the West Wall and the Breakwater Village trap, and he had applied for the one on the West Wall, on the west arm of the big wall, and then the one in Breakwater Village. When my brother died, he had done very well doin' that. The first two weeks he put the trap in the water they paid for the whole works. They paid the boat off that he had a note on for quite a while and paid the guy helping him. The guy that was workin' for him made $7,000 the first week they worked. And that was in, what, the '70s? That was good money, and he bought a truck out of that first week—clean. And that was a total success from there on in. They caught big scup before Newport caught 'em. They had 55,000 pounds at $1.35, and they got them in five days. And the fish were like this big. They were huge, and they got 'em before Newport got 'em, and they got the price before Newport got 'em. People wanted to buy them at the time. There was a real good market for 'em, and then when Newport got 'em they lost them and got squid, which was better yet. They hit it perfect, both, on that first year he did it.

For a time, Tom gave up fishing and worked as a welder at Electric Boat building submarines. Not thrilled with the job and its hazards, he left to work for a local boatyard before finally deciding he would return to fishing:

My brother, all that whole spring, had been lookin' for somebody to go trappin', and I was like, "Nah, I ain't goin' fishin' anymore." And he kept callin', and callin' and callin', and finally I went in one day to work at the boatyard on a Saturday and I got two work orders for sanding bottoms. I called my brother up at noontime and he says "Ah, I just hired some guy. He's comin' from Long Island to go." Anyway, I didn't get the job, 'cause I missed it by, like, three hours. That was noontime. I was havin' lunch, and I went from here over to Oakwood Products, ordered a 100 lobster pots, and gave them two weeks' notice when I went back and then started lobstering. The first year I went fishing for myself I think I grossed like $7,500 for the year. Big success! It was 1981.

So I got the lobster pots, and that wasn't a real success. Those were wooden lobster pots. You'd go and you'd order kits; they'd give you so many laths and you'd just put them together. I remember buying lobster pots, and I'm like "Oooo! This is the answer to all my problems!" I put the things in the water. A friend of mine was workin' at the lobster place down there, and he was like, "You're not even gonna be able to live, man." And that whole winter there, I mean, that winter I was drinking tea and eating macaroni and peanut butter sandwiches. To go out for a big entertaining evening out there was to go to the bowlin' alley and have a cup of plain tea, 'cause it cost like forty cents. And that was it. For fun and entertainment when you weren't workin', you went ice fishin', 'cause you could get the shiners for free and you didn't have to buy anything.

After the sudden death of his brother, Tom bought the business from his sister-in-law. The early years for him were, to say the least, a bit of a struggle. As with most fishermen starting out, however, his determination to make it work saw him through.

Then he died in '82 and I got 'em from my sister-in-law. We started out with nothin'. We had a 20' skiff with an outboard on it. That was my first trap boat, and we did everything by hand like they did in the '30s. We bailed all the fish by hand, we set all the anchors. To set the anchors, we'd bring two or three of 'em down in a pickup truck, dump 'em on the beach at low tide, pick 'em up with the skiff a little when the tide came up so you could roll them into the skiff. Bring

'em out, set two or three anchors, come back in, get two or three more, and just keep goin' back and forth. That was how I did it with one other guy. Same thing we're fishin' now: three, four hundred pound anchors, and when we picked 'em up, rather than being smart and asking someone for help, we put a little mast with falls in it and we picked those friggin' things up by hand, six foot at a time. Pull it up, take a rollin' hitch on the rail of the skiff, cinch it off, let it down, take another little bite. And if we could have done it any harder we would have had to work to find a harder way. But it worked. I mean the first year we had 70,000 pounds of squid or more out of those two traps. It was good; it became a success. And then it only took me another ten years to get a boat big enough to do it, and I don't have a big enough boat to do it now, really. I had a 20' skiff like the big skiffs we have, and two 16' skiffs when we started, and we'd just fill the skiffs up with fish. Basically, just bail them into the thing with dip nets. This boat here (NORTH STAR) works. I mean honestly, it works fine, but it would be nice to have one big enough in the spring to actually do this, and personally, I think the future is there. We're goin' to have to get a bigger boat, 'cause I think there's goin' to be a lot more fish to deal with. I don't think there's any way there's not goin' to be a lot more fish. The big boats are all being regulated out of business. The big steel boats, they can't afford to even be here.

For now, generations of Rhode Island trap fishermen continue their work to the best of their abilities given the current economic and regulatory climate. It remains to be seen how much longer this tradition can last. As Anthony Parascandolo notes:

... it's really, really to a point where you have to struggle to make enough money to last till the next year. Like this net right here, was ten-fathom deep. A couple of years ago, my father and I split the whole thing in half and put an extra two fathom into making it a twelve-fathom trap, where a few years ago you would just make a twelve-fathom leader. We used to rig traps in here, sections of traps, and put 'em on the lot and put 'em together, and we haven't been able to do that in years, and years, and years. There's no money left to do all that. It's just about squeakin' by every year, and it seems to be getting tighter with the increase in prices of fuel and things. It's going to be a struggle trying to stick it out long enough for things to slack off on us.

Documentation of the Trap Fisheries

In documenting the last fishermen utilizing the floating trap, I have restricted my focus to the technologies and the people employed within this fishery. While fully aware of the problems facing both fish and their environment, I chose not to add them to this discussion. Any industry we create as a society inevitably produces its share of difficulties with which we must cope. Regulation of the fisheries within the United States is an amazingly complex process, and as with most things, sharply divided opinions surround every issue. Undoubtedly, kernels of truth exist on both sides of the divide, and perhaps the solutions we seek are to be found somewhere in the middle. We currently import over 90 percent of the fish we consume in this country. As a nation, we heavily regulate our fishermen and fish stocks out 200 miles from our coastline, while simultaneously eating fish coming from countries with few or no constraints. As consumers, it may be wise to take these facts into account when considering these larger problems.

The purpose of this book is not to enter the debate surrounding our fisheries, but rather, to honor and celebrate the human side of this story. Fishermen are simply our neighbors. They get up each morning and go to work to earn a living, raising their families with the same hopes as we do. They represent, however, yet another endangered group of producers. Rhode Island's abandoned factories no longer ship goods around the world, and the state's farmers now produce less than 2 percent of the food consumed within its borders. Perhaps there is more to the end of these traditions than we have considered, and I hope the story this book records brings a greater appreciation for what we stand to lose.

The Plates

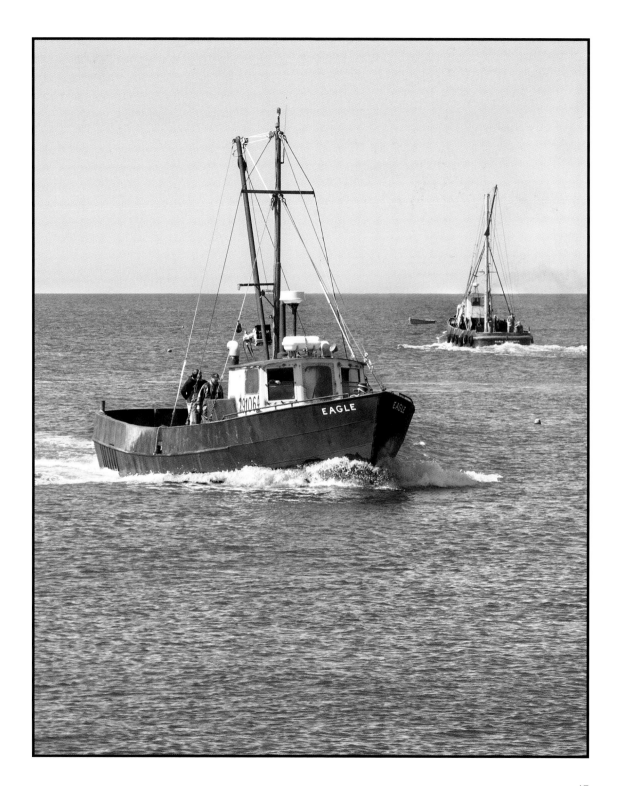

Crewmen aboard the *Eagle* and the *Maria Mendonsa* begin the season's work by building traps they will tend throughout the summer. The *Mendonsa* fishes three traps in separate locations, taking advantage of the migratory patterns of their target species. Traps, by law, are set in very specific sites, and special permits are required for each. Most trap sites have been in use for over 150 years, and once abandoned, cannot be reopened.

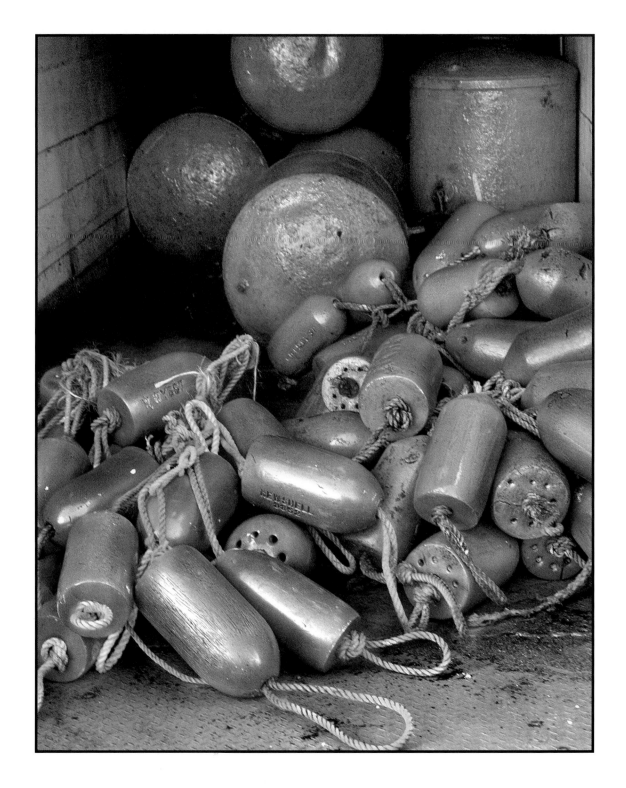

Trap fishing is a gear-intensive business. The floating trap requires miles of line, acres of nets, hundreds of floats, and thousands of pounds of anchors to moor it all in place. Beyond the gear, however, is the knowledge of how to put it all together and make it work. Passed down through generations of fishermen, this knowledge fades as fewer young men and women enter what remains of this industry.

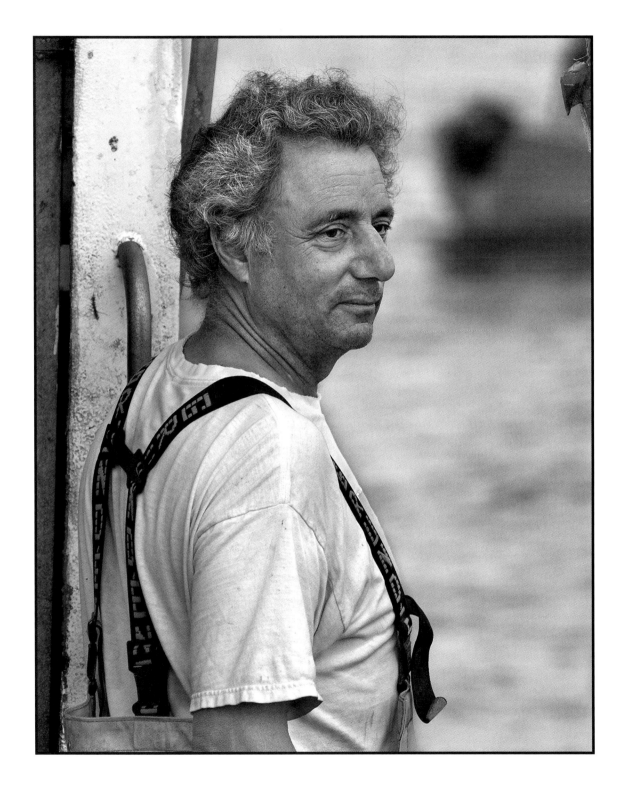

Anthony Parascandolo, captain of the *Christine Roberta*, owns and operates one of the two trap companies fishing from Sakonnet Point. Both his father and grandfather were involved in the fishing industry, as are all of his father's brothers and many cousins. His family began by buying, trucking, and selling fish, eventually adding traps to their lives as opportunity allowed.

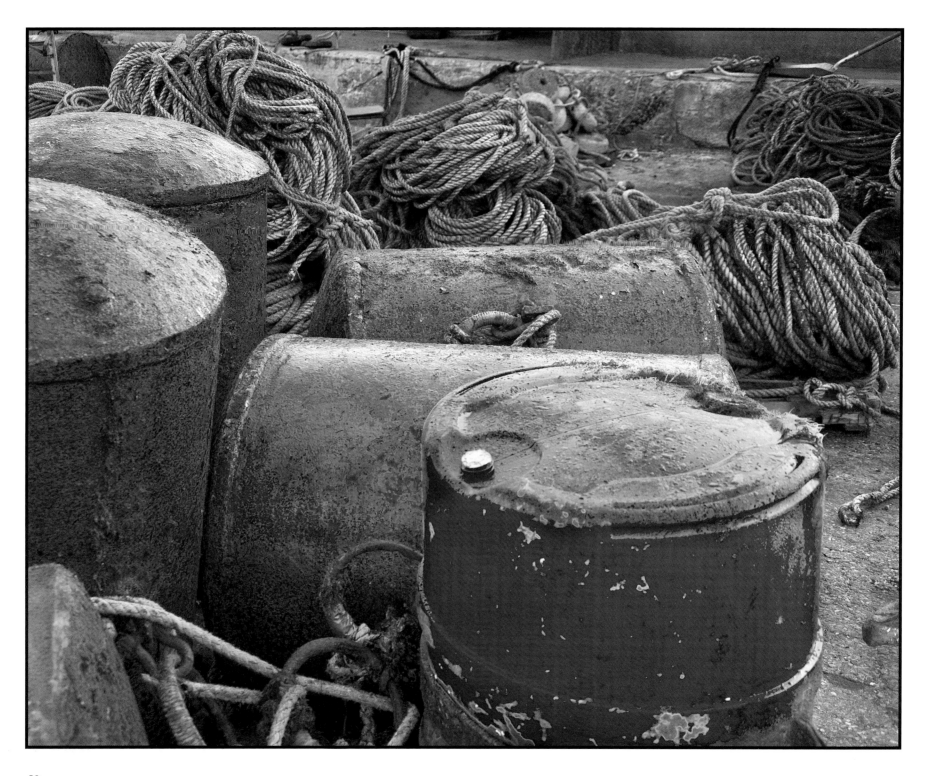

Left: Steel barrels provide flotation for the trap while anchors weighing up to 1,000 pounds hold them in position. Subject to forces of nature such as high winds, ocean waves, and tidal currents, the surface area created by the twine they support generates significant strains that must be held in check.

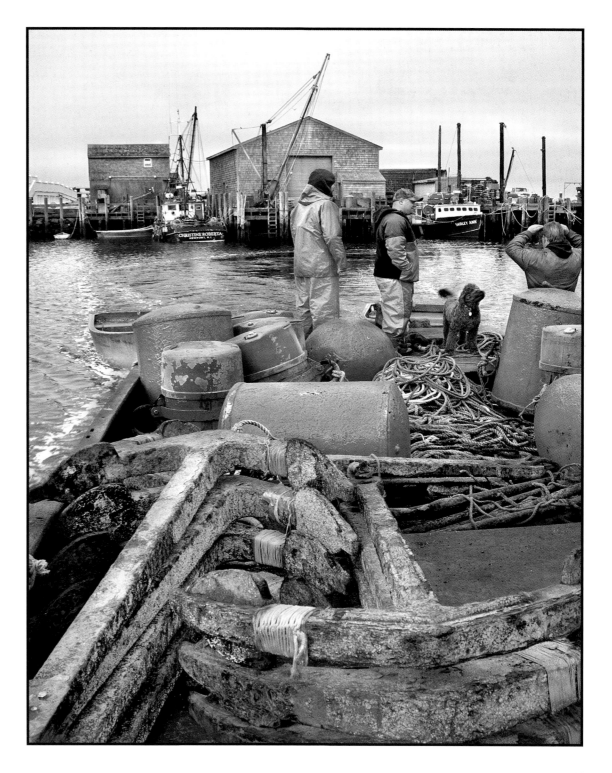

Right: Constructing the trap is an art form in and of itself. The first step is to set the frame of the trap, from which the twine, or netting, will hang. After positioning the numerous lines and barrels of the frame, fishermen tension the trap by pulling its anchors outboard with the ship. With the frame thus set, twine is brought and hung from it. Built into the twine are smaller floats along its entire top edge that not only help suspend the net, but also keep fish from escaping over the upper edge. Lead, iron, or concrete weights hold the bottom of the twine to the sea floor, keeping fish from simply swimming under the netting.

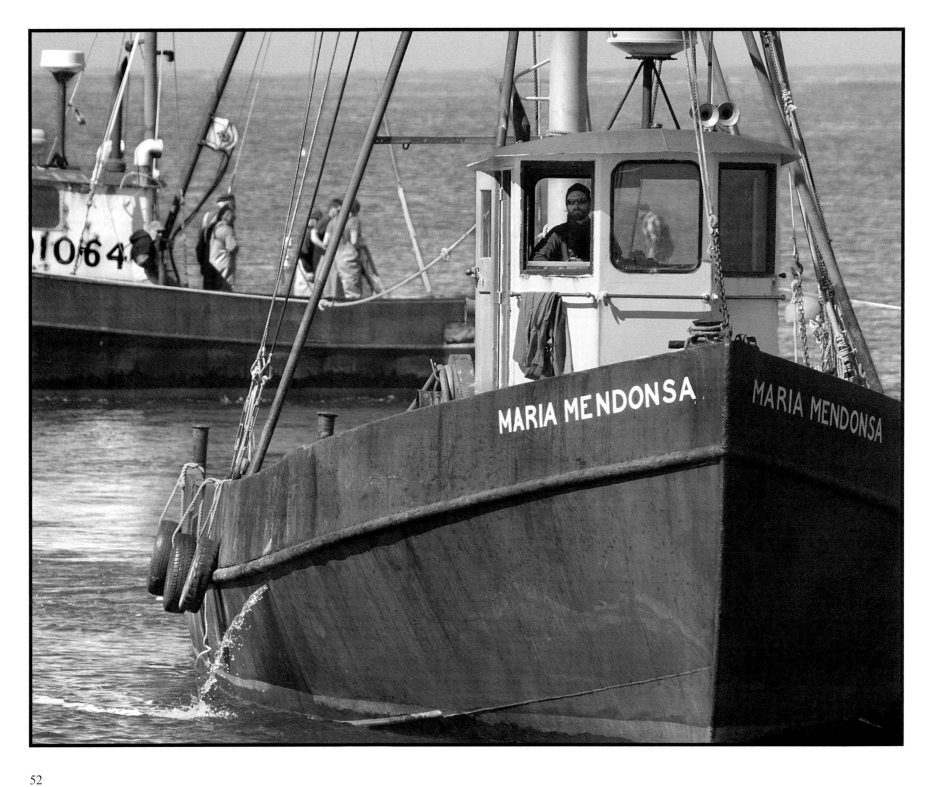

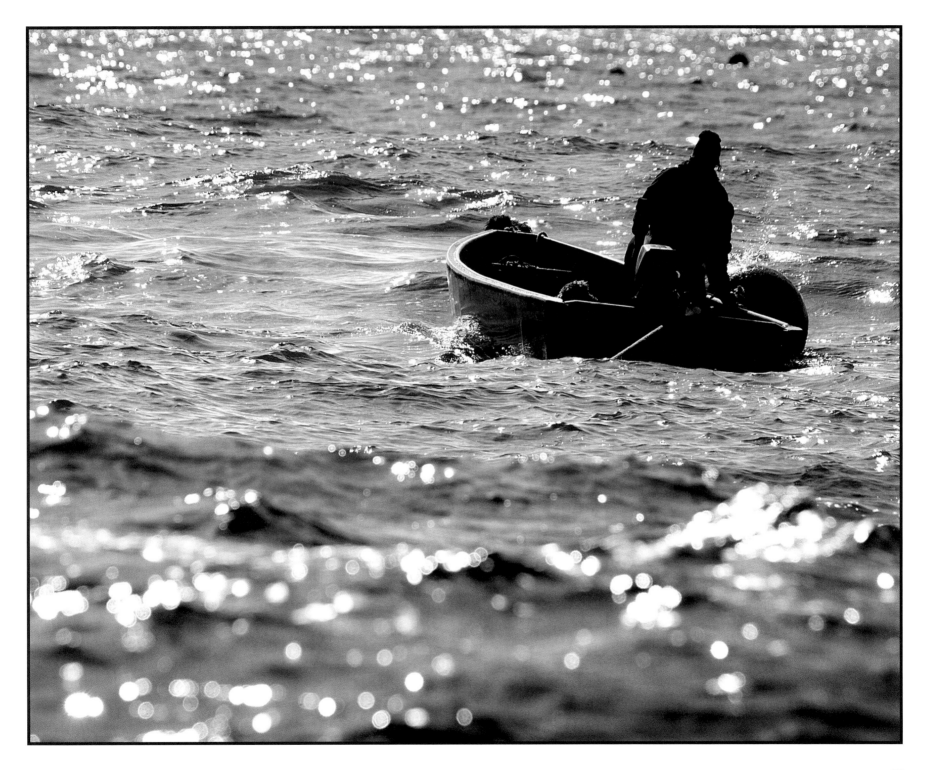

Previous Page Left: The *Maria Mendonsa*, piloted by Luke Wheeler, tows the *Eagle* sideways using a bridle as they set the leader. Some 1,500' in length, the leader forms a fence as it stretches from the shoreline to the trap, running from the ocean's surface to the sea's floor.

As the cable passes across the deck, crew attach the leader's netting to the frame of the trap, which had been set in place the previous day. Buoys support the top edge of the twine while fishermen add weights to the bottom edge of the net before sending it overboard. The leader is a tapered piece of netting made specifically for the particular site the trap occupies, as it must follow the contour of the ocean bed below. Narrow where anchored to the shoreline, it increases in height as the depth of the water becomes greater.

The use of powered vessels such as these, rather than the smaller boats once rowed to each trap, is one of the few ways in which trap fishing has changed over the course of time.

Previous Page Right: A fisherman tends to the corner barrel as the frame of a trap is anchored into place. Tension from opposing anchors holds the trap in position. To assure the frame is straight, crew in a distant boat will signal the mother ship when the barrel is in line with the others. To communicate this information, an oar held vertically in the workboat is lowered, indicating the exact moment the ship should drop the anchor.

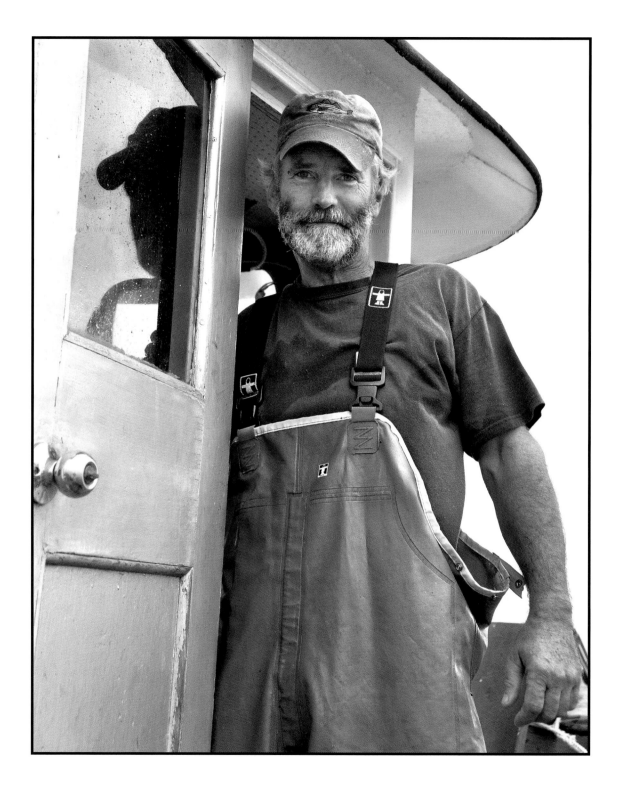

Left: Alan Glidden, owner of the Black Point Fish Trap Company. Like all trap fishermen, Alan owns numerous trap locations at which he may or may not set nets. Certain species of fish might appear at one trap, but not at others, depending upon their migratory paths or the depth and quality of the water in which it is set. For instance, large amounts of fresh water entering the ocean as runoff from land surrounding a bay after a heavy rainfall may change the salinity of the water, altering the paths fish take as they move along the coast. Variation in the temperature of the water at each site may also help determine a specie's course. Having multiple sites allows fishermen to work different species at different times throughout the summer months. One site may catch scup or bass, while another catches squid. Trap sites further from the coast are held for the day in which other species may be harvested once again.

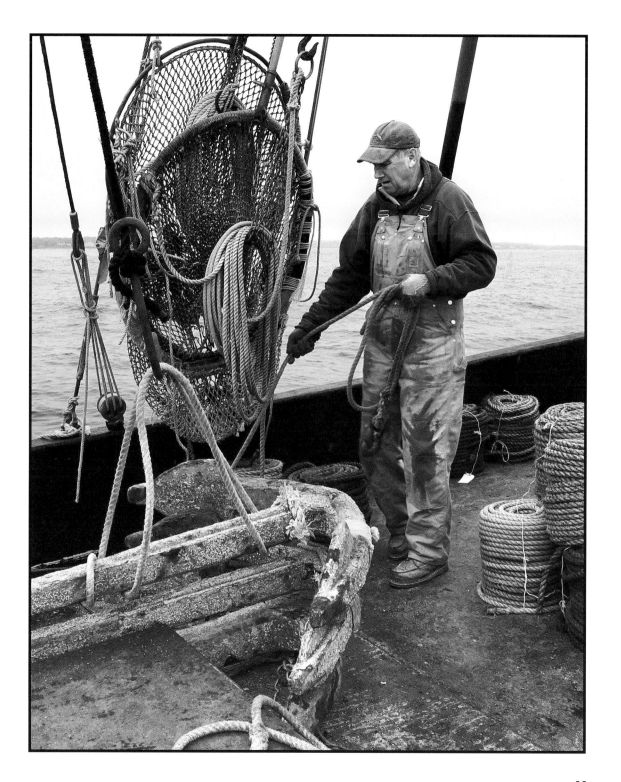

Right: Alfred Sullivan, or "Sully," prepares to swing an anchor onto the transom deck as the crew works to get a trap's framework into position. The ship's winch will lift the anchor from the deck and crew will run it aft as the man on the winch pays out line. Once positioned on deck, the anchor line is attached to the appropriate barrel and the ship steams out until it is pulled overboard. Numerous anchors pulling in opposite directions assure each barrel's position in the water.

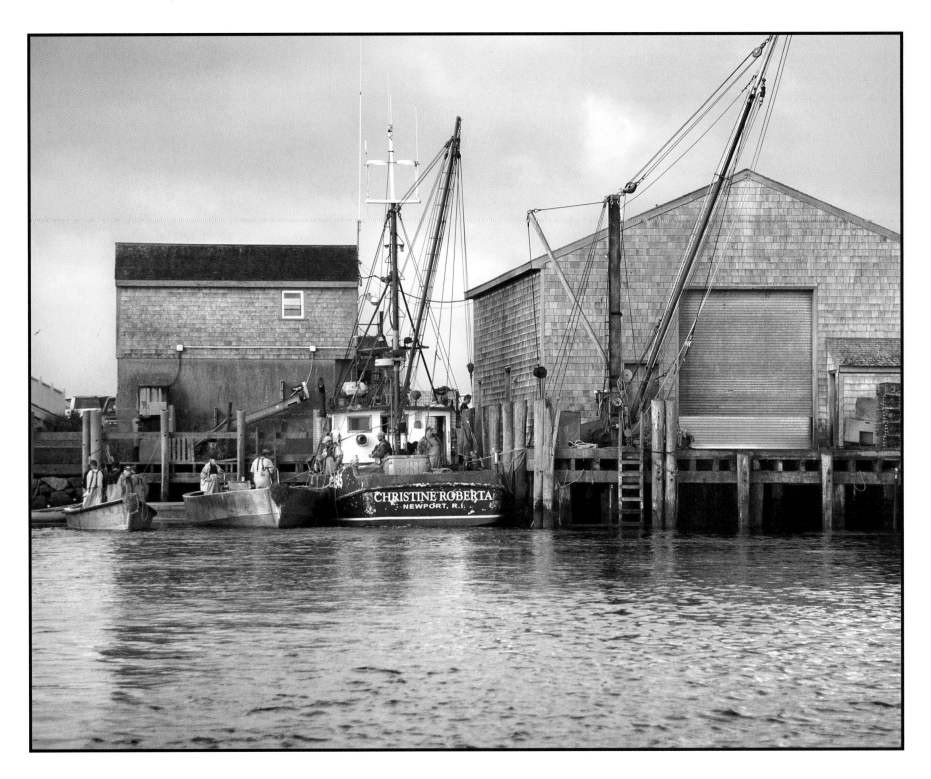

Left: The *Christine Roberta's* crew assembles for the morning's work at Sakonnet Point. Part of Little Compton, Sakonnet is on the peninsula that forms the eastern boundary of Narragansett Bay along the state's border with Massachusetts. Point Judith, the other port from which trap companies operate, sits on the western mouth of the bay. The building on land directly behind the vessel houses an office for the Parascandolo operation, as well as gear used in the fishery. The large building on the dock to the right functions as a fish handling and shipping center. Fishermen off-load their catch from the boat and into this building by conveyor, where it is sorted and packed with ice for trucking.

Trap companies have long operated from both Newport and Sakonnet, but the development of the waterfront in Newport and the corresponding rise in property values drove fishermen to seek new locations from which they could work. At the time of these photos, the Parascandolo family still maintained a wharf on the Newport waterfront for additional operations. There, the family handled landings from trawlers and maintained a fueling operation catering to other local fisheries. Five years later, this wharf too was up for sale.

Right: Alan Wheeler stands at the helm of the *Maria Mendonsa*. Adam Lotz, one of Alan's two partners, appears through the pilothouse window in the background. Alan's grandparents shipped fish aboard steamships to numerous markets along the eastern seaboard. Early on, fish were packed with ice into wooden barrels for transportation. Alan is the third generation involved in the fishing industry, while his daughter and two sons represent the fourth.

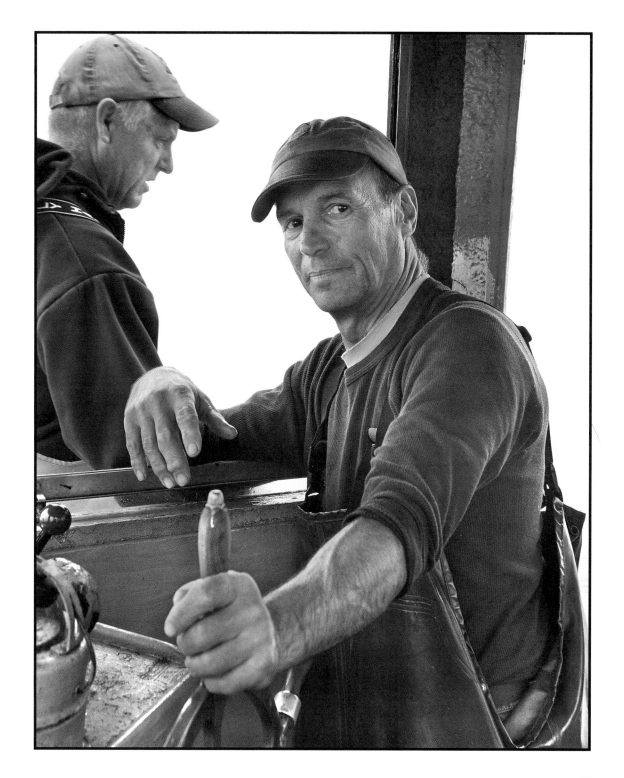

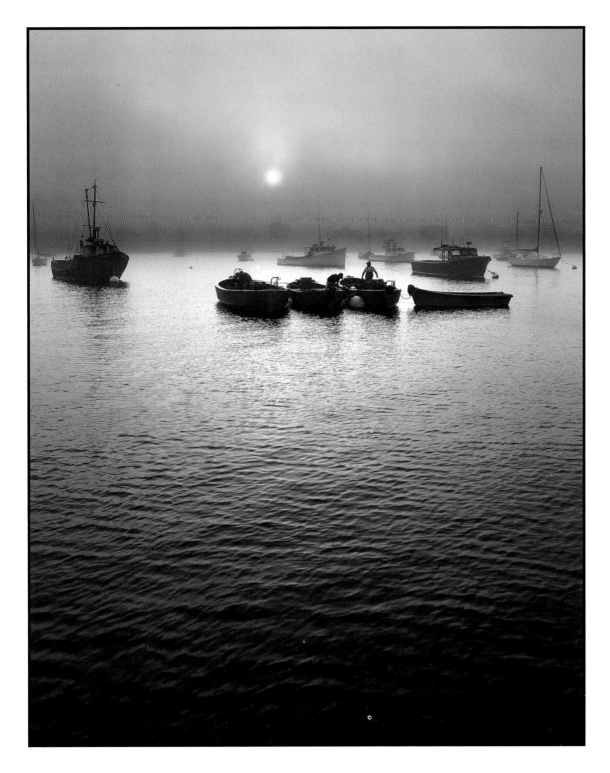

Crewmen prepare their longboats on a foggy morning. The *Christine Roberta* will tow them from the crowded harbor as a group before allowing them to stretch into a line behind her. Other types of fishing vessels also operate from Sakonnet Point: lobster boats, draggers, and gill-netters still have a place on the waterfront, and many trap fishermen work secondary jobs in these fisheries.

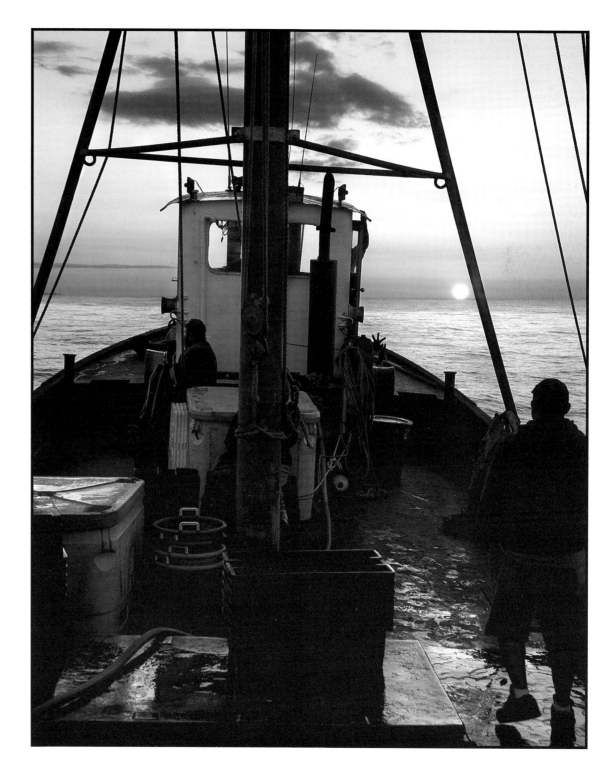

The *Amelia Bucolo* steams from Point Judith to her trap site as the sun rises over Block Island Sound. The morning run to Black Rock is approximately twenty-five minutes, and a more beautiful commute is hard to imagine. The *Bucolo* is a sister to the *Maria Mendonsa*, although lengthened by ten feet later in her career. Built as "carry" boats for the trap fishing industry, each vessel can handle tens of thousands of pounds of fish.

Left: Tom Hoxsie heads out on the *North Star* to check three traps located around the Harbor of Refuge. With the shortest commute of the four companies, Tom can be on any of his three traps in about ten minutes, saving both time and fuel. While an offshore trawler was burning some $1,800 of fuel each day during this trap season, *North Star* required a mere $800 of fuel over the course of an entire year.

Right: Crews from Sakonnet prefer to ride to their traps in their longboats. Both operations have sites off Aquidneck Island's shores and others within a few minutes of Sakonnet Harbor. Depending on weather and the number of fish in the trap at each site, they may visit one, two, or all three traps during the day.

Three companies use purpose-built steel or aluminum longboats in their daily operations, while Tom Hoxsie works from wooden skiffs he builds himself. The 32' longboats provide a stable work platform for crewmen as they haul twine or perform other tasks related to the business. To help them with their work, the nozzle boat has an onboard winch powered by a gasoline engine, which helps them close the nozzle before they begin hardening the net.

In the early part of the last century, crews rowed wooden versions of these boats, built by locals, to the traps. Once there, they loaded them with fish and rowed home. Larger vessels with engines began towing longboats to and from the site when marine engines became both common and cheap. Today, these larger vessels also carry their fish back to port for processing and shipping.

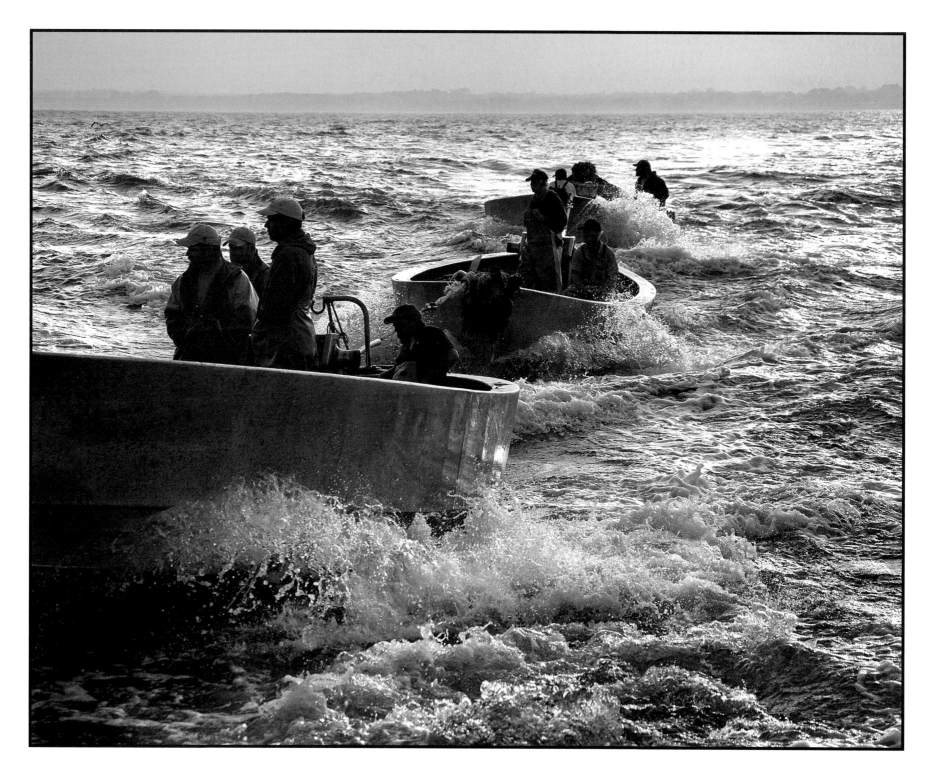

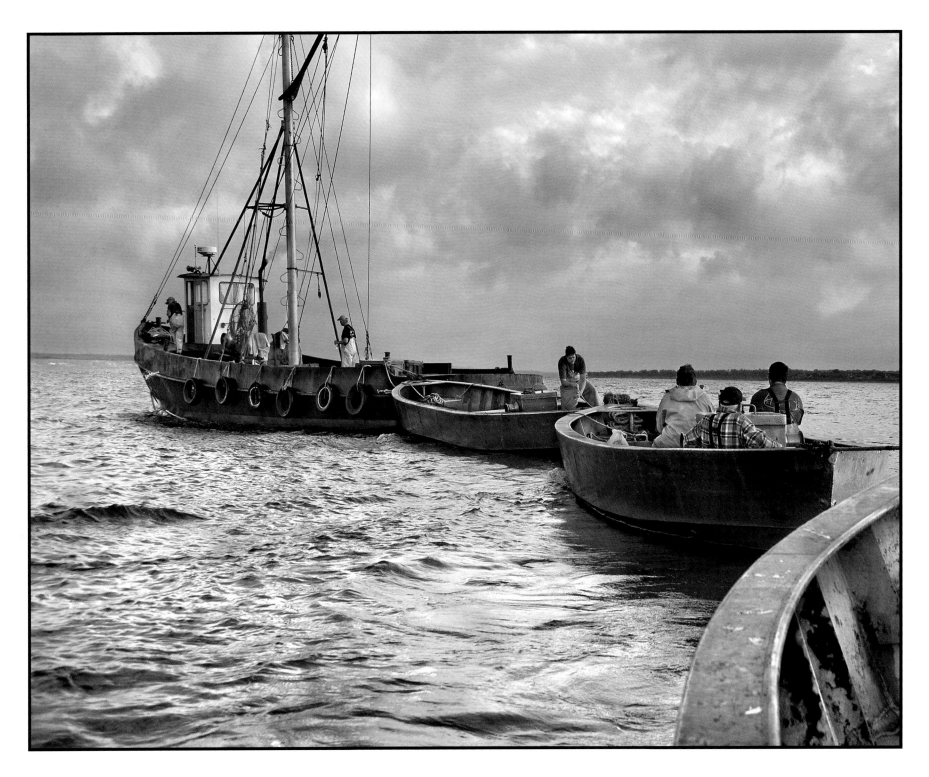

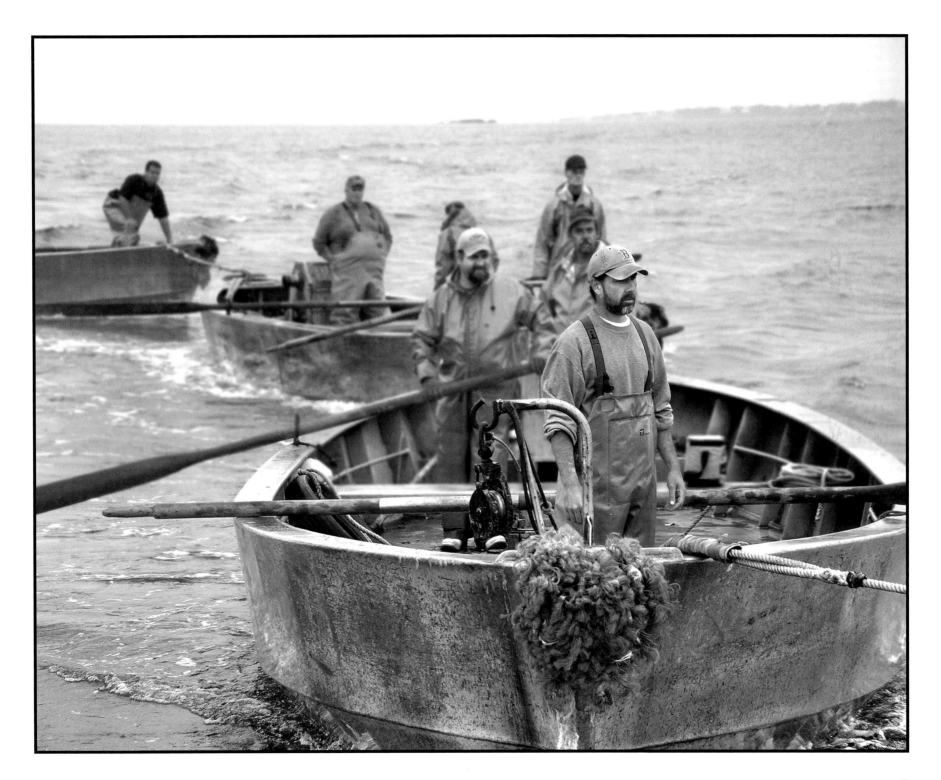

Previous Page Left: The *Maria Mendonsa* turns at the harbor entrance and heads to her first trap. Displacement hulls such as these are not as fast as boats that plane, but are far more economical to operate. Given short distances to trap sites, fuel savings are more valuable than the time they could save with faster boats. The vessel's design also allows fishermen to carry sizeable loads without fear of capsizing. With 30 or 40,000 pounds of fish on deck, stability is of the utmost importance.

For electronics, trap boats generally carry a global positioning system, a radio, and radar, although on most days line of sight or compass bearings are adequate. While these vessels have small cabins forward where crew can ride out of inclement weather, they are more commonly used to store foul weather gear and fishing equipment.

Previous Page Right: Crew from the *Christine Roberta* contemplate their approach to a trap. The trap boat releases its longboats while under weigh, allowing momentum to carry them the rest of the way with little assistance. Once released, the longboats separate from each other and head to their individual stations.

The actual trap portion of the net—the parlor—consists of a floating box made of twine. Fish seal their fates once they swim up the kitchen's ramp, through the nozzle, and into the parlor. The nozzle, the only way out, is closed by fishermen in the nozzle boat to prevent their escape. Each longboat assumes a position on one of three sides of the parlor, leaving the head of the net for the trap boat itself. Once the ship makes fast to the head-end of the parlor, it lifts it with an onboard winch. In this way, fish forced by the crew to this side of the ship cannot escape over the floats.

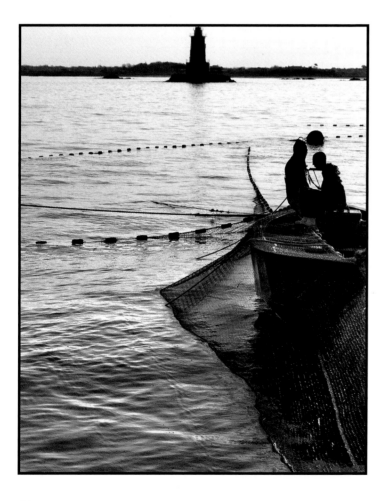

Left: Two crewmembers from the *Mendonsa* wait at a trap site near the lighthouse at Sakonnet Point. After the longboats get into position on three sides, they also hoist their edge of the parlor into the air and onto the rail of the boat. At this point, they await the signal from the nozzle boat to begin hardening the trap. The angled floats below the lighthouse trace the top edge of the wings, a section of the trap that guides fish further into the kitchen.

Right: The *Amelia Bucolo* heads from her berth in Point Judith to the trap at Black Rock on a bright June morning. The essential gear on deck consists of plastic totes and baskets used to separate the catch by species, a large tote in the center of the vessel carrying ice to keep fish cool, and a bull net on the starboard rail used to scoop fish from the trap. The large hatch in the foreground provides access to the hold of the vessel where spare gear is stored. The engine room is beneath the pilothouse and is accessed through the fo'c'sle.

Two separate trap companies fish from Point Judith: Tom Hoxsie's operation with the *North Star* and the Alan Glidden's Black Point Fish Trap Company with the *Amelia Bucolo*. Point Judith is one of the few remaining deep-sea fishing ports in New England, once holding the position as the ninth largest in the United States. The port's status, as well as the income it generates for the local economy, has declined as new regulations and tightening restrictions end fishing careers. With its unique geographical position, at the divide between the colder northern fisheries and the warmer southern, Point Judith fishermen are known for their adaptability. Draggers, scallopers, gill-netters, lobster and trap fishermen all operate from the port, and many vessels switch gear throughout the course of the year to take advantage of open fisheries.

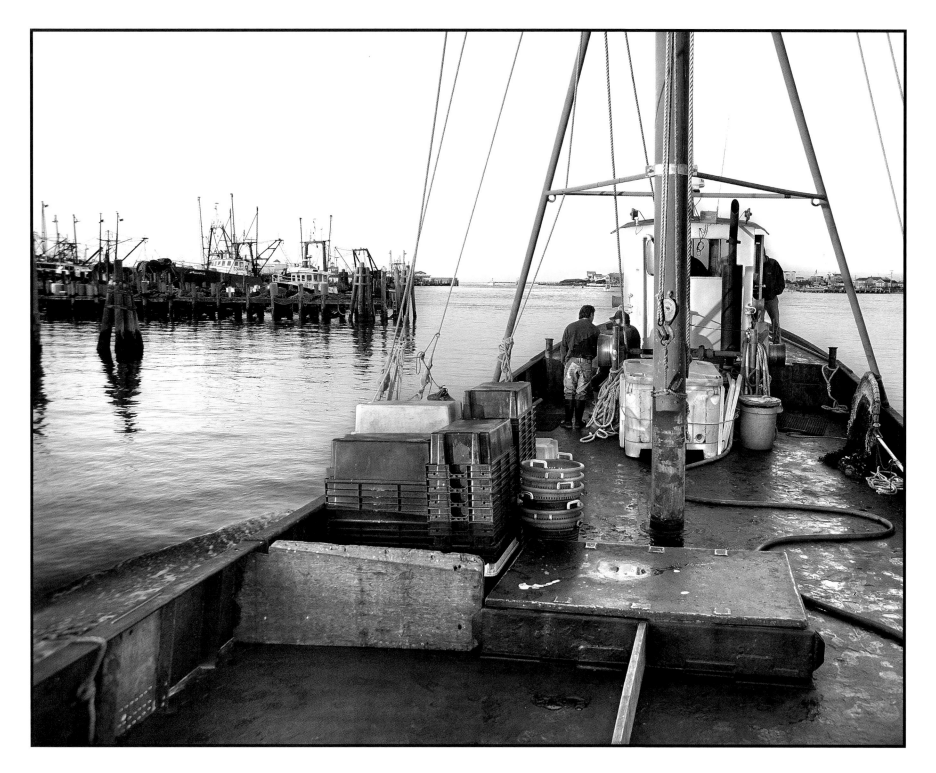

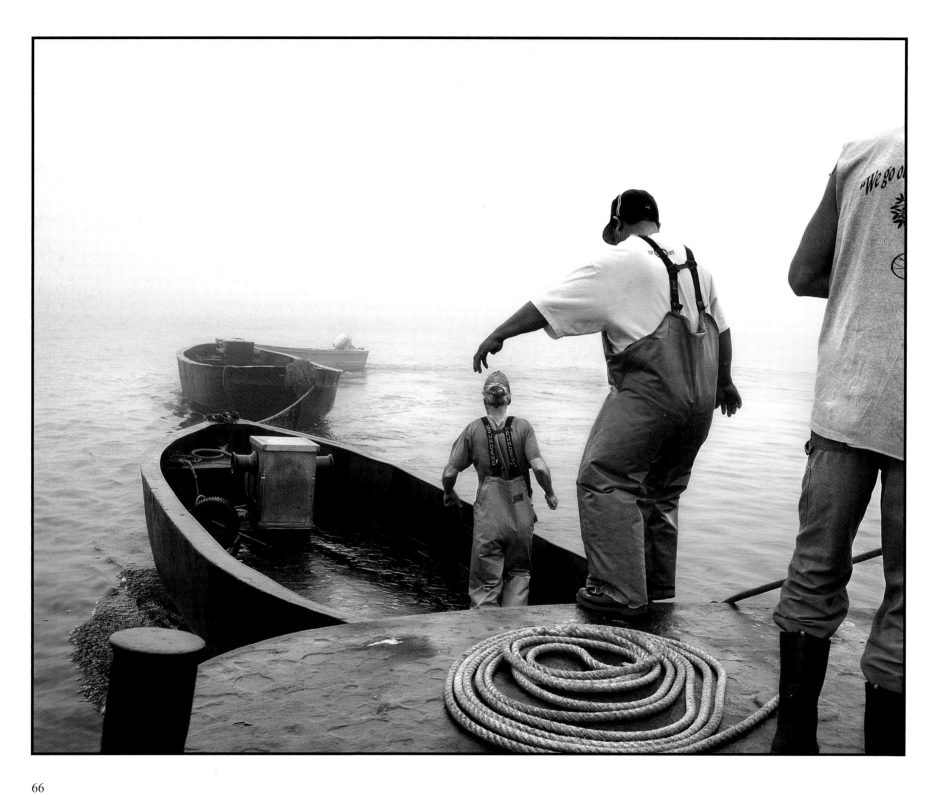

Left: Crewmen from the *Amelia Bucolo* enter the longboats as they approach the trap. Trap fishing requires more people than the typical trawler, as fishermen haul the netting by hand. The Black Point Fish Trap Company employs seven men on the boat throughout the summer. With thousands of pounds of fish in a trap, many hands are required to bring the reluctant mass to the surface.

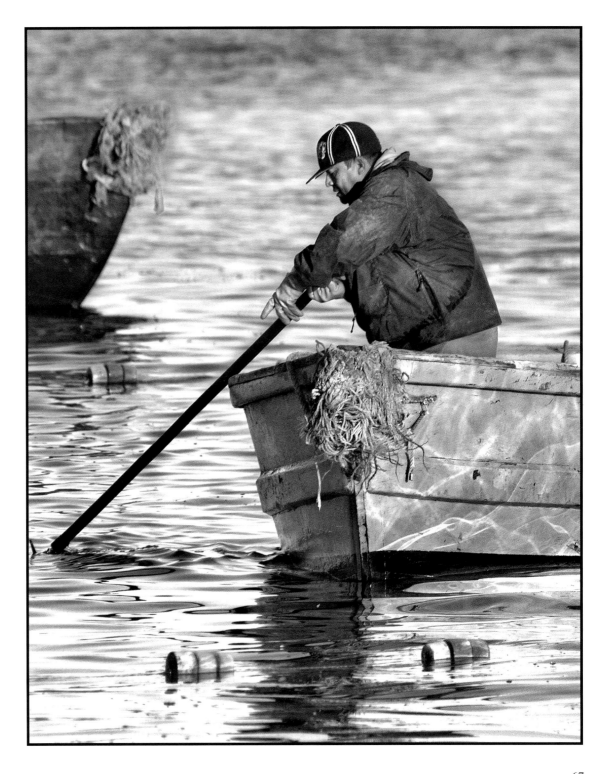

Right: Saul Umana uses a boathook to pull his skiff into position on one side of the parlor. Floats, occasionally called corks as they were in the past, line the top edge of the twine, keeping fish from going over in their efforts to escape. Saul came with his family to the United States from El Salvador. He worked as a fisherman in his home country and has a son fishing from Point Judith, continuing a family tradition for another generation.

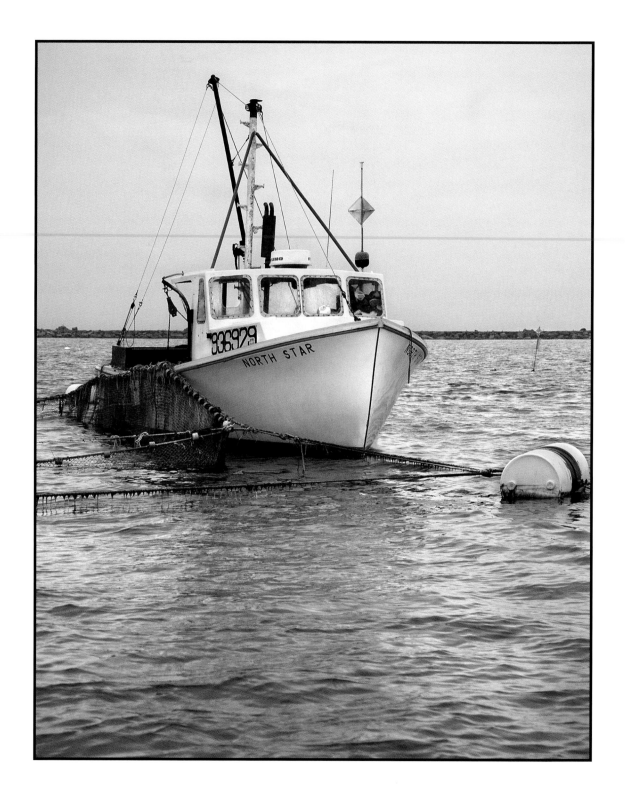

North Star tied to the head end of the parlor. The winch on the boat's pot-hauler raises the net into position, firmly anchoring the vessel until the crew has finished emptying the catch. As trap fishermen are given just a few short months in the summer to operate, most take up work in another fishery once the trap season closes. Tom Hoxsie converts the *North Star* back to lobster fishing during the winter months, the job for which she was initially designed.

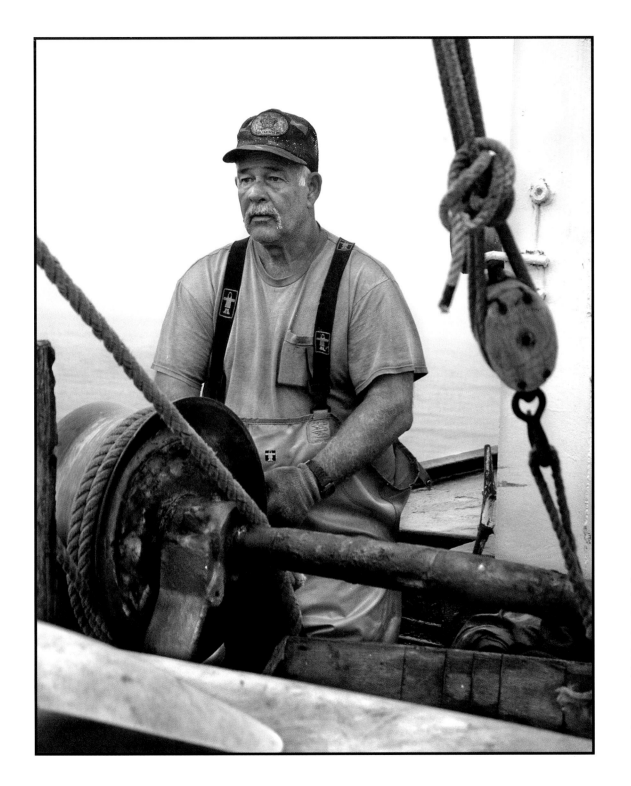

James Main, the captain of the *Amelia Bucolo*, tends the winch as the head end of the parlor is hauled from the water. Asked how long he has been fishing, Jim replied that his father woke him one morning when he was ten years old, telling him, "You're going fishing," and he has been at it ever since. Working for most of his life offshore on trawlers, Jim came to trap fishing at the end of his offshore career, making it possible for him to continue fishing while still returning every night to a warm and dry home.

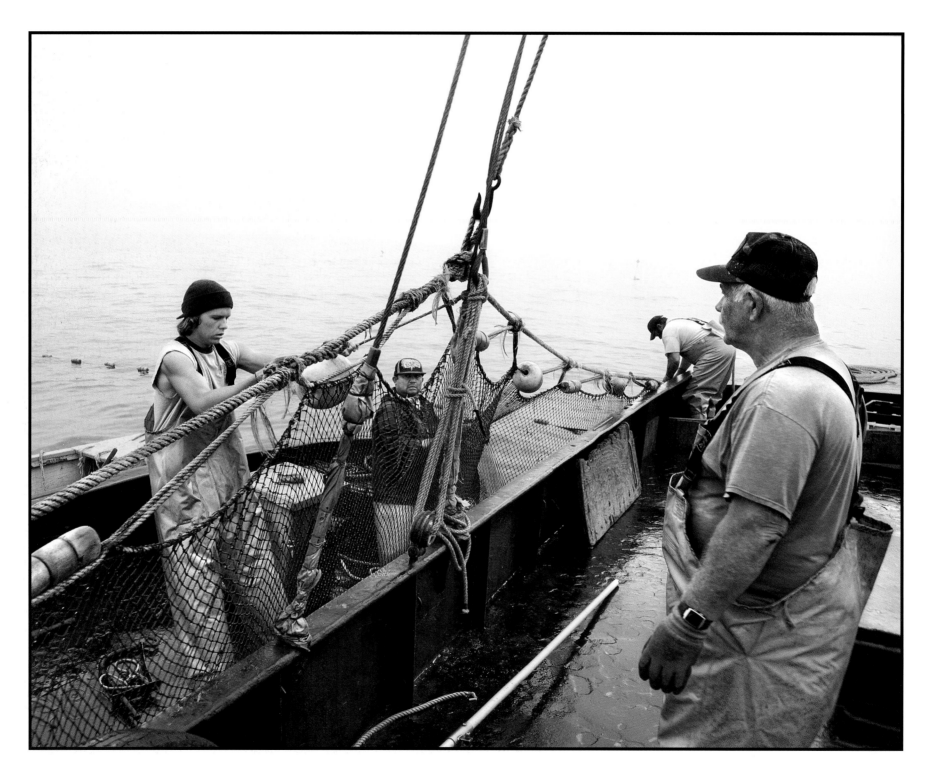

Left: With the net hauled above the rail, Nick Lord works to lash it to the vessel as Jim looks on. The floats used along the top edge of the net are clearly visible, and the heavy line to which they attach is part of the frame of the trap system. Once deckhands secure the vessel to the net, the entire crew will board the small boats to begin hardening the catch.

The fishing industry now has difficulties enticing young men and women into the business, despite its reputation as a place where people with grit and determination can reach the top. There are countless stories of people working their way up the ladder from the position of deckhand to captain. As both state and federal agencies tighten control over fishermen, they reduce the number of licenses available. Young people now have nowhere to go within the industry. Without a license, there is no business for them to create, causing them to seek opportunities in other fields.

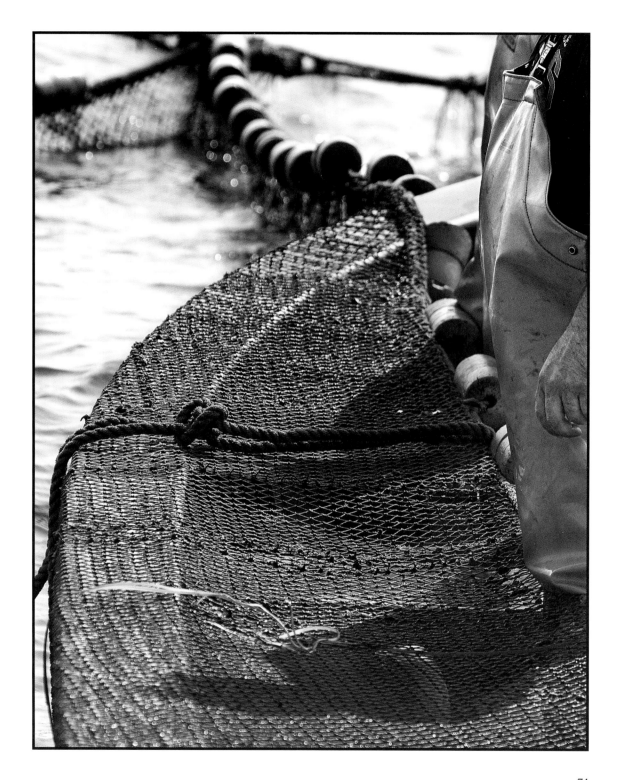

Right: While the design of the floating trap has varied little in 200 years, the most significant change has come with the type of materials used to make the netting. Once made from all natural fibers, such as cotton or hemp, the twine itself would rot beyond use in as little as one or two seasons, depending upon its location within the trap. Today's traps are made of nylon, a material developed just prior to World War II.

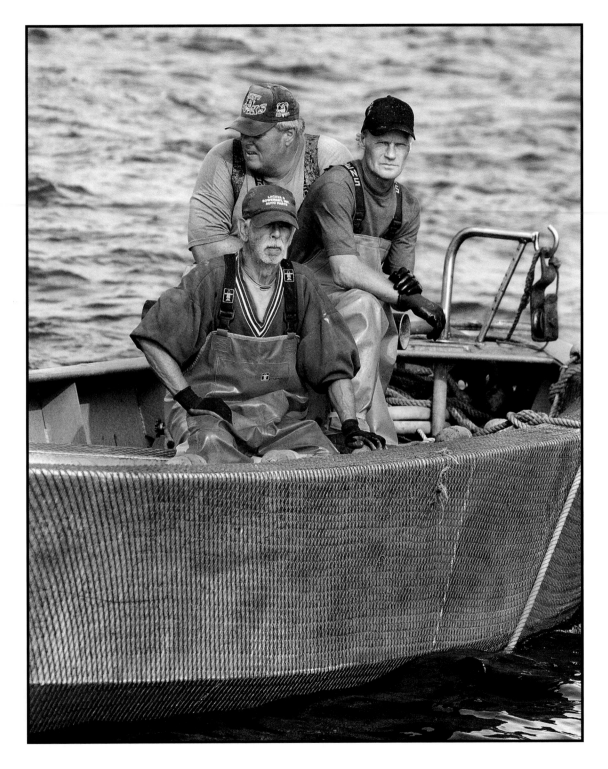

Left: Charlie Crapo, Don Rosiana, and Robert Palmer from the *Christine Roberta* wait to begin hardening the trap. George Mendonsa and his brothers had these longboats built in Maine to replace their original wooden workboats, a move that saved them many hours of maintenance over the years.

Right: Sam Willis, Ian Campbell, and Tom Hoxsie begin hauling one of their three traps. While Tom's traps may be the smallest, they offer certain advantages. Tom's gear requirements are much less, as is his need for labor. He is fully operational with the *North Star*, two crewmen, and a single skiff. With these resources, Tom mentioned that he caught enough fish to make some 60,000 meals, in addition to the baitfish trapped, over the course of the previous year.

Visitors to this site can see much of its layout, traced by floats bobbing on the ocean's surface. The leader net is visible here, centered in the trap and disappearing into the fog in the distance where the far end attaches to a breakwater. This end of the leader meets the wings, which funnel fish further into the trap. Having closed the nozzle behind them, Sam, Ian, and Tom begin hardening the trap by hauling the net into the skiff, forcing the catch towards the *North Star*. As they work the fish closer to the boat, they drop back overboard the netting previously brought into the skiff, all the while maintaining hold on the edge of the net just coming aboard. This keeps the skiff from filling with twine.

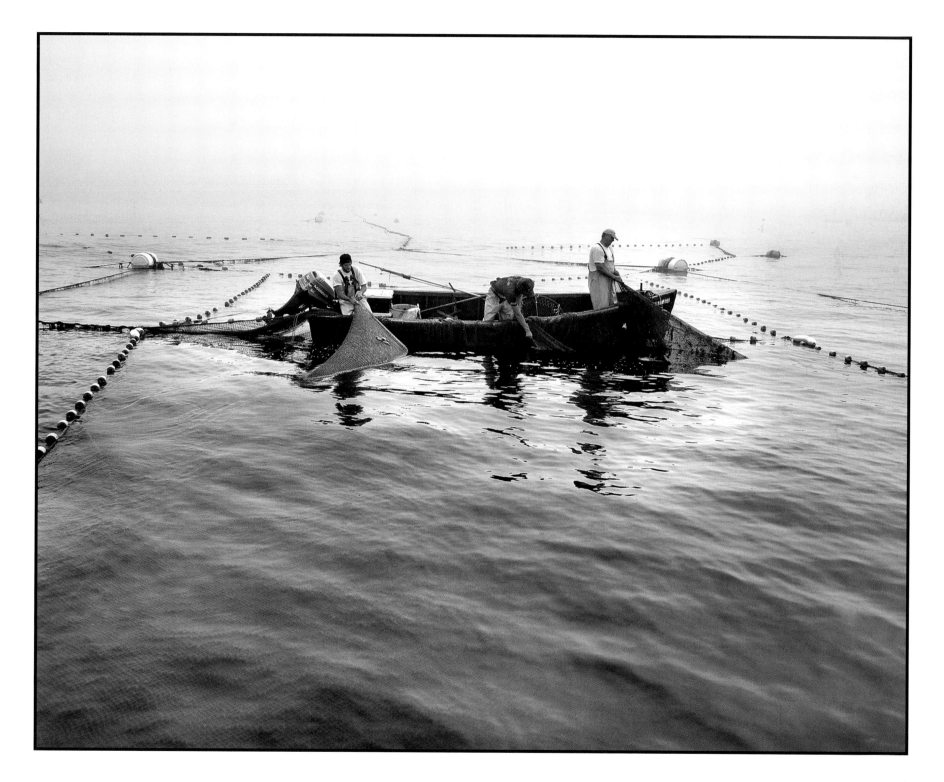

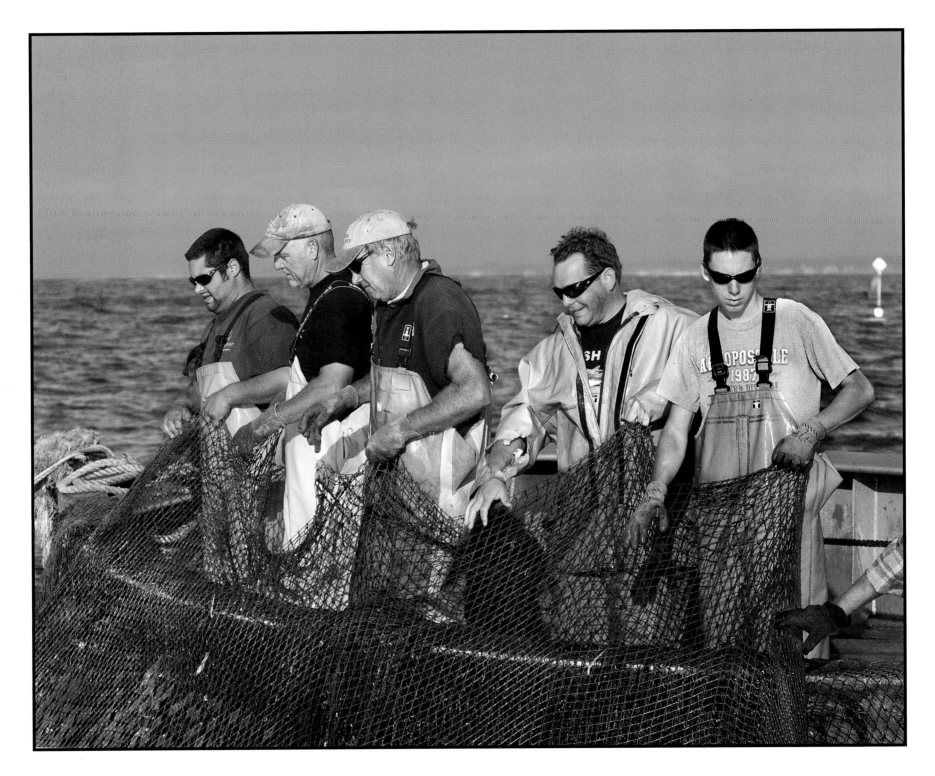

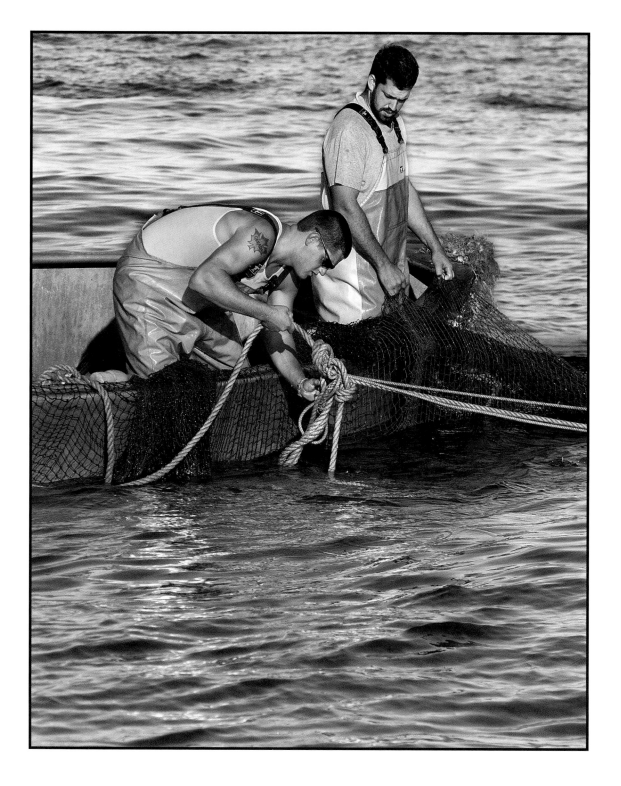

Left: Ed Abrantes, Adam Lotz, Alfred Sullivan, Jay Linhares and the youngest of the crew, Nick Lotz, haul twine on a brilliant day. Adam, one of three owners of the company, is Nick's father. Both Ed's and Jay's fathers once fished for the company as well. Sully, after fishing for a short period in his youth, chose to go into the construction trades. After his retirement from the Plumber's Union, he returned to the business of fishing.

It is rare to find people who enjoy the work they do as much as fishermen. Despite the many governmental agencies at their shoulders—and fishermen joke there are more people in government offices overseeing what they do than there are fishermen—they love the ocean and dread the day they will be forced to look for work ashore.

Right: Aaron Taylor works on the control lines leading to the nozzle as Devin Ferreira holds twine in place. The nozzle controls the passage of fish both into and out of the parlor. While some fish find their way back out of the trap through this opening, most do not. Should trap fishermen reach their daily quota, they can simply leave fish swimming in the trap, without harm, until the next day.

Right: Stephen Menard works his section of the parlor. The heavy steel and aluminum longboats make very stable platforms from which to work the traps. While designed to carry fish in the days before engines, most of the loading today is along their rails as crew haul both twine and fish to the surface. Smaller boats could not successfully resist these rotational forces.

Far Right: Roland Smith (Bucky), Jim Main, and Rick Cambio work together to keep fish moving towards the *Bucolo*. They are reducing the area available to fish swimming within the trap, eventually leaving them with no room to escape the bull net used to hoist them to the deck. At this point, crew begin to see what types of fish they have, as the water is now shallow enough for them to be visible from above.

The migratory patterns of certain species are remarkably precise, and fish arrive at trap sites generally within a week or two each year as they have for the past hundred. Because of this, fishermen must be ready, or risk losing a major portion of their yearly income. Uncooperative weather at this time of the year leads to worry over their ability to get their traps in place on time. Once the traps are set, however, they look forward to the arrival of great schools of scup, one of their most important species.

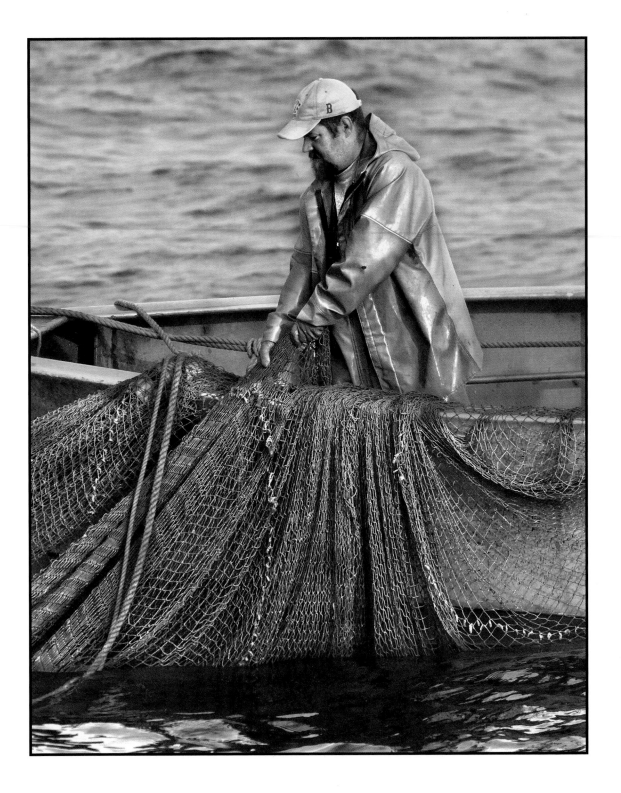

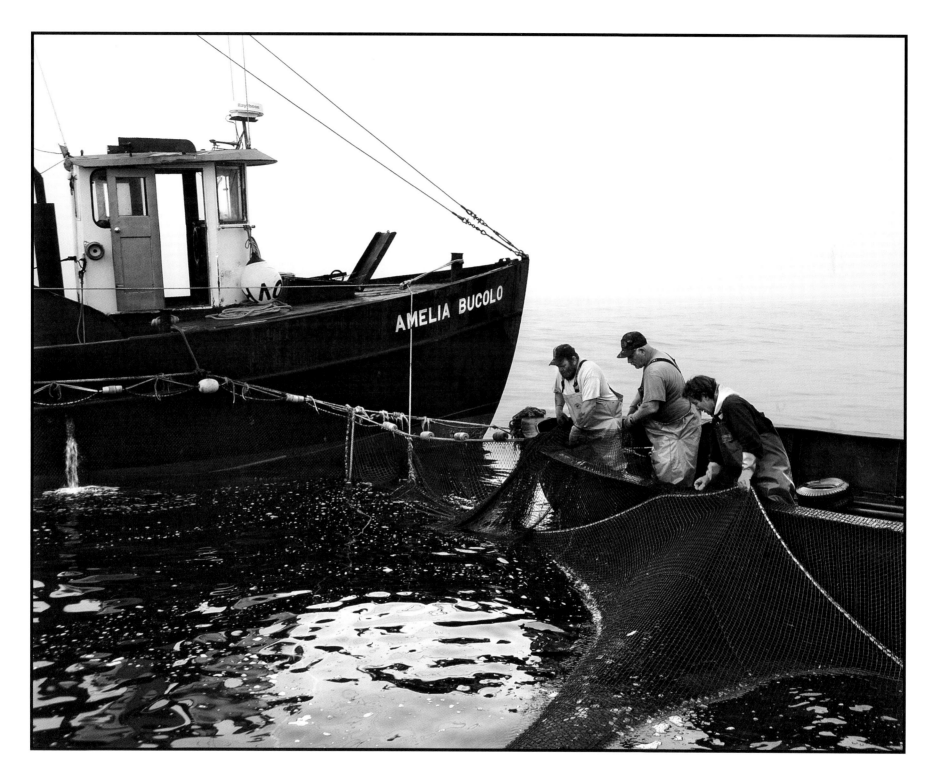

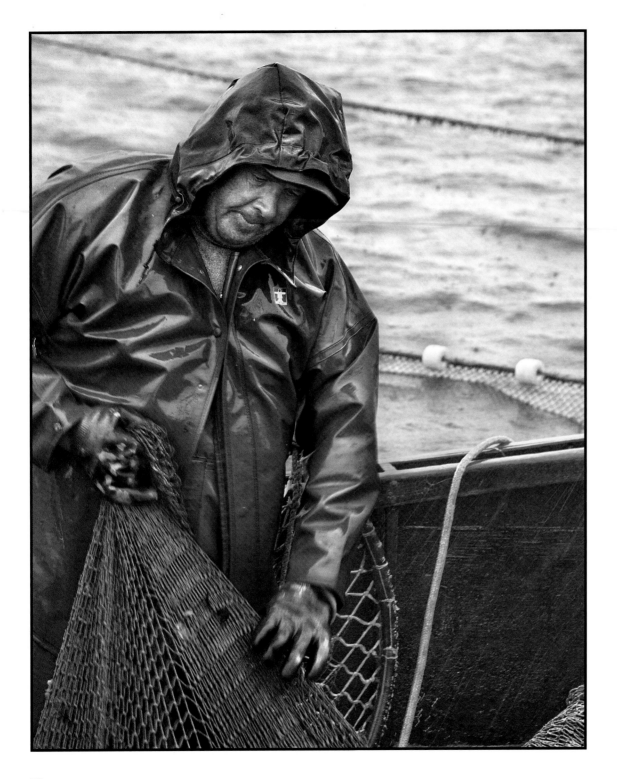

Tom Hoxsie pulling twine in the rain. While in general, commercial fishing seldom stops because of weather, extremely rough days can keep trap fishermen from emptying their nets. The heavy longboats endanger crews' hands and fingers when crashing together as the catch is hardened. Two of Tom's traps are within the breakwaters at the mouth of Point Judith, often providing enough protection from summer storms to allow him to fish while others wait.

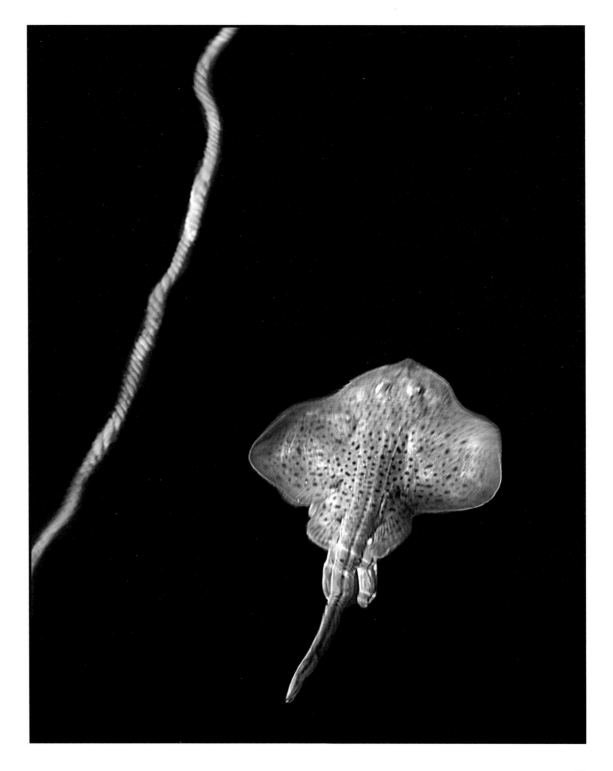

A skate swims near the ocean's surface, searching to escape its predicament. When current regulations allow, skates are generally used as lobster bait, although the "wings" on large skate are suitable for human consumption. Proving too big for the former and too small for the latter, this fish was tossed overboard to swim away and resume its normal life.

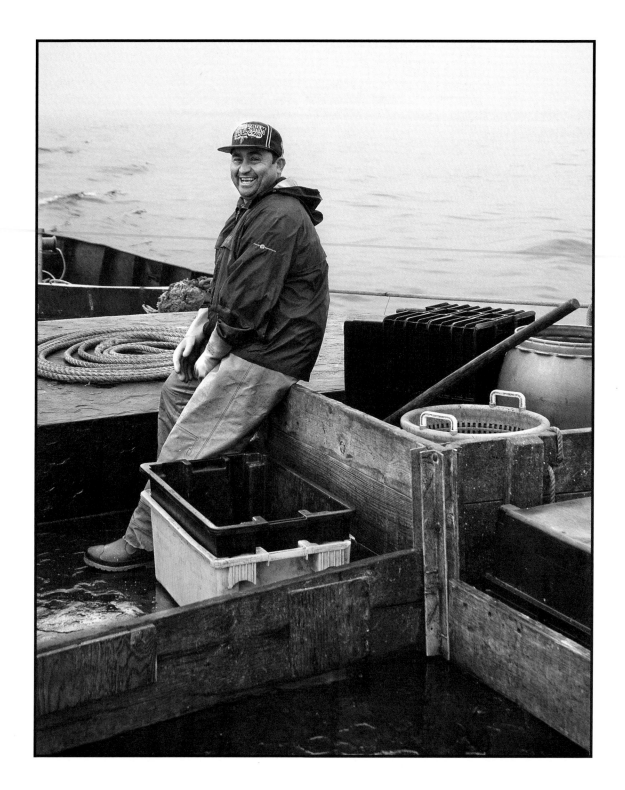

Saul Umana relaxes on the short trip to the site. Trap fishermen leave their docks to begin the day's work at first light, usually between 5:30 and 7:00, depending on the time of year or the captain's inclination. When fish such as scup, striped bass or squid migrate through, crews work six or seven days a week as the majority of their income depends upon these fish. In the middle of the summer, trapping usually slows, and fishermen may skip a day between visits to give traps time to fill.

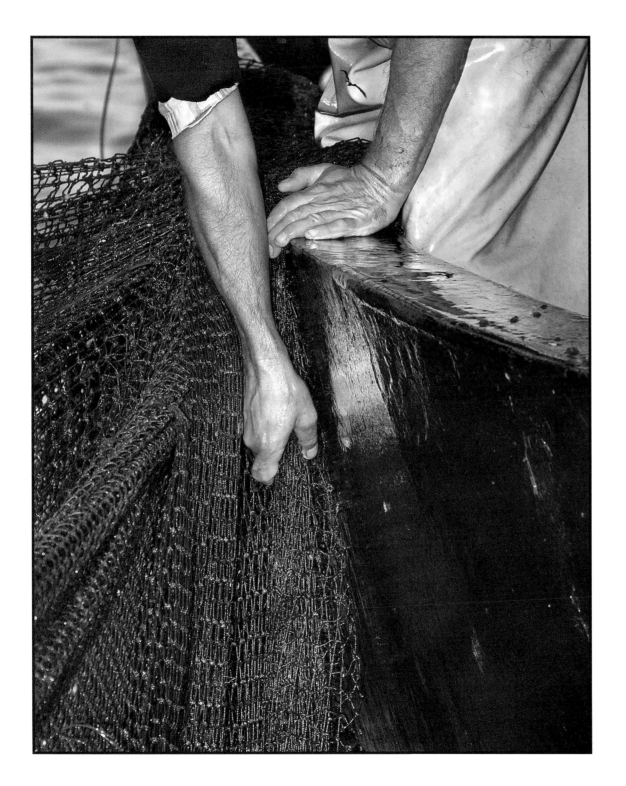

While modern technology has made fishing easier in many ways, it is still heavily dependent upon manual labor. Trap fishing remains one of the most elemental of all the commercial fishing technologies, where large groups of men still pull nets by hand. There is a certain beauty in the work they do, although this is more readily appreciated by those not involved in the actual toil.

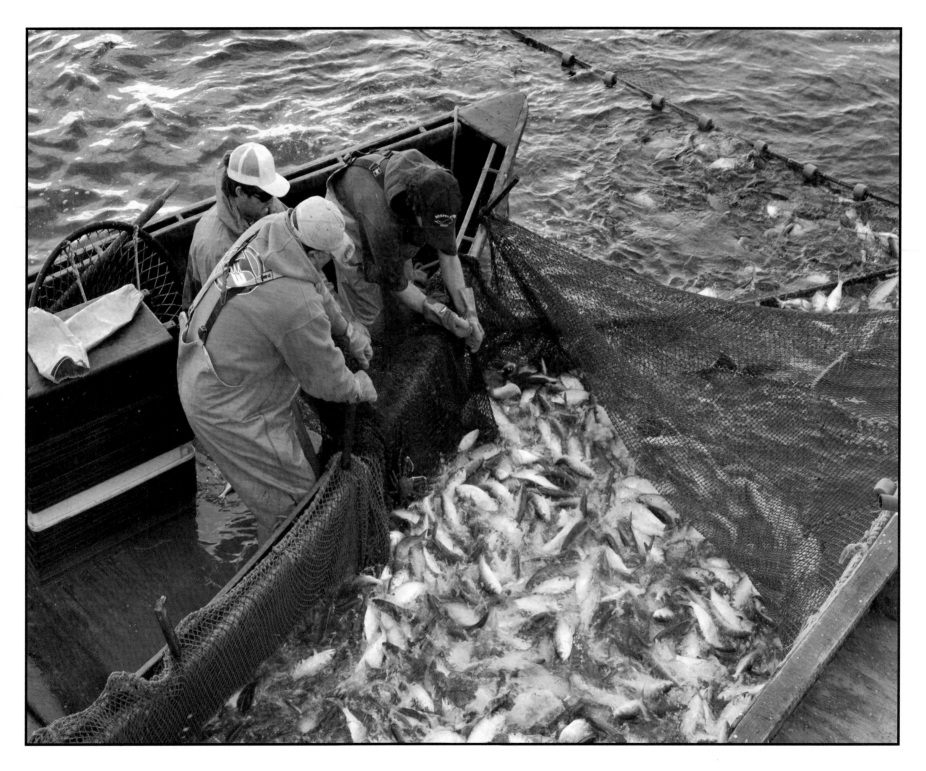

Left: The *North Star's* crew finish hardening the catch. The fish, consisting mostly of pogies, are packed into the little remaining net left to them. To help with the process, Tom slides large dowels through the twine and between the rails of the skiff. These dowels act as spare hands, holding the net they have managed to pull aboard against the struggling fish. Pogies seen making it over the net have only temporarily escaped; they remain in the parlor and are gathered the following day.

Tom's traps are well located for catching pogies on their migratory path, although their appearance can seem a mixed blessing. Not overly valuable, they are primarily used as bait, but still provide income with the large numbers caught. To the unaccustomed, it is a spectacular sight when thousands thrash the water to a froth as they are forced to the surface. Raised and dumped into the boat, they make a memorable cacophony as their tails slap the *North Star's* deck.

Right: Gulls are constant, if unwelcome, companions to all fishermen. Remarkably adaptable and clever, not to mention eternally hungry, they take full advantage of any situation where they may steal a free lunch. Pilfering is kept to a minimum, however, as there are generally enough crewmen on deck to keep them at bay. Nonetheless, they occasionally swoop in to grab fish from open totes when opportunity calls.

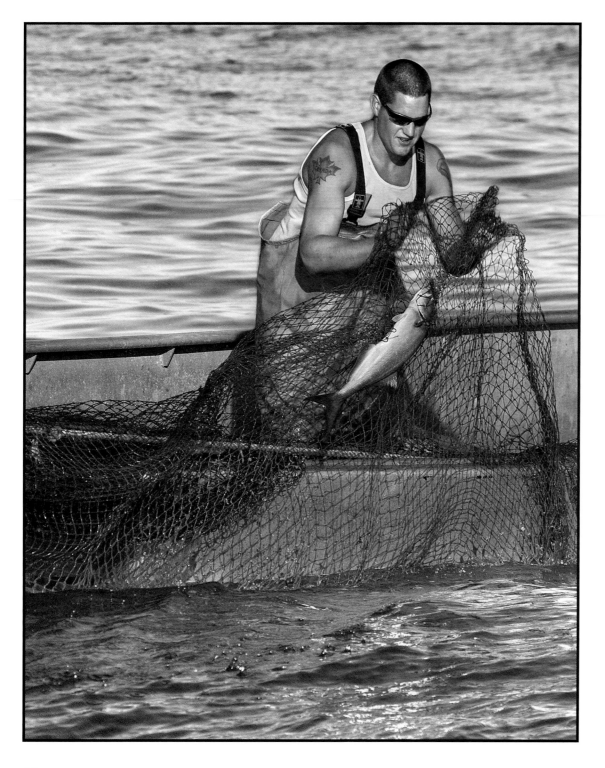

Left: Aaron Taylor flips a bluefish stuck in the twine back into the trap. Fishermen treat bluefish and their teeth with a healthy dose of respect. Bandaged hands are commonplace as crews handle thousands of them over the course of the season. Frenzied schools of blues can shred the trap's netting, although this was more of a problem in the past when twine was made of cotton.

Right: Bucky and Jim haul twine. As with many still in the industry, fishing has been a lifelong pursuit. Both men have spent the larger portion of their careers far off Rhode Island's coast on trawlers and swordfish boats. The draggerman's lifestyle is markedly different. Trips lasting anywhere from five to ten days at sea keep them far from home, making family life difficult for all concerned. Trap fishing has become the perfect way for fishermen to do what they know and love without the disadvantages offshore work entails. Trips are short and end where they began every day. The trap season also closes before cold temperatures blanket the region, and while the work is hard, it is not carried out around the clock as it is at sea.

For young crewmen, trapping can be the beginning of a career or a summer's job, tiding them over as they plan their next move. Like all outdoor jobs, there are people who fish because they dread a working life surrounded by walls. Fishing offers an alternative to the typical nine-to-five job many others enjoy.

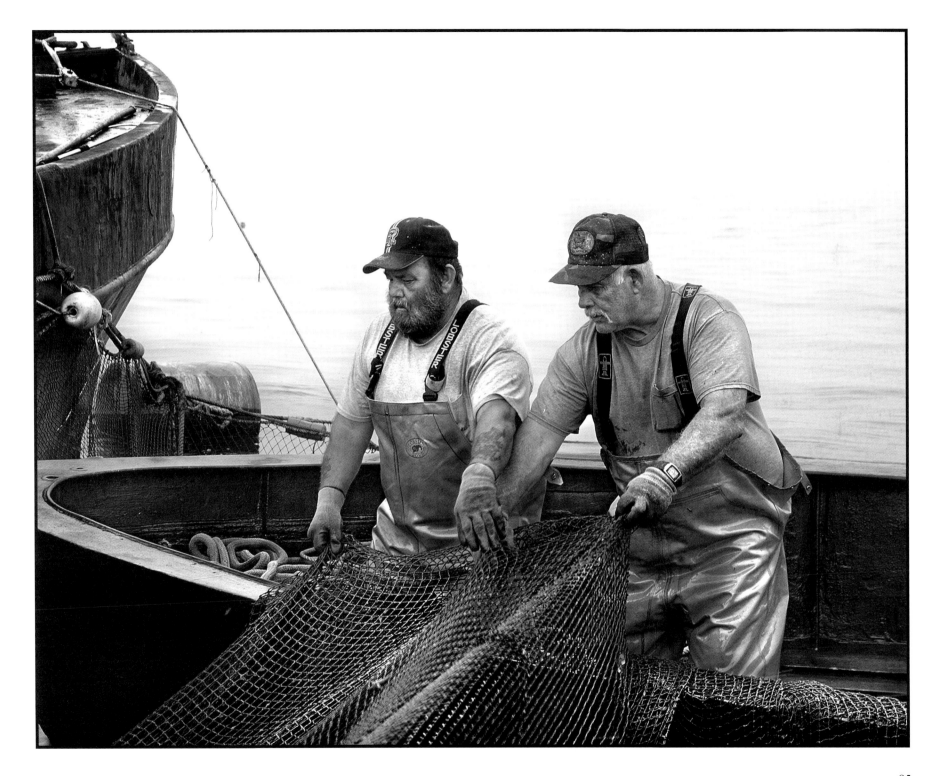

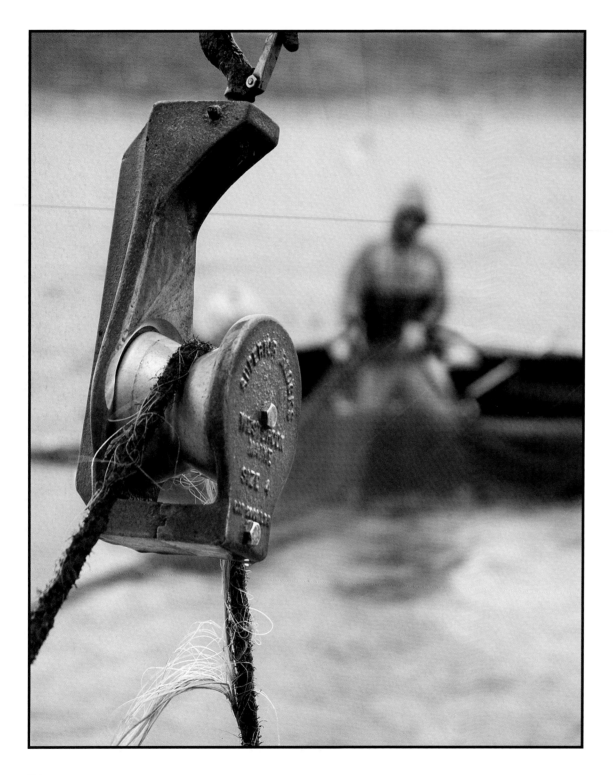

Rain pelts Sam Willis as the pot-hauler takes the weight of the head-end of the parlor through this block—the same block used to raise lobster traps once the fishing season ends.

Portrait of Thomas Hinckley. Tom has worked for Alan Glidden for a number of seasons on the *Amelia Bucolo*, and is seen here concentrating on the work at hand. Having spent many years in Central America, Tom speaks Spanish fluently and uses it on a daily basis while chatting with Saul Umana, a transplant from El Salvador.

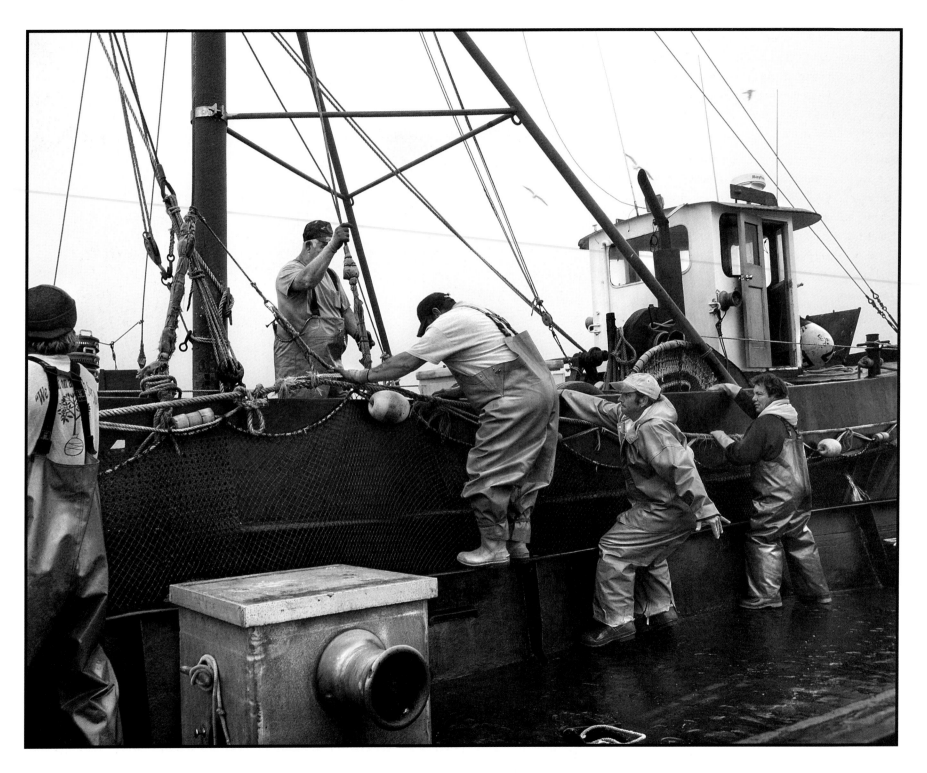

Left: Bucky climbs aboard the *Amelia Bucolo*. At this point, the net has been hardened and the fish are ready to bail from the trap. Bucky returns to the deck to help land and sort the catch. The other three: Nick Lord, Tom Hinckley, and Rick Cambio remain in the longboat, continuously hardening the net as others remove the fish.

Trap fishing is much like opening a grab bag. Except for times when the entire catch is composed of a single species, most days offer a variety. On any given day, the nets may include scup, albacore, striped bass, sea bass, flounder, skate, dogfish, butterfish, menhaden, false albacore, ocean sunfish, squid, whitefish, weakfish, stingray, blackfish, fluke, eel, sea robin, or any other number of species.

One exciting day, an enormous tuna entered a trap at Sakonnet Point. Once a common occurrence, fishermen noted this was unlikely to happen again for another dozen years. On another day, this particular crew found a great white shark swimming in their trap. Fortunately, the fish seemed subdued by the time the crew arrived and released it back into the sea.

Right: Alan Glidden, after closing the nozzle, begins to haul the trap itself. Alan's enthusiasm for trap fishing stems from both the green nature of the fishery as a whole, and from the quality of the fish they produce. Scooped from the ocean as if it were nothing more than an oversized aquarium, fish are seldom damaged as they are with other methodologies.

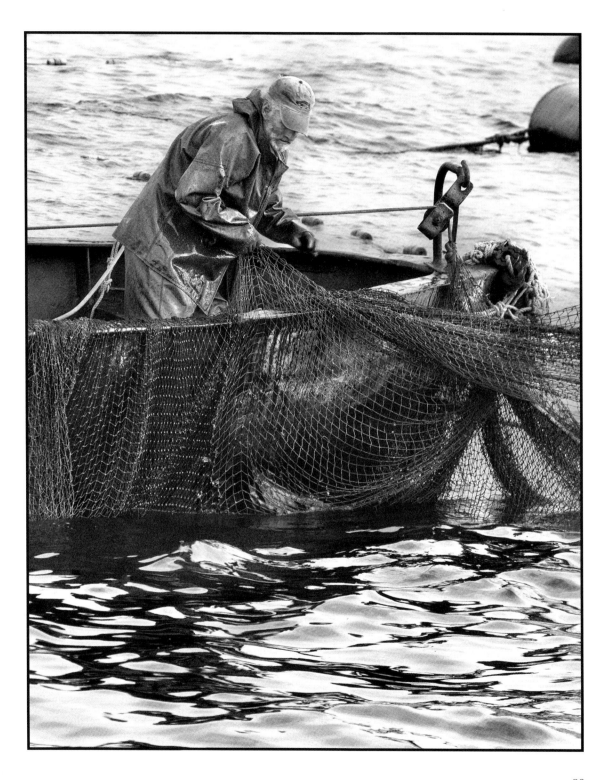

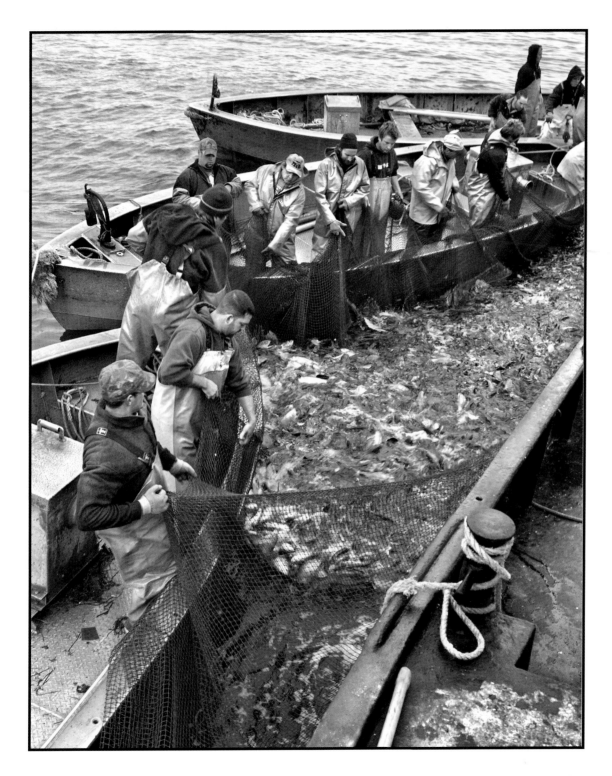

Left: The entire crew hardens the catch against the starboard side of the *Maria Mendonsa*. In the heyday of trap fishing, when over a hundred men might have worked for one company, this would have been considered a small crew. Alan Wheeler's crew count rises and falls to match his needs.

Right: The bull net, capable of lifting nearly a thousand pounds of fish, is raised and lowered by the ship's winch, off-camera in this shot. Nick Lord, handling the net, will swing it overboard where men in the longboat guide it into the thick of the catch. When full, Nick gives a shout to the man tending the winch to lift them aboard. Crew in the longboats guide the net over the rail, and once cleared, the weight of the fish swings the load to the other side of the vessel. Everyone on deck is careful to stand clear, as there is little chance of halting its swing.

The bull net's clever design allows it to open under load, something that helps fishermen quickly empty the trap. The bottom of the net purses together with chain. At the right moment, Nick releases this pursing, dumping the fish on deck where they are sorted into baskets, totes, and barrels.

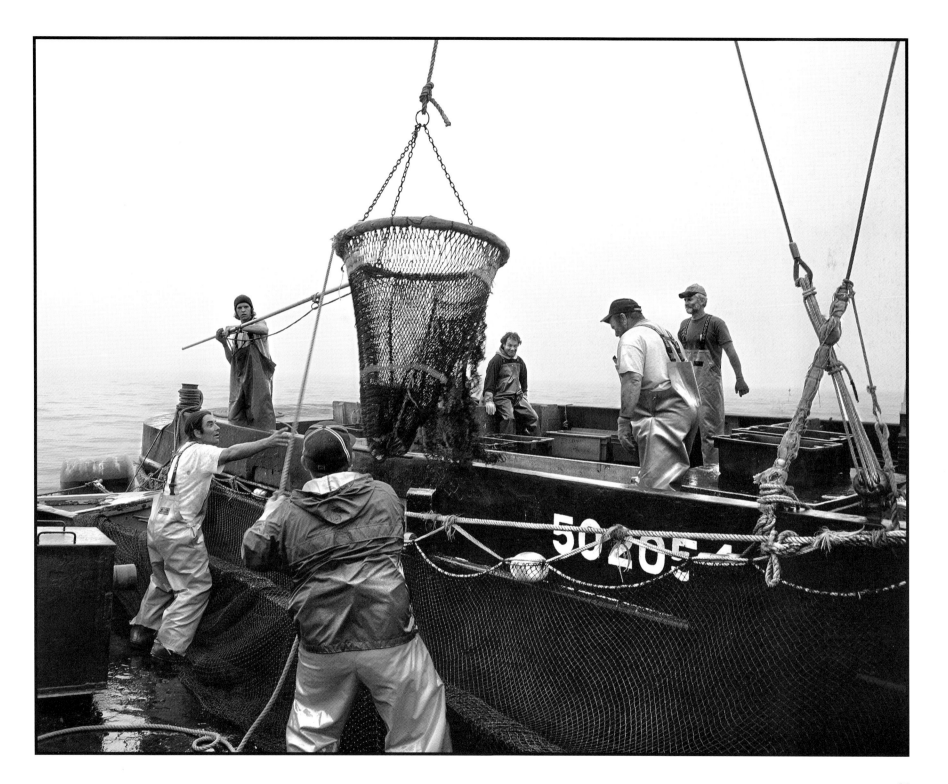

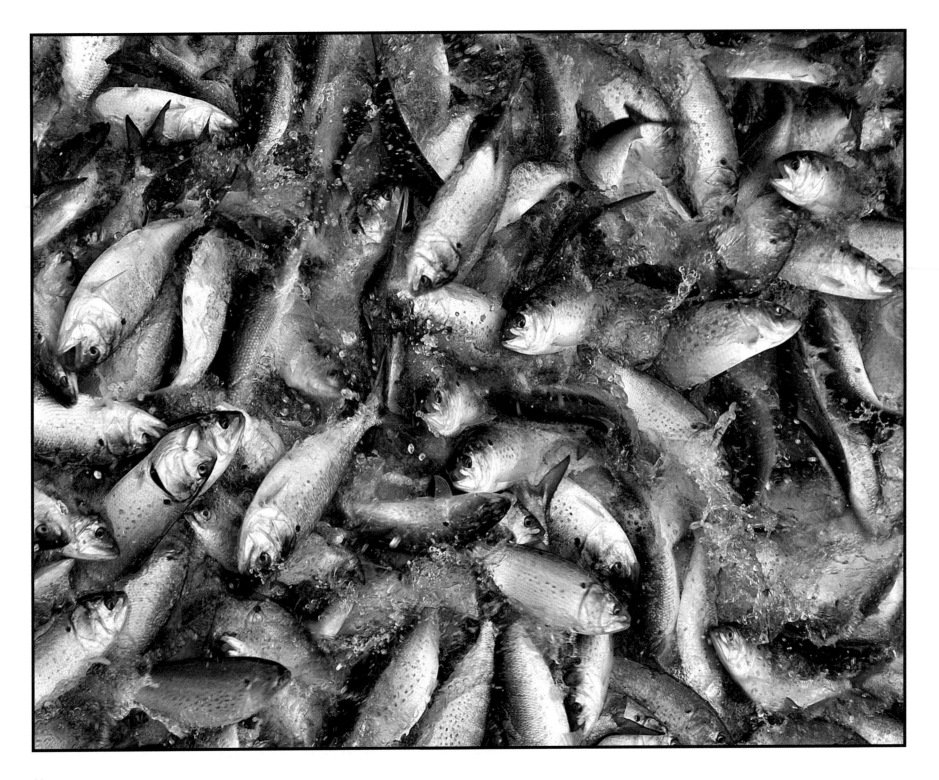

Left: Thousands of menhaden thrash the little bit of ocean left to them. This species seems to have more names than any other found in New England, a reflection perhaps of their widely ranging habitat. The Atlantic menhaden, also called mossback or bunker, swims in waters from Nova Scotia to the coast of Florida. Usually referred to locally as pogies, they die easily and spoil rapidly. Beyond that, they are oily and bony creatures generally unfit for human consumption, although they are processed for their Omega-3 oils.

Pogies school by the millions while out to sea, and when they hit, fill traps quite rapidly. While trappers sell them as bait, larger fishing operations seining for menhaden sell them as a food source for other animals such as pigs, chickens, household pets, or farm-raised fish such as salmon.

Right: Sully leans against the winch drum as he watches the coastline pass by. The winch is one of the more important pieces of gear on the boat, responsible for all of the heavy lifting. Note the deep grooves worn into the drum's bronze surface by rope bearing heavy loads, a true measure of the work done by this machine over many years of operation.

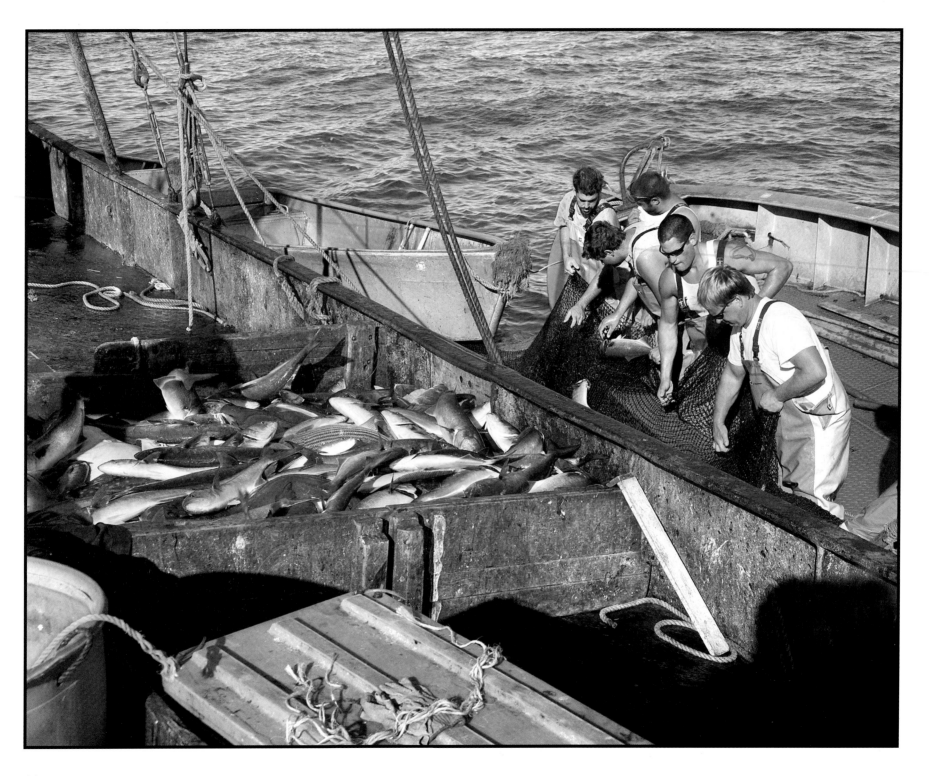

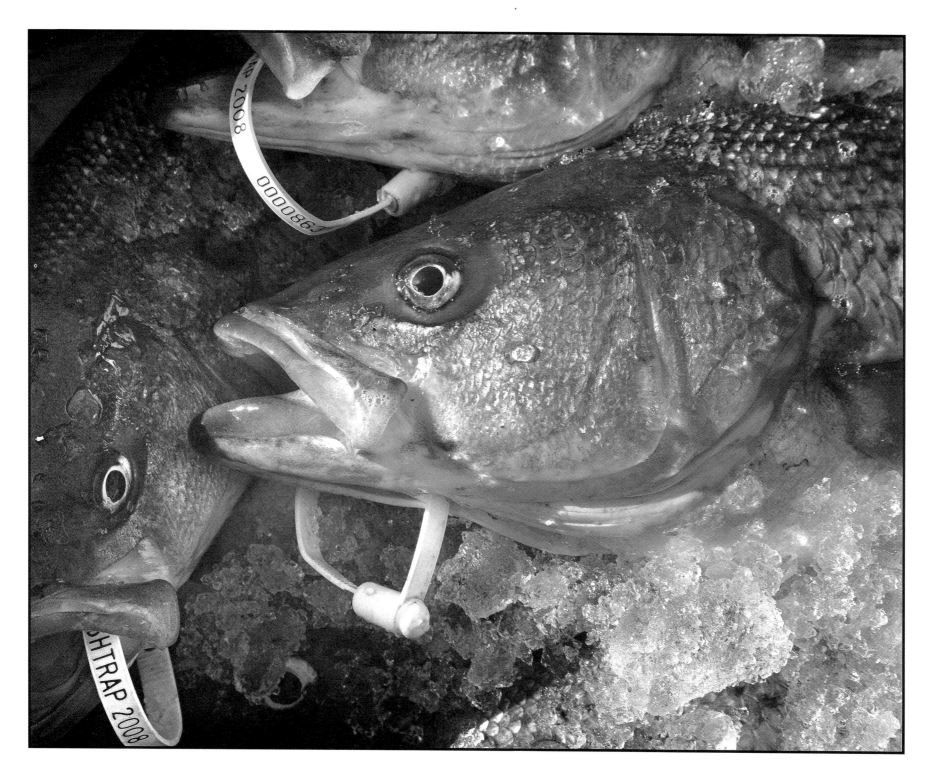

Previous Page Left: Between each pass of the bull net, the crew continues condensing the fish still within the trap. The port deck of the vessel has been heavily loaded, so the remaining fish will go to the starboard side to keep her on an even keel. This trip consisted largely of striped bass and bluefish, with the usual handful of other species.

The aft deck of this boat, as with all large fishing vessels, is readily divided into pens. This makes a convenient way to separate species, but more importantly, it keeps thousands of pounds of slippery fish from careening across the deck in rough weather. Not only dangerous to crew caught in the avalanche, this quick shift of weight can dangerously affect the stability of the ship itself.

Previous Page Right: Striped bass are highly prized, to both sports and commercial fishermen alike. Because of this, heated controversy surrounds this particular species. Local sportsmen prefer stripers to almost all other finfish and feel commercial ventures cut into their share of fun. The Rhode Island Fisheries Management Report for this year sheds interesting light on the technologies used to catch them.

In 2008, the quota for striped bass in Rhode Island was divided between floating trap fishermen, who were allowed 40 percent of the annual quota, and rod and reelers, who took a 60 percent share of the allowed catch. In that year, the rod and reel quota of 145,918 pounds was taken in a mere 20 days, while trap fishermen took most of the summer to fill their quota of 97,450 pounds, a reflection of the relatively passive nature of the fishery.

By law, commercial fishermen must record every striped bass they catch on a daily basis, turning over their logs to a fisheries management agency each week to assure an accurate account of the fish taken. In addition, they must place a trap tag through the mouth and gills of each bass caught or face significant fines. Fishermen place these tags long before their boats reach the dock to insure themselves against harsh penalties.

Right: Sam Willis empties the trap's contents onto the sorting table aboard the *North Star*. A longtime crewmember on the boat, Sam works as a fisherman during the trapping season and heads south to work on his family's cattle ranch for the remainder of the year.

Originally designed to fish for lobsters, *North Star* works well as a trap boat. Built of fiberglass, she has lower maintenance requirements than those of either wooden or steel vessels. While somewhat small for their biggest day's fishing, her size helps keep overhead costs low. It is also easy for Tom to switch fisheries at the end of the trapping season; he simply removes the portable sorting table and loads the boat with lobster traps.

As with most people working within the industry, Tom is largely self-sufficient. To survive financially, fishermen don't have the luxury of calling in outside tradesmen to fix problems arising on a near-daily basis. Beyond mending their own nets, fishermen repair their own engines, mechanical and electrical systems, and other essential gear. They construct their own skiffs and pull worn hull plating from workboats before welding on new. Fishermen design and build new gear to make life easier, safer, or in difficult economic times, more efficient, all while operating a successful fishing business.

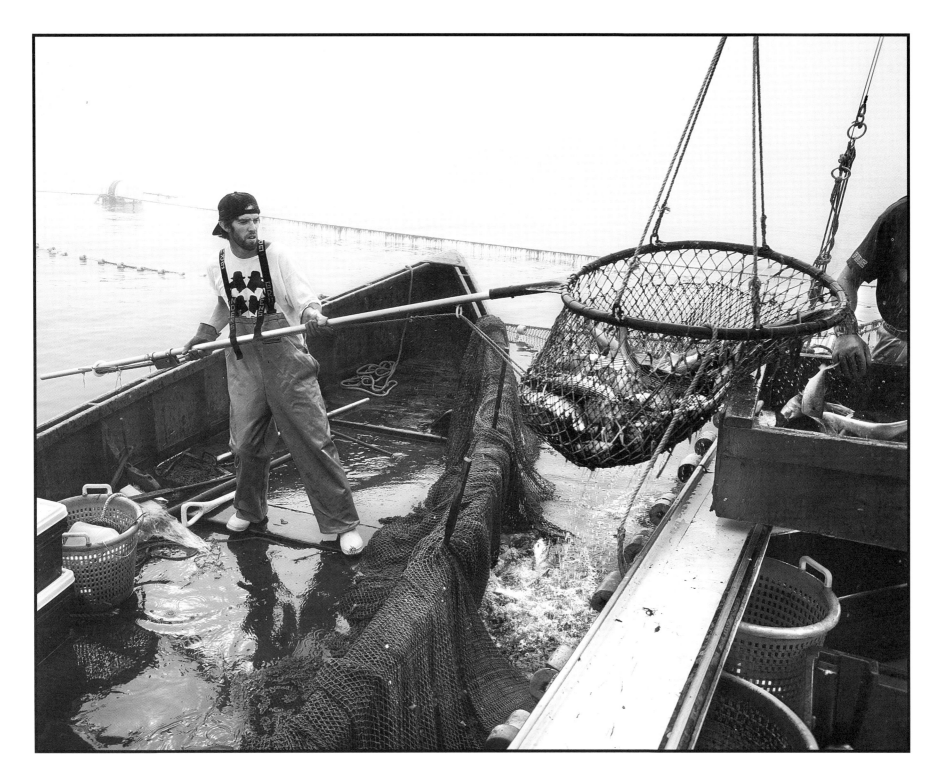

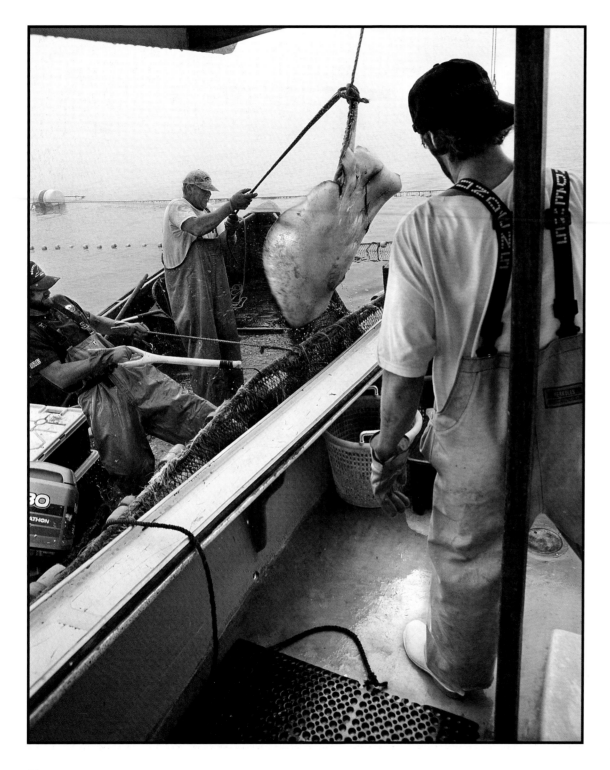

Left: Sam hoists a stingray from the trap as Tom holds its tail to control its movements. Once raised high enough, Ian will pull the net away from the hull to allow the fish to slip between it and the boat when released. Stingrays are also treated with caution, as their whip-like tails conceal a dangerously large and serrated barb with which they strike. Much larger rays than this have been pulled from the trap.

Right: Scup, also known as porgies, are one of the most valuable species, much as they were to fishermen working the coastline in the 1800s. Ranging from Cape Cod to South Carolina, they are known for their light taste and the fight they give when hooked. Spawned near the inner-continental shelf, the highly buoyant eggs drift to protected coastal waters. The average porgie weighs between one and two pounds and matures between two and three years of age, but can reach three to four pounds and lengths of up to eighteen inches.

A homely fish with a large forehead and a small mouth, the bodies are a dull silvery color with traces of light blue throughout. A series of horizontal lines run the length of their bodies, and they are topped with a spiny dorsal fin. Scup winter in deep waters, between the middle and outer continental shelves, only returning to the Rhode Island coast as the waters warm. In one remarkable run, George Mendonsa recalled removing 100,000 pounds each day for an entire month from a single trap. Today, trap fishermen try to stretch their quota over the entire length of the scup run, helping to maintain market prices by not exceeding demand.

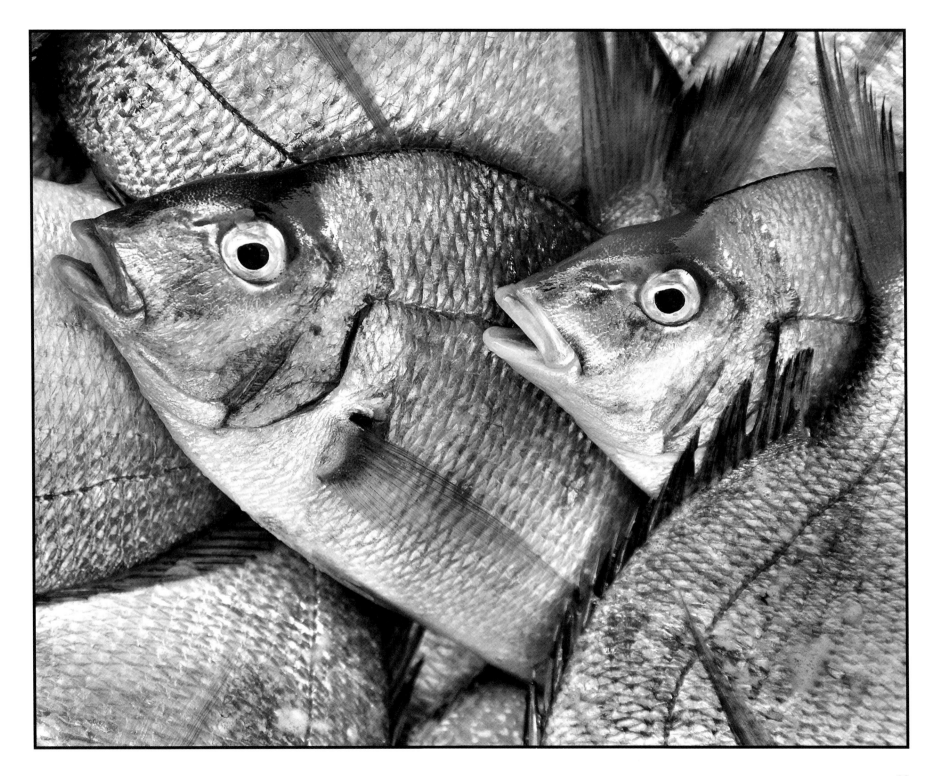

Dreary weather does not dampen Ian Campbell's enthusiasm for the day as they harden the net on the West Wall trap. Ian spent this summer working as a fisherman on *North Star* as a break from his job as a firefighter in the West. His cousin, Nick Lord, works as crew on the *Amelia Bucolo*.

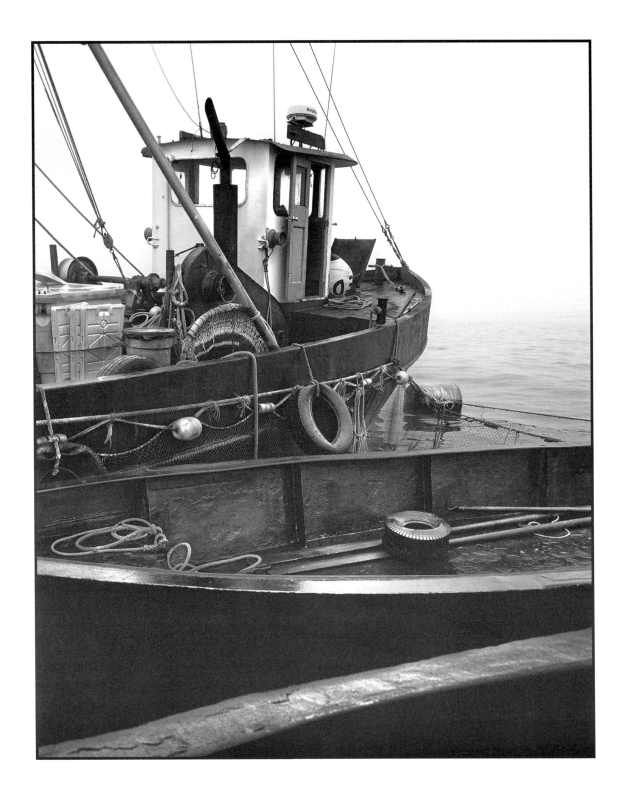

The *Bucolo* is shown here tied to the head of the trap at Black Rock, east of Point Judith. The seven-member crew is aft, sorting fish they have taken from the nets. There are relatively few places left in the United States where trap fishing still occurs, and while the smallest state in the union, Rhode Island leads the nation in trap sites. Nearly half of the sites in the country are within this state, with the majority of them between Newport and Sakonnet Point.

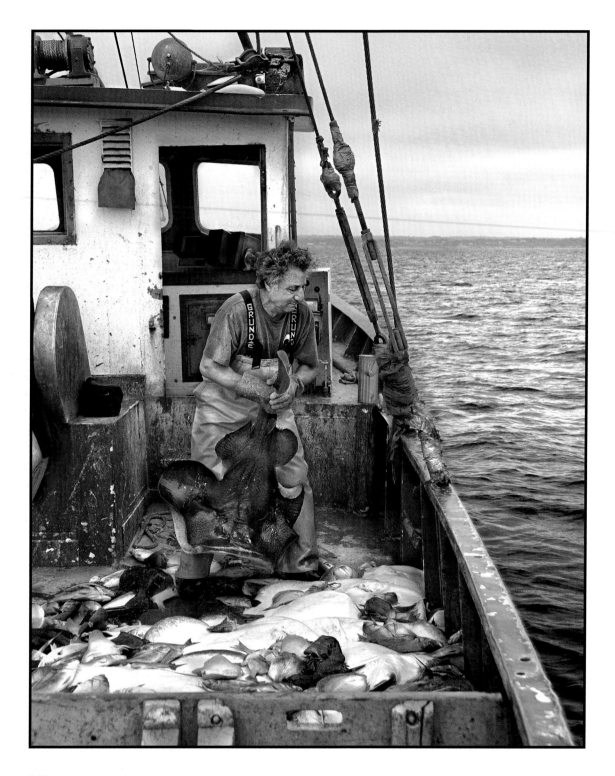

Anthony Parascandolo wrestles an American torpedo back overboard. This unusual fish has been plentiful in Rhode Island waters in recent summers. Of no commercial value, these large and blubbery animals easily reach hundreds of pounds, and fishermen handle them with kid, if not rubber, gloves. Although not as famous as the electric eel, the torpedo can discharge a shock of nearly 200 volts.

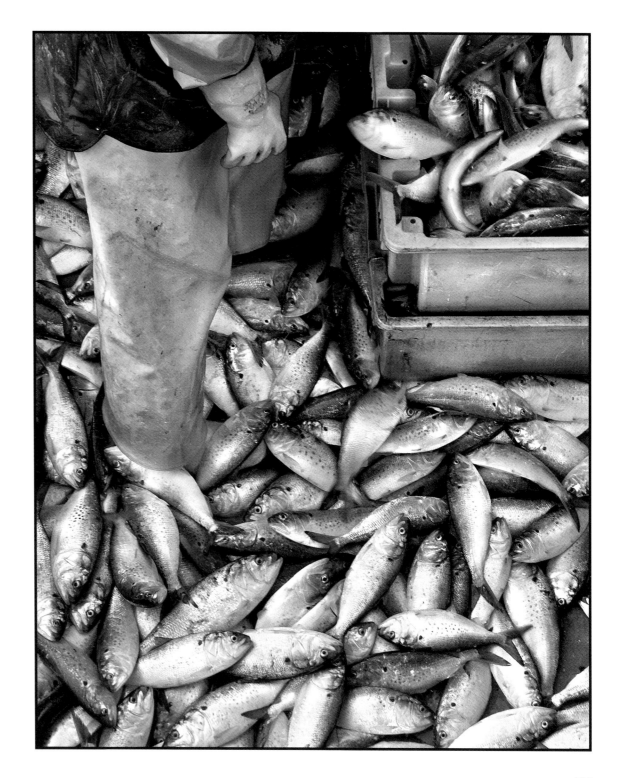

Ian stands ankle deep in menhaden on the deck of the *North Star*. The brightly silvered pogie has a distinctive spot behind each gill. Striped bass, bluefish, sharks, mackerel, and tuna voraciously consume this species, as do many sea birds. Gulls, gannets, and egrets, to name a few, all take advantage of the enormous schools of this hapless fish. Popularity has many disadvantages.

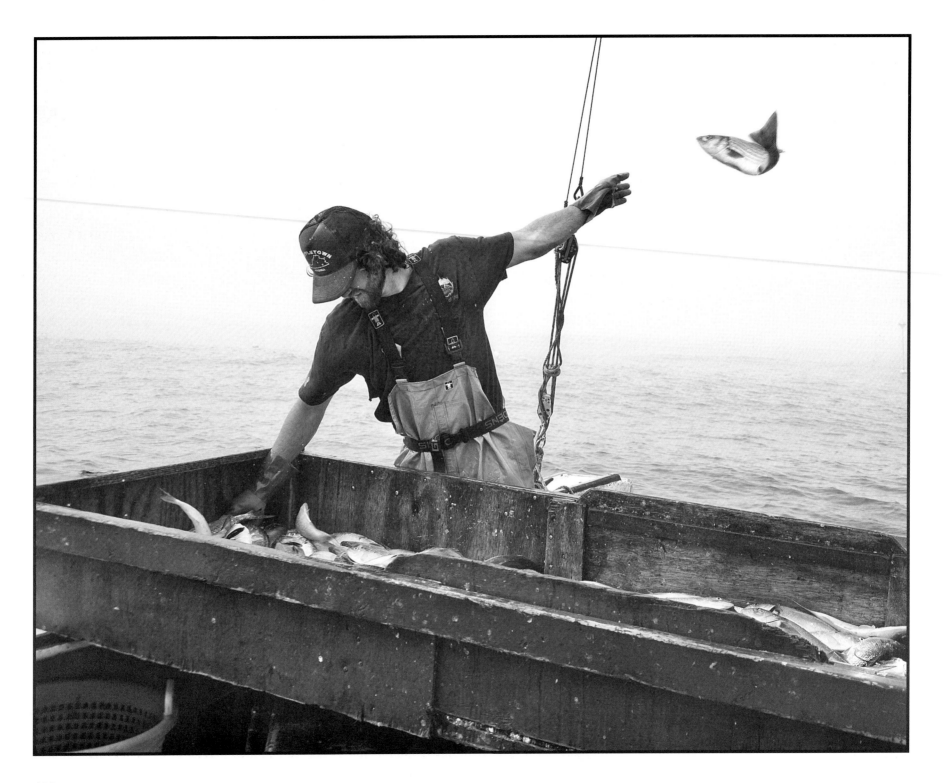

Left: Ian unceremoniously tosses a small striped bass back into the ocean. This removable table makes it easier for the *North Star's* crew to sort fish they will keep from those they return to the sea. Trapping is perhaps the greenest of the commercial fisheries, with its low fuel and refrigeration requirements. More importantly, however, is the nearly complete lack of bycatch.

Fish caught in the trap that fishermen are not allowed to keep are known as bycatch. They may be too small, like the striper in the photograph, not edible, or simply not allowed under current regulations. In trapping, fishermen sort the catch as it is brought onto the deck. Unwanted fish go back overboard and swim away. While there will inevitably be some fish lost, it is not unusual to see but a handful die in a catch of thousands and thousands of pounds. Trap fishermen can easily select target species from the pile and discard the rest.

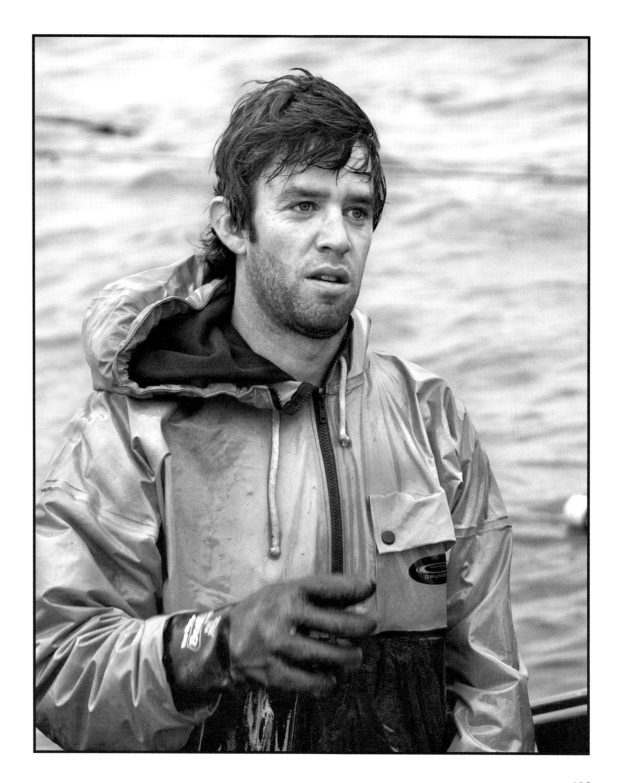

Right: Sam Willis at work in the skiff. Fishing, to most commercial fishermen, is much more than a job. The crew from the *North Star* keeps fishing poles aboard for use later in the day. Throwing pogies into a tote of water as they empty their traps provides them with live bait with which to tempt striped bass. Leaving the *North Star* tied to the trap, they often take the skiff to try their hand in fifteen minutes of sport fishing before heading home.

Left: Despite the widespread use of electronics, it is still possible to find magnetic compasses on commercial fishing vessels. Elegantly designed instruments that respond magically to invisible forces, they are often the only navigational tool needed. In deep fog, fishermen may prefer using GPS and radar to get them safely to and from their traps, but the compass has the advantage of simplicity working in its favor. When all else fails, knowledge and a compass brings them home.

Right: The *Maria Mendonsa* turns from the trap and heads home with a deck loaded with fish. Fishermen are, by both nature and necessity, masters of many trades. In tough economic times, simply knowing how to fish is not enough. Fishermen must know how to maintain and repair all of the complicated gear they use or add to their financial burdens.

Beyond knowing how to repair nearly everything they use, fishermen must also excel in the business of handling and marketing their catch. Where, when, and how to sell their fish are critical decisions that can make or break an entire summer's effort. Additionally, rapidly changing regulations must be understood, increasing the number of meetings they attend as well as the volume of paperwork they read in their efforts to stay informed.

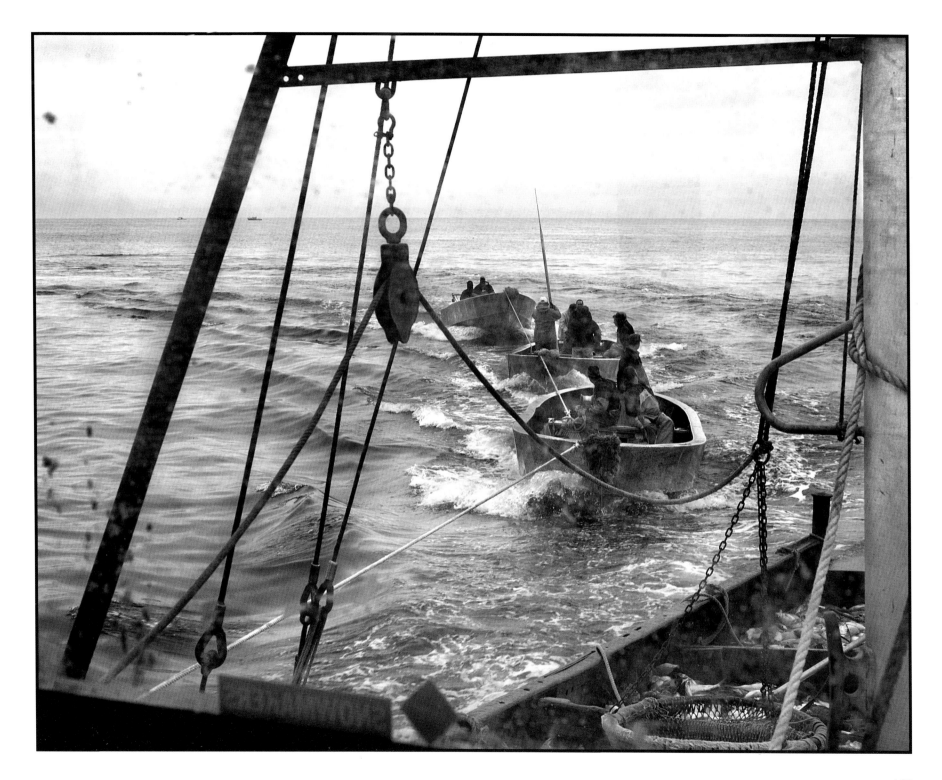

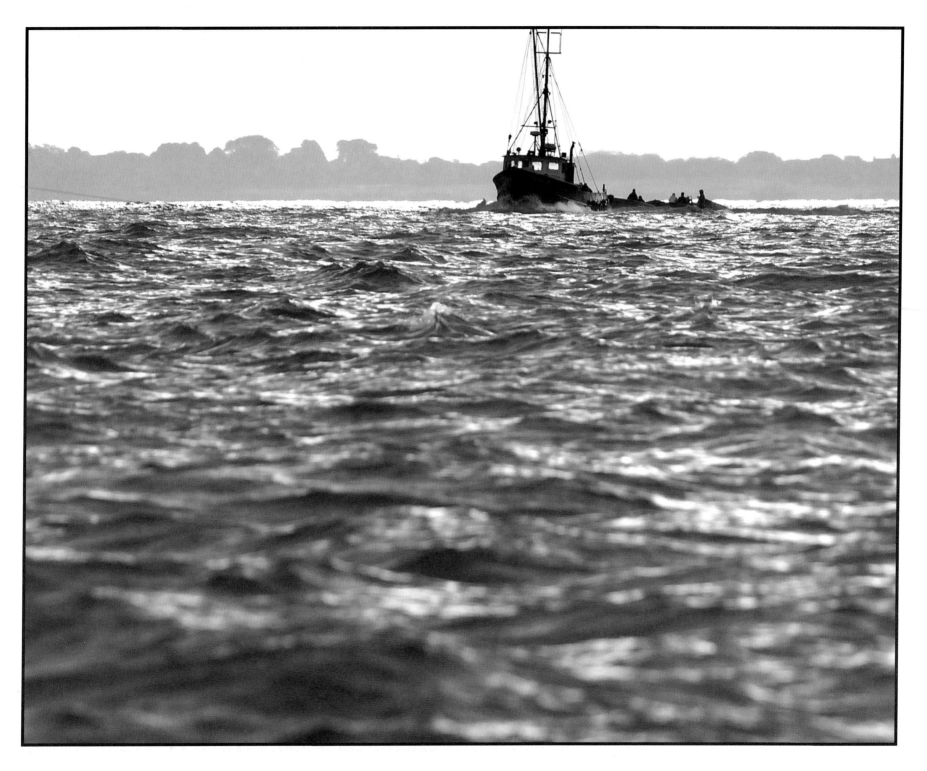

Left: *Christine Roberta* steams across choppy waters in early June on her way to the trap off Aquidneck Island. A steel-hulled vessel built for work as an offshore lobster boat, her large aft deck makes her suitable for trap fishing as well. At the end of the season, she is leased to continue work as a gill-netter throughout the winter months. The decline in business at the other Parascandolo operation in Newport is indicative of the plight of the fishing industry overall. At one time, a large part of the New Bedford fleet unloaded their catch at their Newport facility, often three vessels at once. Anthony Parascandolo notes that they are now lucky to unload three vessels per week.

Aquidneck Island, long known as the center of East Coast yachting, was once a hub for the trap fishing industry, and the vessels from Sakonnet still have traps whose leaders begin on its shoreline. Newport became a summer playground for the rich during the 19th century, and dozens of imposing mansions were built along the island's coastline. These monuments to wealth stand in dramatic contrast with the activities of local working fishermen, who continue setting their nets where rolling green lawns meet the water's edge.

Right: Donald Rosinha stops to answer a question while hauling a trap. As with many others, Don briefly fished before pursuing a more lucrative professional career off the water. After retirement, he came back to fishing on the *Christine Roberta*. In addition to fishing, Don and his wife operate a small restaurant in a nearby town.

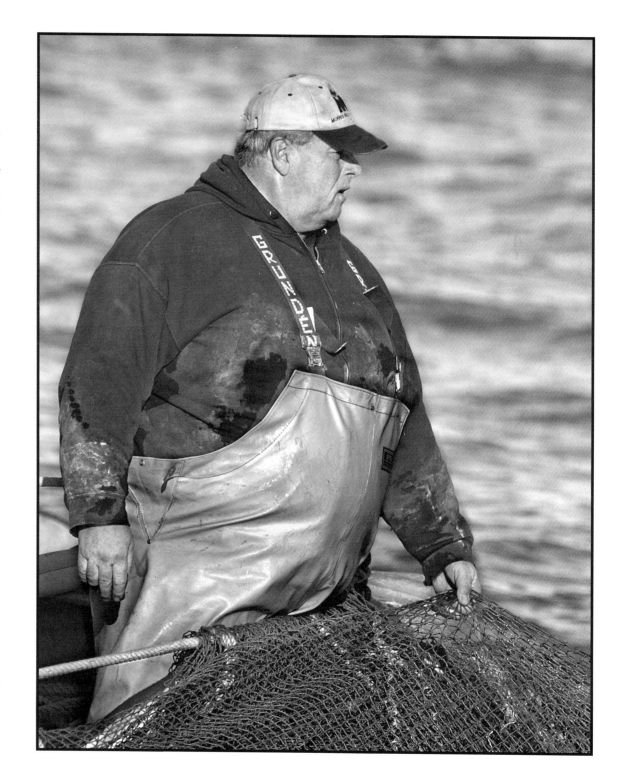

Left: Crew from the *Maria Mendonsa* stand silhouetted by the early morning light as they begin rowing their boats towards the next trap. The trap season is busiest at both ends of the summer. Fish migrating north at the beginning of the year provide large catches, as they do in the fall on their journey back towards warmer waters.

Right: Crew from the *Maria Mendonsa* work on calm seas to repair a leader cut by a passing yachtsman. The ocean, if nothing else, is certainly a beautiful place to work. As one fisherman noted, there are few offices with views which can compare. This lighthouse, built atop Little Cormorant Rock in 1884, once contained a fourth-order Fresnel lens, some seventy feet above the ocean's surface, which twice stood against storm waves that matched its height.

Many older fishermen talk of themselves as having been "fished." Perhaps more than other professions, fishermen have more opportunities to practice "take a child to work day." In tight-knit communities, fishermen know the children prowling their docks and go out of their way to include them in their daily lives, giving them bait with which to fish, allowing them to soil their clothes in the engine room, and lending them a skiff for adventures across the harbor. It may be nothing more than the attention and responsibility given them that lead children down this particular path, but once hooked, they seldom chose to escape.

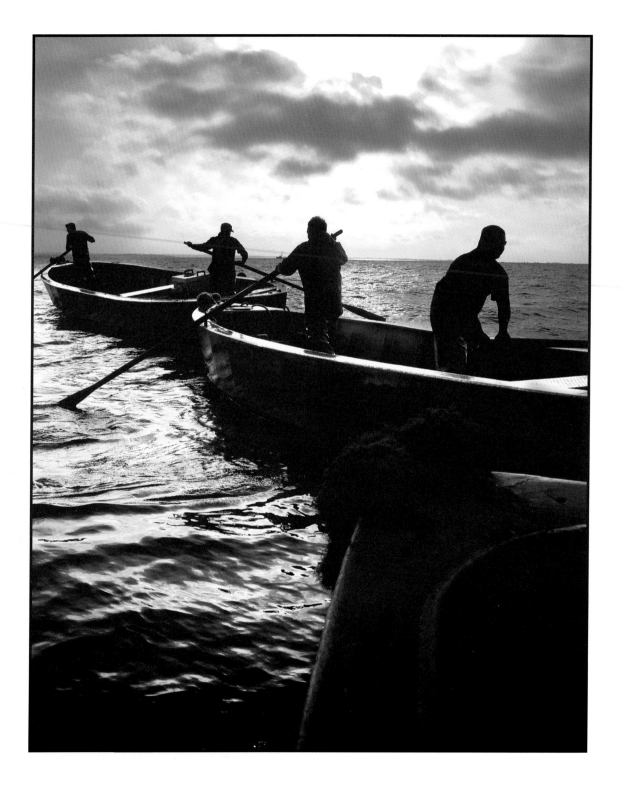

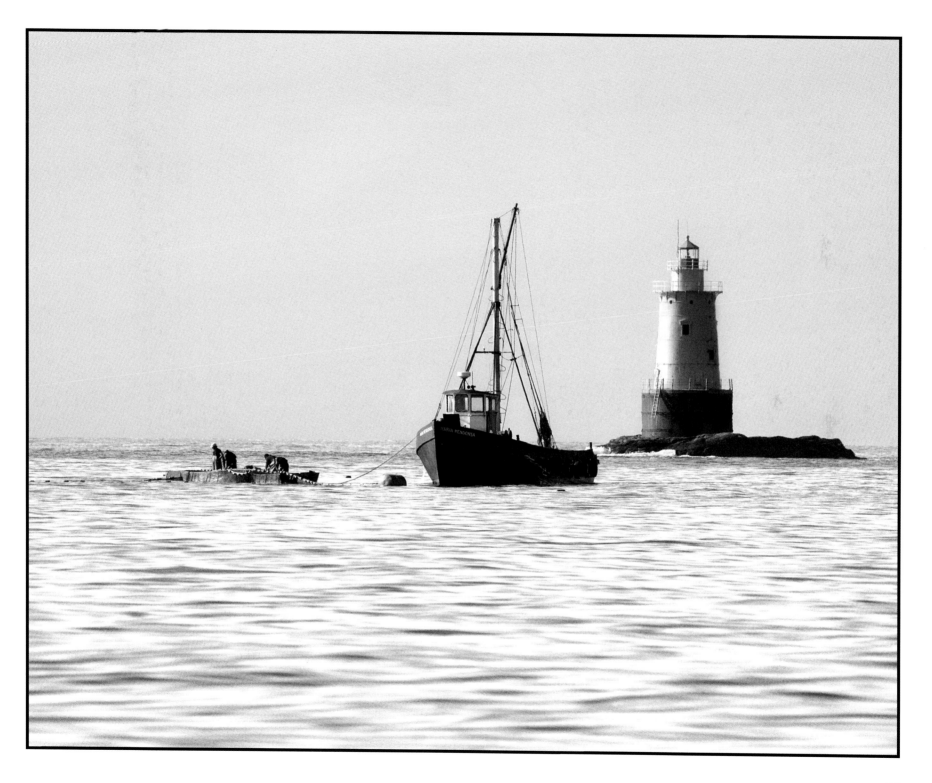

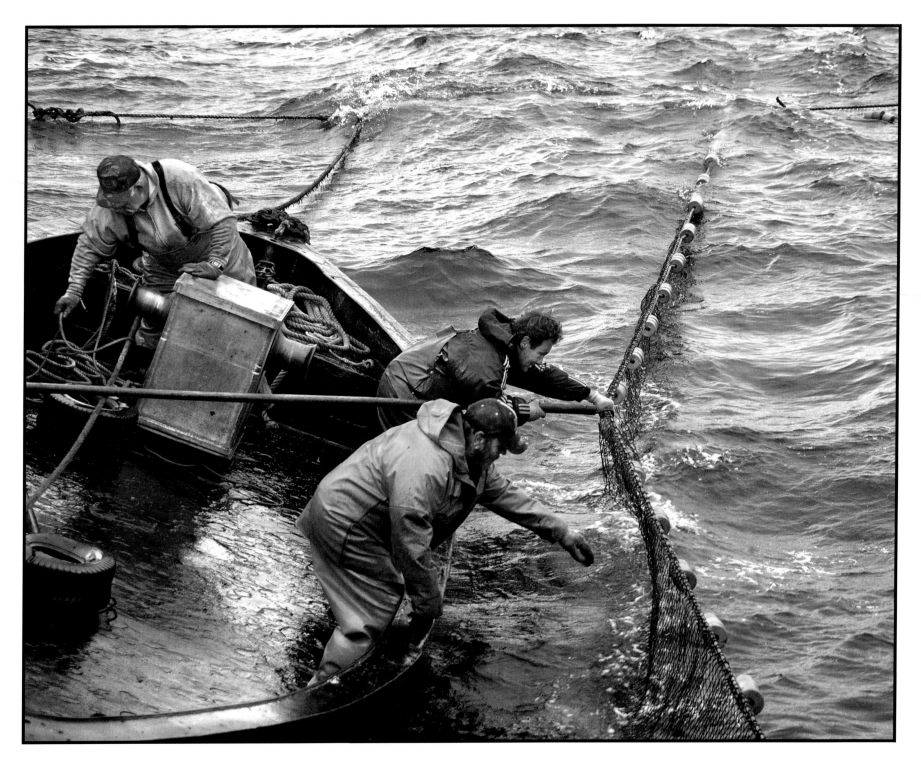

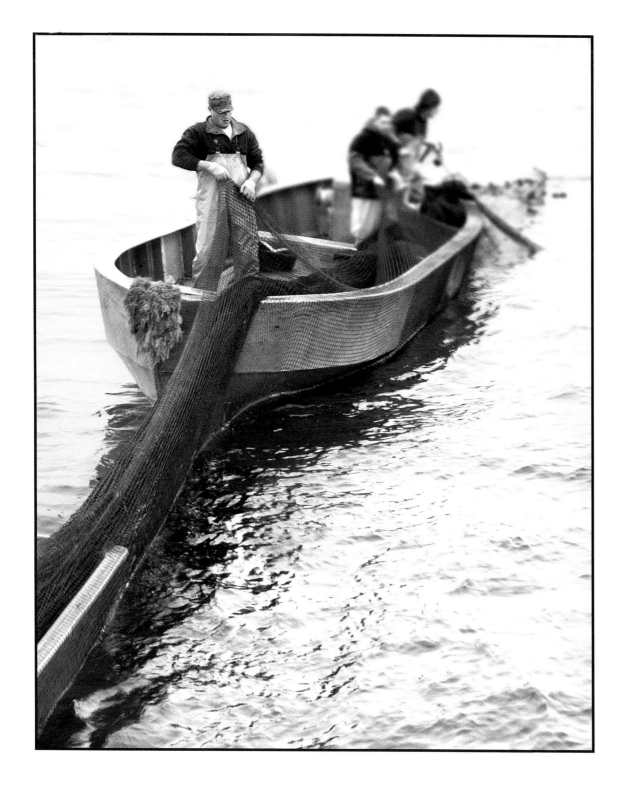

Left: Jim Main, Bucky Smith and Rick Cambio grab onto one edge of the parlor on a blustery day. Days like this make work more difficult, but no money is made while sitting idly in port.

Like all commercial fisheries, trapping is highly regulated. Scientists working for the federal government decide the year's quota for each species, based on how they feel the fish are doing as a whole. As with most living creatures, fish populations are generally cyclical and difficult to count or track. As fishermen note, they have tails and swim away. Rhode Island receives a larger portion of the federal quota because traps along the state's coastline have always been productive.

Right: Aaron Taylor stands in the bow of a longboat as they begin hardening the net. The day's catch consisted largely of scup, as great schools began passing this section of coastline on their migratory swim. This boat is made of aluminum, much lighter than the older steel boats used by the *Amelia Bucolo's* crew. As an added benefit, aluminum boats require little maintenance at the end of the season, whereas the steel boats need new coats of paint at a minimum.

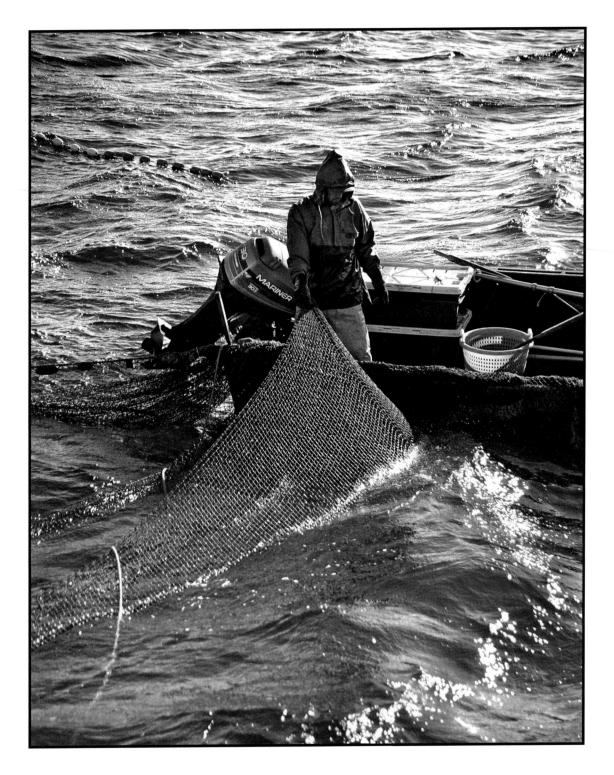

Sam Willis works his corner of the parlor on a grey and choppy morning at the West Wall trap. While both weather and water temperatures can affect their migration, fish move through this area on a fairly regular schedule if they are coming at all.

View from the pilothouse on the *Maria Mendonsa*. A straightforward control center, the house contains a bronze wheel for steering, a magnetic compass, the throttle and gear shift for the main engine, and both a radar screen and a satellite navigation system hanging from the overhead. The paper form taped to the console is a deviation card for the compass. Surrounded by iron and steel, the compass seldom points towards true north. This card gives the helmsman corrections to add to any particular course heading chosen, negating the ship's magnetic influence.

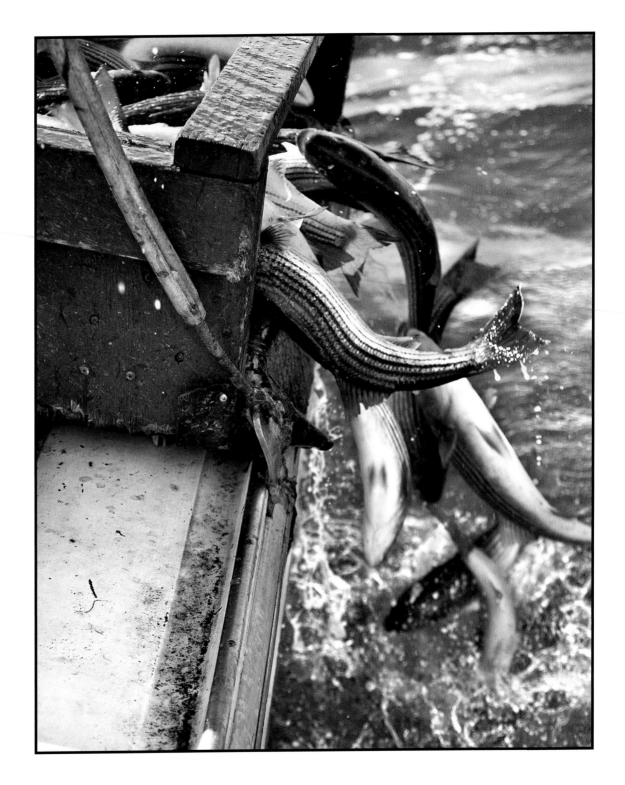

Striped bass that are too small to keep make their exit. This process assures little to no bycatch; fishermen only retain the size and type of fish they are allowed.

Portrait of Ed Abrantes. Part of the problem today's fishermen face stems from their independent natures. The fishing industry is a highly politicized business, with many interested groups striving to make their voices heard. Fishermen realize they fare better as a group speaking as one to their elected representatives, but a sense of independence and demands on their time often keep them from organizing in a meaningful way.

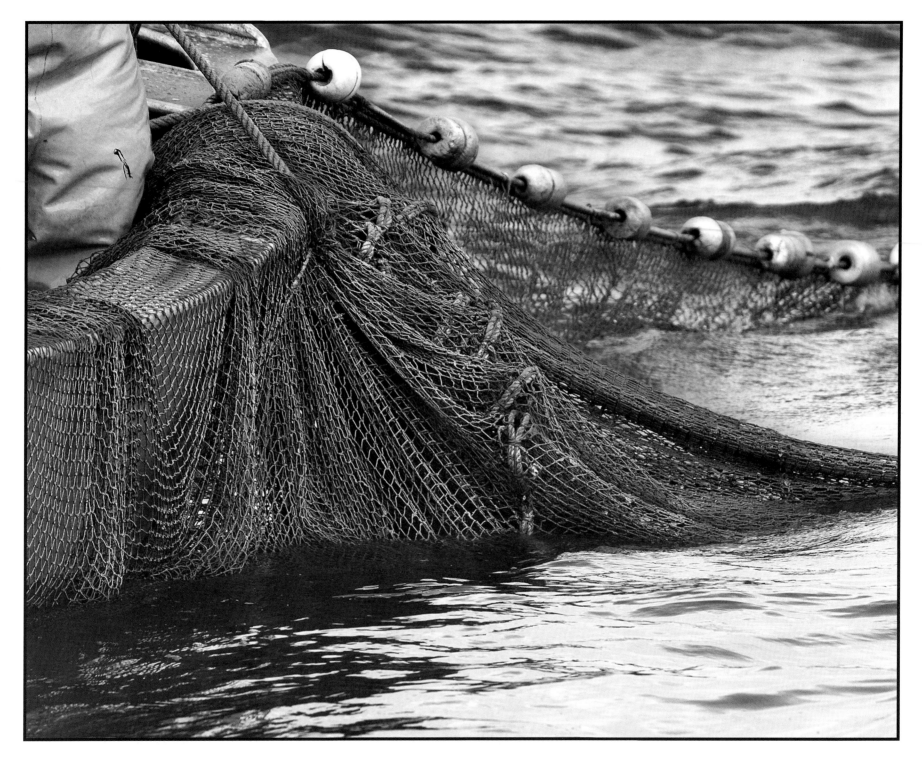

Left: Crew harden the Sakonnet Point trap. A significant amount of handwork goes into building each trap. While the twine itself is made by machine, fishermen must do the rest by hand to finish the structure. One new problem for trap fishermen is there are only a few people left who know how to build a trap from scratch. Today, fishermen repair traps as needed, and it is unlikely that any new traps will be built.

It is possible to trace the use of this type of trap back several thousand years to the Romans. There are large floating traps in the Mediterranean still used to catch the giant bluefin tuna that migrate into the area on a yearly basis. Many of these traps have remained in the same family for hundreds of years.

The bluefin caught there are too large to bring aboard with a bull net. After trapping the tuna, a traditional "matanza," or killing of the fish, takes place. Fishermen spear and bleed the largest of the tuna before they gaff and haul them aboard. For thousands of years, the very same traps set in the very same locations have proved a source of great wealth in the Mediterranean Sea, although fishing with modern equipment now threatens their future as well. [9]

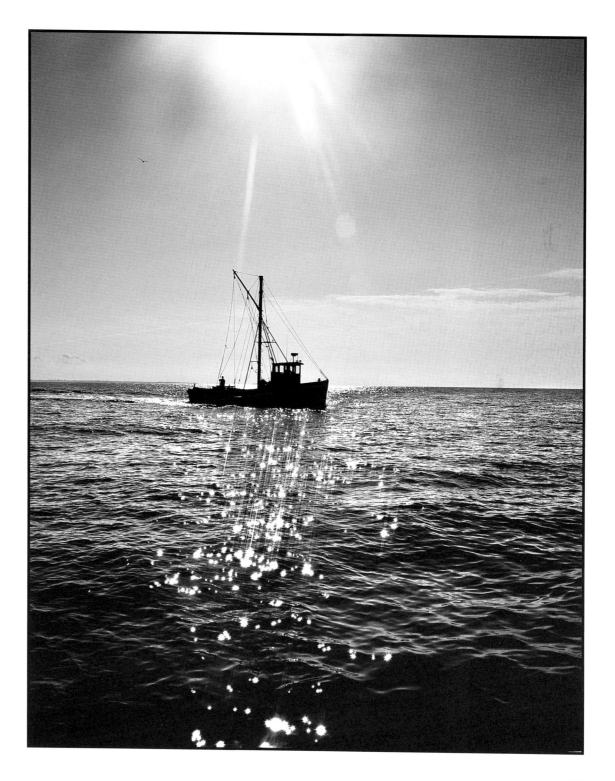

Right: *Maria Mendonsa* circles to the east as her boats maneuver into position and ready the trap for hauling. On one particular day, this trap contained some 40,000 pounds of false albacore. Proving too heavy, the crew split the trap open and allowed them to escape. Having re-sewn the net, the *Mendonsa* returned the next day to pull the 15,000 pounds of fish caught once again.

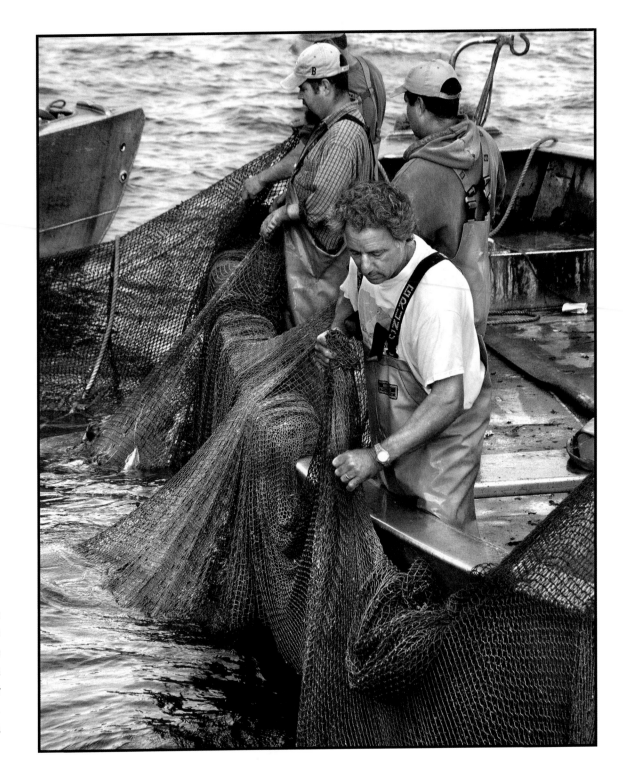

Anthony Parascandolo and his crew pull twine at the Aquidneck Island trap. Anthony started work within the family business while in grade school. Getting off the bus at the end of the day, he would help repair wooden crates used to ship fish to New York and Philadelphia, or dump fish off-loaded from trawlers onto sorting tables. At that young age, it was necessary for him to stand on a crate and several lids just to reach the work.

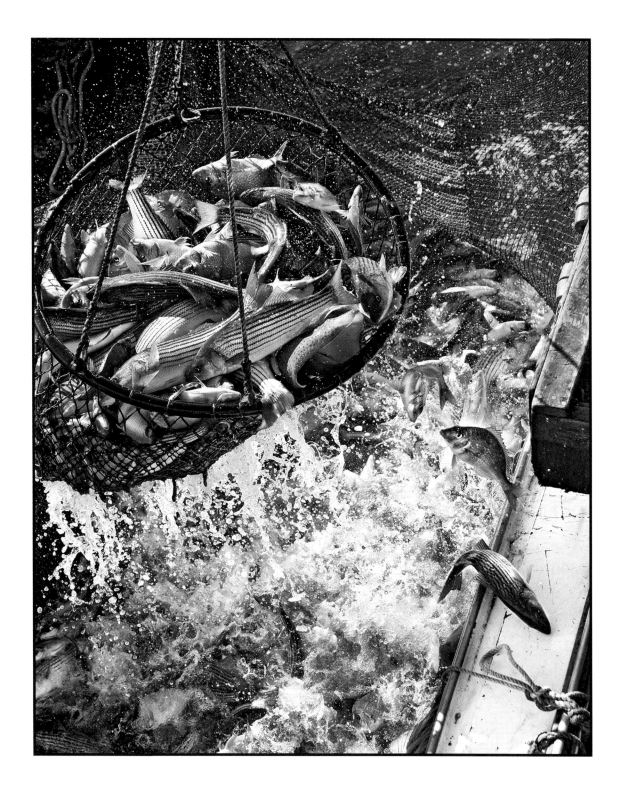

The bull net on the *North Star* swings a load of striped bass aboard as other fish leap clear of the water in vain attempts to escape. Trap fishing is one of the cleanest ways to catch fish: they are not brought to the surface from great depths, they have not been dragged around, and no hooks damage their mouths.

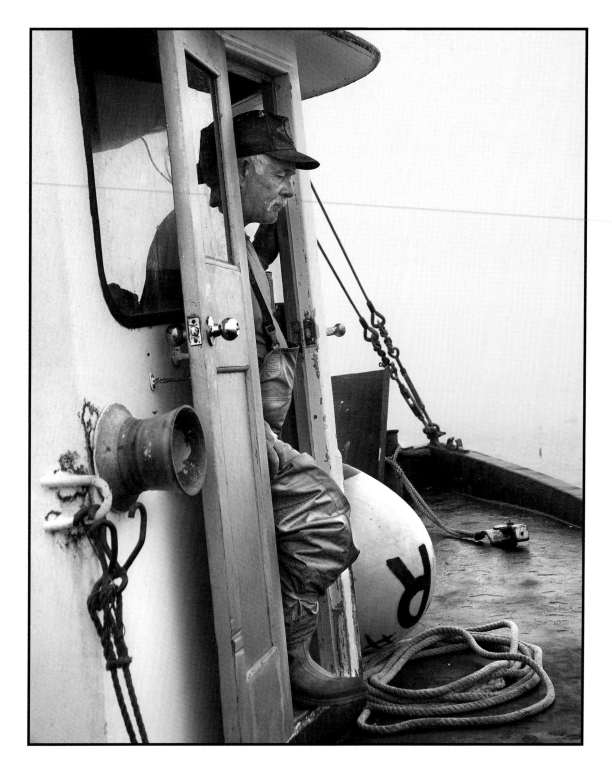

Left: Standing in the pilothouse doorway, Jim Main waits for the longboat crews to locate themselves around the trap before swinging the *Bucolo* into position. One unexpected problem occurs when regulations remove a species from the allowable catch list; the demand for that type of fish disappears. Now unfamiliar, younger consumers are less likely to purchase the fish when they return to the marketplace, and fillet-of-squarefish becomes the new standard.

Right: Sea robins swim towards the ocean's surface within the trap. The origin of their name is obvious given the large, wing like, pectoral fins spread to their sides. While swimming, they are visually stunning, but once landed, their wings fold and they become rather homely. Their sharp spines make careful handling a necessity, and they occasionally make croaking sounds when removed from the water. They use their six, leg-like appendages to stir sediments on the ocean's floor as they search for food or bury themselves as they wait for unsuspecting prey, simultaneously hiding from those who would prey upon them. Their beautiful red and orange bodies reach lengths of up to twelve inches, although their emerald green eyes, surrounded by an opalescent gold ring, are their most compelling feature. While edible, sea robin are seldom eaten; they are usually kept by fishermen to be sold as bait.

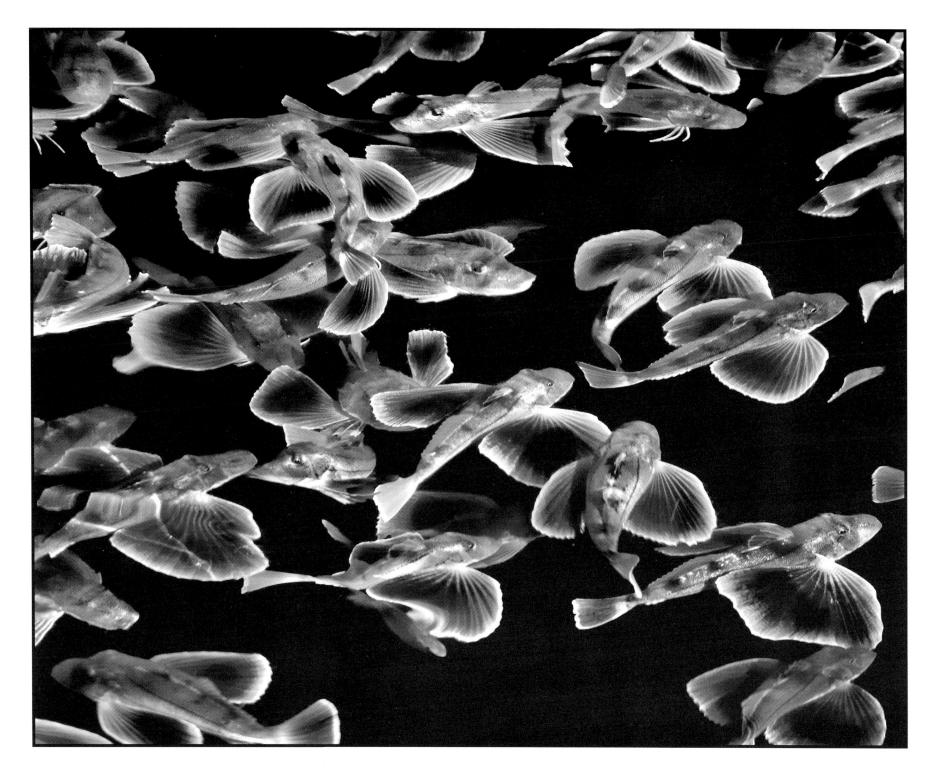

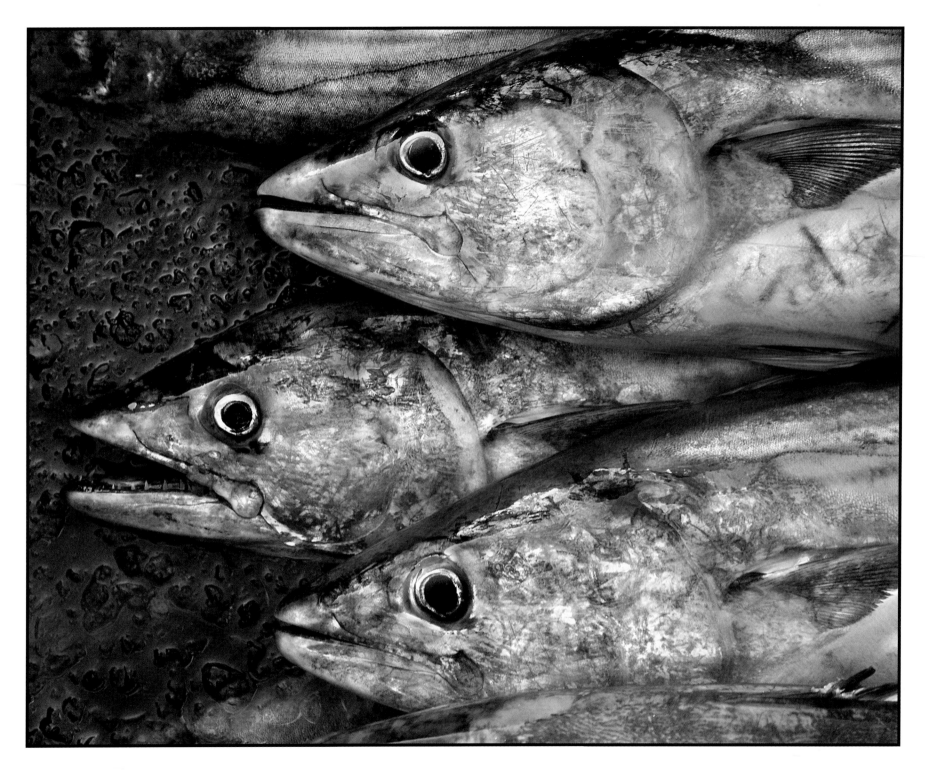

Left: Bonito caught on a warm summer day are kept cold in a tote of ice and water until they reach the docks. These steely-blue fish have all the earmarks of high-speed predators. Tough and streamlined, these animals are known for both the velocity at which they swim and their voracious appetites. They can reach 32" in length and weigh eight to twelve pounds. As can be seen in this photograph, they have a row of sharp teeth on the bottom jaw, but unlike many of their cousins, no teeth on top. They prey on mackerel, menhaden, squid, silversides, sandlance, and alewives, and are in turn eaten by predatory fish both larger and faster.

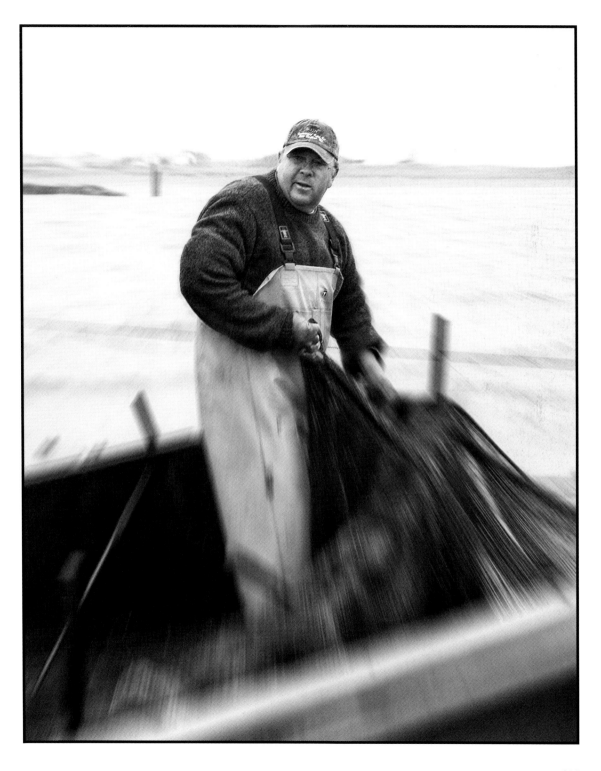

Right: Tom Hoxsie in his skiff. Tom has experimented with countless fishing technologies in his lifetime besides trapping, including long-lining, lobstering, and pot fishing.

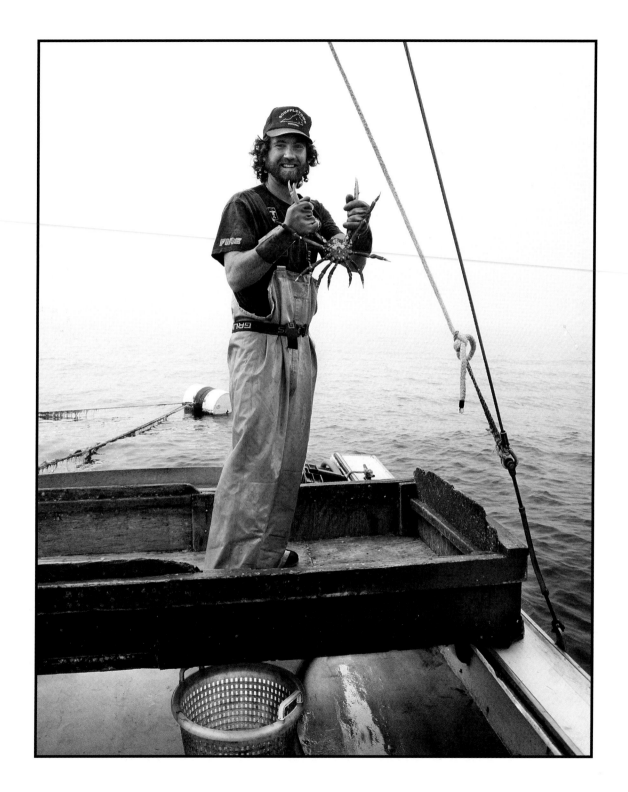

Ian Campbell displays a spider crab before tossing it back into the waters outside of the trap. These crabs, which have no commercial value, create real headaches when the become entangled in the twine. Unfortunately, they are plentiful in the area where Tom Hoxsie sets his traps. Tom has discovered that crabs do not seem to foul netting made from polypropylene, and hopes to replace twine on the bottom of the trap with poly to minimize this problem.

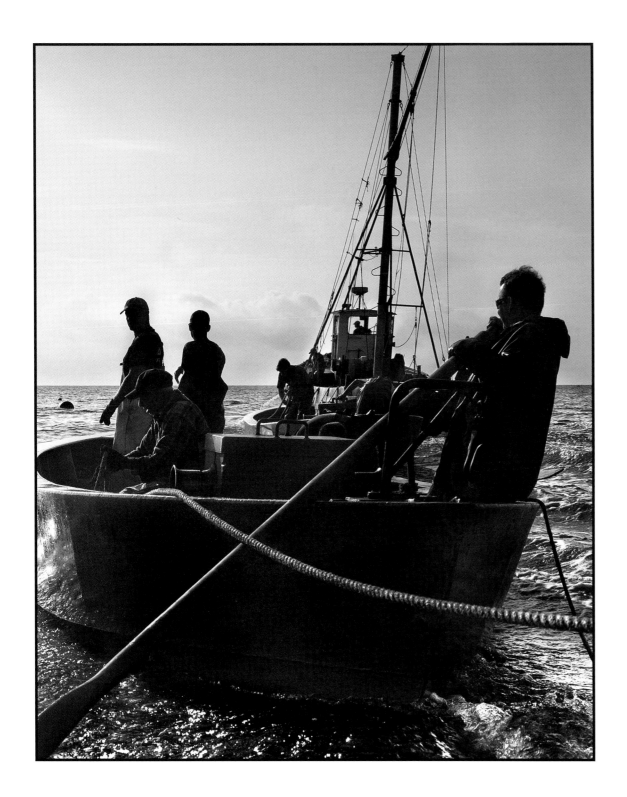

Towed by the *Maria Mendonsa*, a crewman swings his boat into line as they head to the east. While these boats are made of aluminum rather than wood, they are much like the boats once rowed to trap sites a hundred years earlier. Long, broad, and double-ended, they can handle enormous loading at their rails without capsizing. Long before the advent of powered vessels, they also functioned as carry boats, bringing home the day's catch.

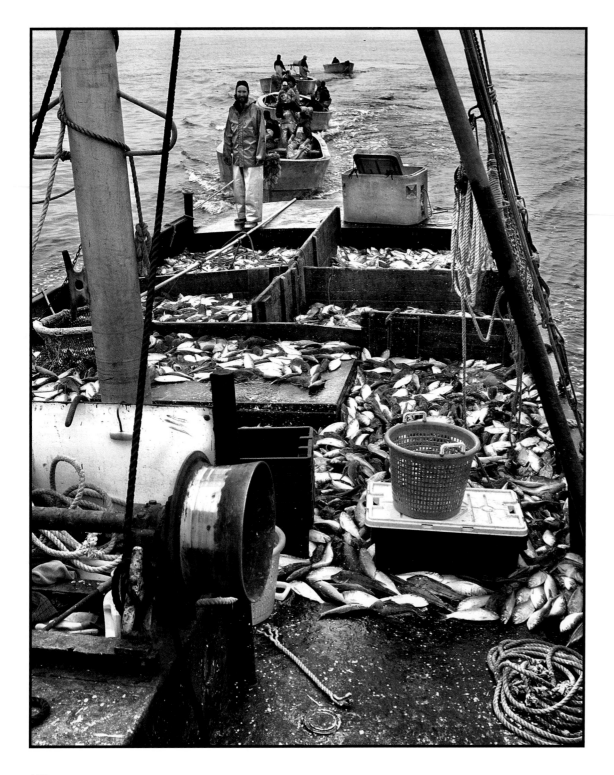

Left: Luke Wheeler, the fourth generation in the family to make a living from the sea, overlooks a deck load of fish as the *Mendonsa* heads back to her berth. Luke's father stated he could have easily landed a million pounds of fish during the summer had regulations allowed. Note the use of penboards on deck to keep the catch from shifting in rough water.

Right: A view from the beach of the *Amelia Bucolo* at the Black Rock trap site. Records from the 1880s, long before trawlers came upon the scene, show trapping to be vastly superior to other techniques in use at the time. Dozens of trap sites, as well as hundreds of fykes, heart traps, and pounds, filled nearly every bay, with floating traps extending the fisherman's reach offshore. The town of Tiverton hosted a public drawing for eighteen trap sites available on its shores alone, keeping each trap sixty-five fathoms from the next.

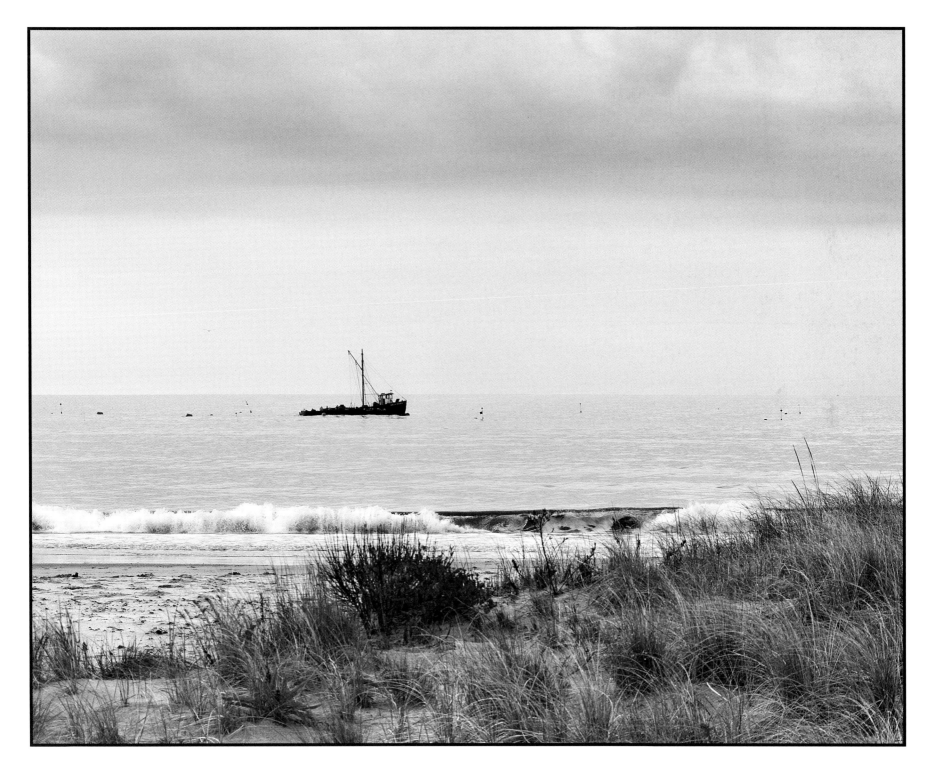

Two of Tom Hoxsie's skiffs are left tied to the *North Star* after completion of the morning's work. As with most fishermen, Tom is a man of many talents. He builds his own skiffs as needed, which not only saves him the added expense of having them built, but also allows him to produce exactly what he needs. Wooden skiffs of this type have always played a role on the local waterfront, having proved themselves efficient, seaworthy, and economically viable.

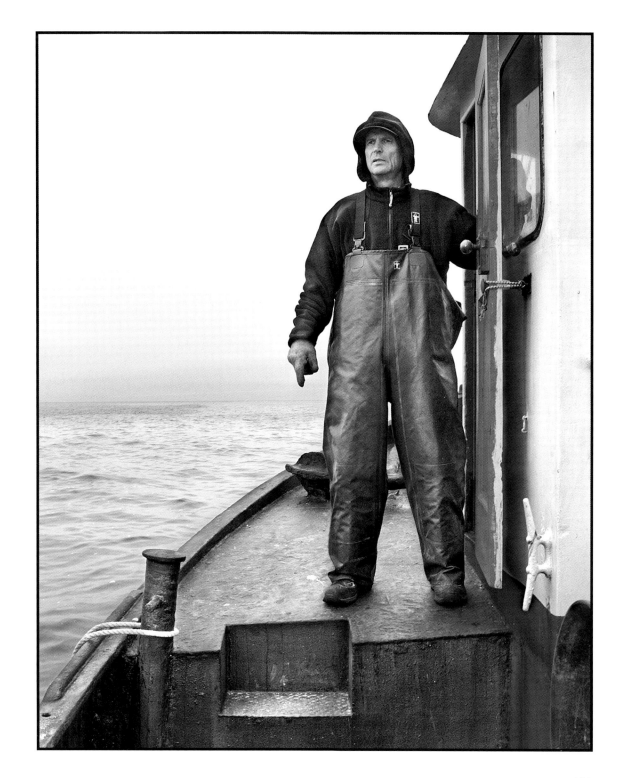

Alan Wheeler watches his crew as they pull twine from the trap, allowing them to kill the summer's weed growth and repair any damage they may find. One benefit to a life on the water is the beauty of the work environment. Vistas along Rhode Island's scenic shoreline present rocky bluffs and sandy beaches, as well as stately mansions and quiet cottages.

Throttle and gear shifts used to control the diesel engine aboard the *North Star*. Along with the wheel used to steer the vessel, these controls are all fishermen require to maneuver their vessels in and around tight docking spaces in crowded harbors.

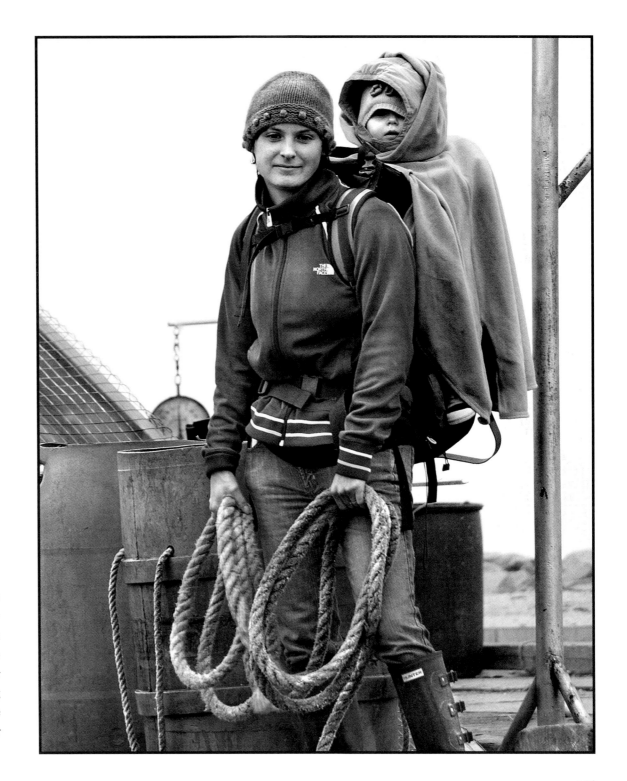

Corey Wheeler Forrest prepares to toss a dock line to the *Maria Mendonsa*. As Alan Wheeler's daughter, Corey is yet another generation in the family's long history in the industry. After college, Corey worked on the trap boat with her brothers and father. When her daughter arrived, however, leaving her two children to go fishing every day proved unworkable. Switching gears for the moment, she now handles important shoreside tasks for the business.

Three silvery moonfish. While many unusual species come aboard, the moonfish is certainly one of the most beautiful. Ranging in size from that of a quarter to a half-dollar, they are reminiscent of silver coins when sprinkled across the black deck of a trap boat. Thin as quarters as well, they desiccate rapidly, and according to Alan Glidden, they were often taken home by fishermen who varnished and hung them as ornaments on Christmas trees.

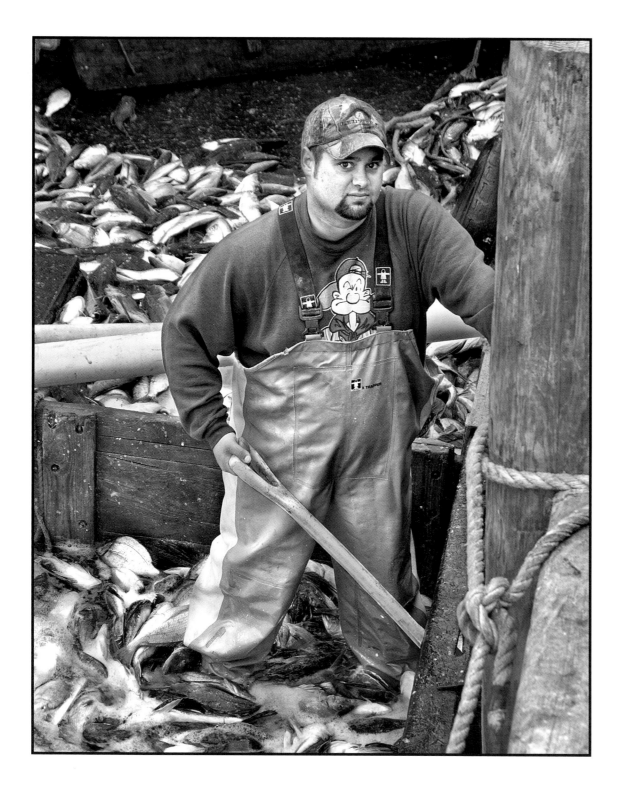

Ed Abrantes shovels the day's catch onto an operational conveyor belt. Flooding the pens with water from the ship's deck pump, Ed can simply push the floating fish overboard and into the chute of the lift. Ed's father was also a fisherman and worked for some time on the same vessel, and Ed has a photo of his father doing this very same job many years earlier.

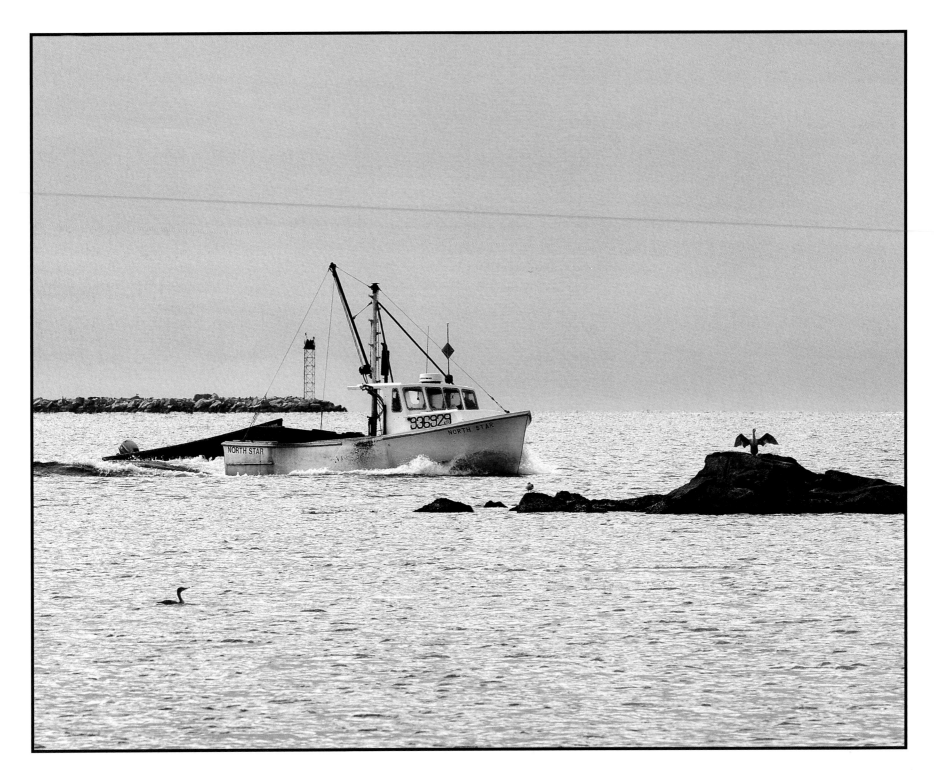

Left: *North Star* heads back into Point Judith from the traps at the east end of the harbor. Two cormorants watch her progress, one drying its wings on the rocks and another actively fishing in the water to the left.

Tom stops at the buyer's dock on the way back to his berth. After weighing his catch, the buyer gives him a receipt for his records. Baitfish, such as menhaden, skate, or sea robin, are kept aboard and brought back to his dock, conveniently located amongst the lobster fleet.

Before World War II, there were many more traps around the stone breakwaters protecting the harbor. At that time, fish were scooped from traps by hand and dumped into skiffs before they were towed back to be unloaded. Fish with little value were taken to a plant in town and rendered into oils for paint or fishmeal to feed cattle.

Right: Sam Willis brings a skiff in through the rain to the buyer's dock where he will drop off several totes of fish. As the season slows mid-summer, *North Star* will often head directly back to her dock while Sam runs this errand. A few trawlers and the offshore lobster boat *Capt. Bligh* remain in port. The white building in the distance with overhead doors is occupied by the Point Judith Coast Guard, which deploys a small cutter and numerous inflatables from this station.

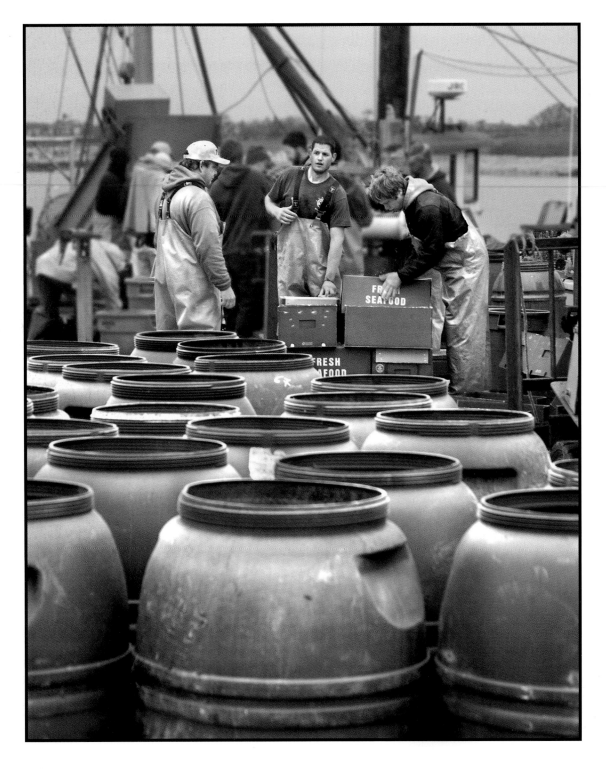

Left: The crew from the *Maria Mendonsa* packs the day's catch. The plastic barrels in the foreground are for baitfish. Crew sort fish destined for New England's kitchens and pack them with ice in waxed, cardboard cartons. Long gone are the days of wooden barrels and packing crates that held hundreds of pounds of fish.

Right: Pogies are salted and stored in plastic barrels. These oily fish make excellent bait for crustaceans. As they decompose within wire-mesh traps, their scent attracts hungry lobsters and crabs. Lobstermen have learned to take advantage of the differing rates of decay for each species of fish. While pogies decompose too quickly in warm summer waters, they are perfect for cold winter temperatures. Skates, a much tougher fish, provide the right amount of decay during the summer.

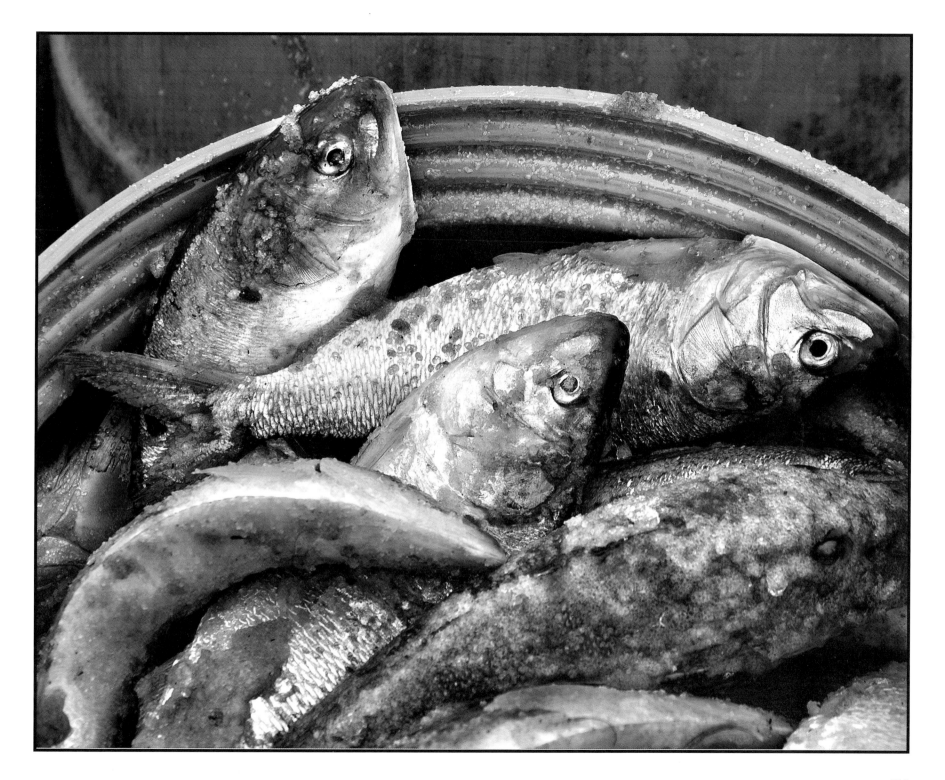

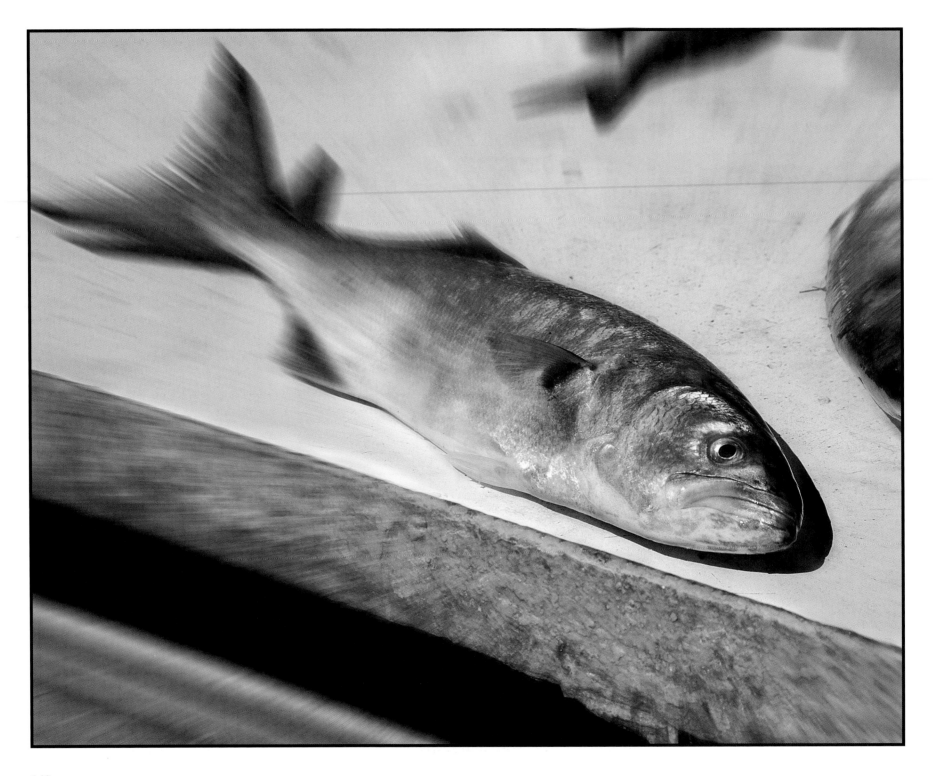

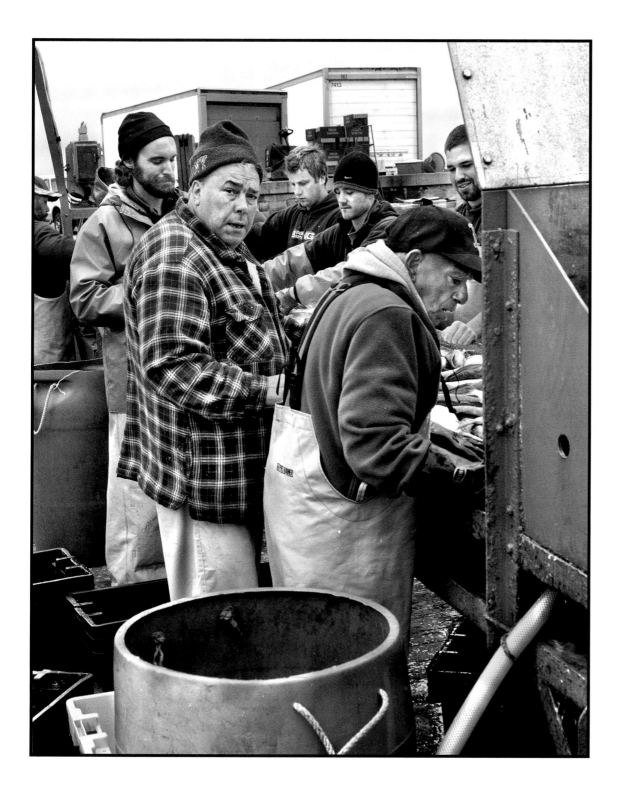

Left: A bluefish heads down the conveyor belt to be packed in ice for shipping. Blues will snap at anything within reach, and will even attack each other when the school's aggressive behavior becomes frenzied. It is not unusual to haul fish from the trap with enormous bites taken from their sides by blues, or to see them devouring fish as they themselves are lifted from the ocean. Blues prefer to eat menhaden, squid, weakfish, grunts and shrimp, but seem willing to devour whatever appears before them. Even women wearing shiny jewelry while swimming have been bitten.

Bluefish take their name from the beautiful blue and green colors of their upper back. This tapers to silver along their sides before turning a creamy white on their bellies. Their tails are deeply forked, and the spiny dorsal fin easily pierces one's skin. They live in most of the world's temperate oceans, and along our Atlantic Coast from Argentina to Nova Scotia. They appear in Rhode Island's waters in June and disappear in October as the sea begins to chill.

Right: John Leite looks up at the camera as he helps sort the morning's catch. Luke Wheeler is to the left and Sammy Peters to the right as fish are lifted by conveyor from the deck of the *Maria Mendonsa*.

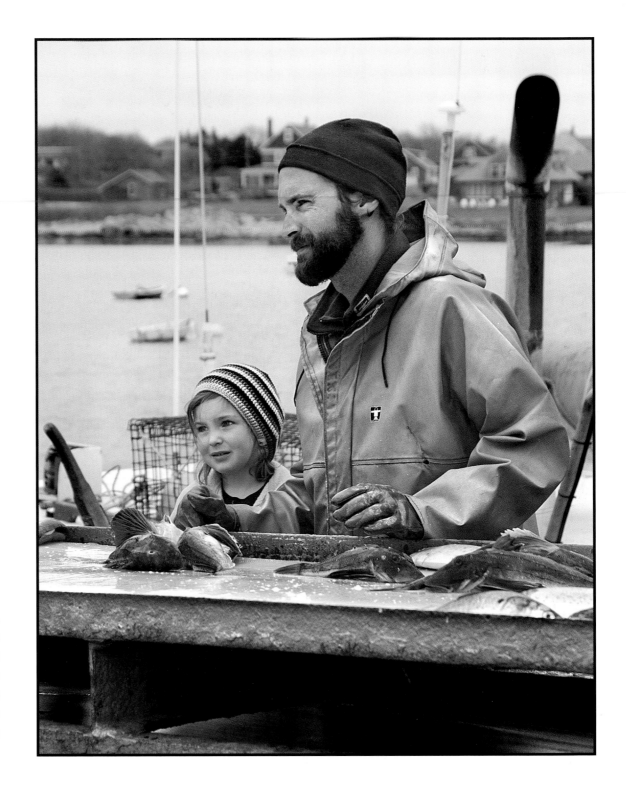

Luke Wheeler and his daughter stand at the conveyor, sorting fish from the day's catch. As a boy, Luke began lobstering from a skiff with his father on the rocky shores of Aquidneck Island. A graduate of Maine Maritime, he chose to fish rather than pursue a career on other types of commercial vessels. Luke also owns and operates the *Shirley Ann*, a day boat he fishes from the Point when done with the day's trapping.

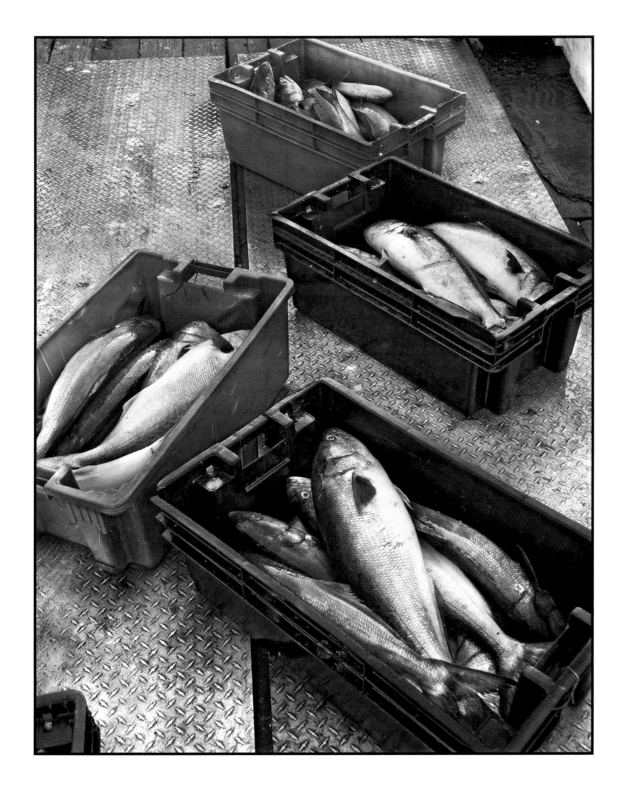

Totes of newly-landed fish, separated by species, await boxing. Few Americans will purchase a whole fish such as these anymore. Once docks brimmed with people waiting to pick the fish they would eat for dinner, but consumers are now far more likely to pull a box from the local grocer's freezer. Today, less than 10 percent of the fish we consume in this country comes from local waters.

Left: Crewmembers weigh fish with this hanging scale before placing them in shipping cartons. Seemingly old and tired, this scale, like all commercial scales, is calibrated periodically by governmental inspectors. The tangible sense of history and tradition etched into the chipped paint on its ancient face adds a certain elegance missing from its modern digital counterparts.

Right: Deckhands chat as they head towards the day's work aboard the *Maria Mendonsa*. While most of a trap crew's time is spent fishing, they must also attend to other tasks throughout the summer season. On this day, crewmembers will remove twine from the trap near the Sakonnet Point Lighthouse.

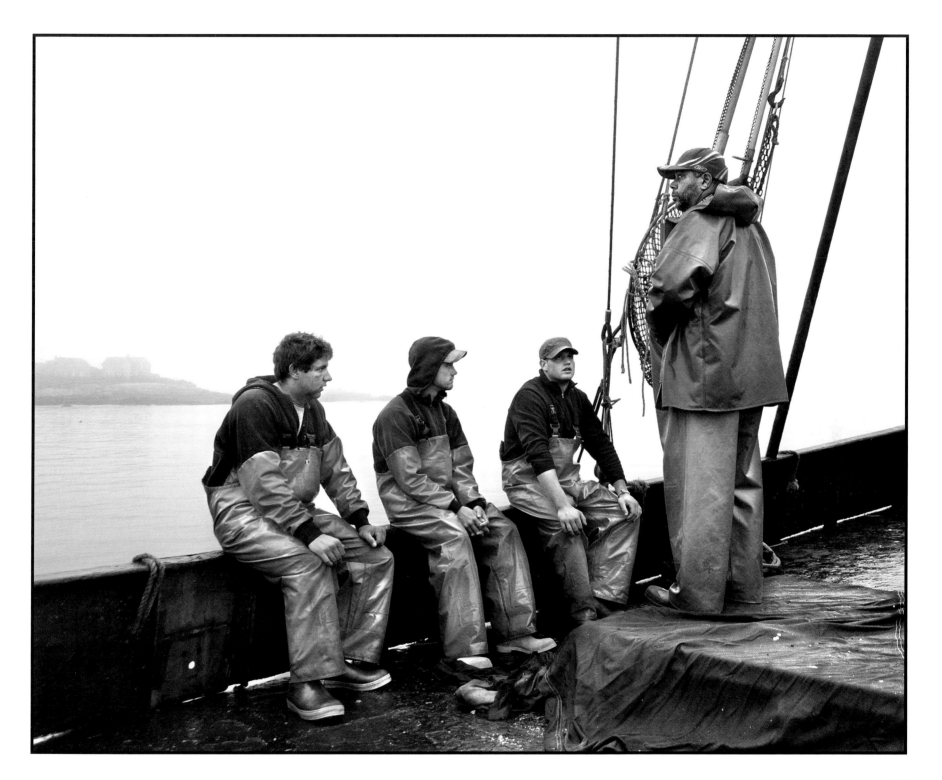

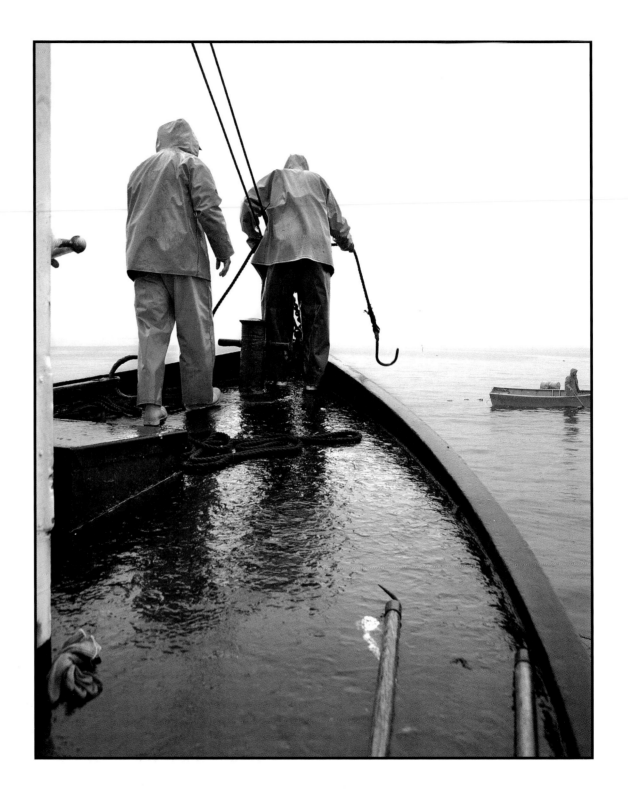

Alan Wheeler gets ready to hook onto netting they will remove through the course of the day's work. This day, like those on which they deploy traps in the spring, is another in which the entire crew must pay close attention to dangers surrounding them.

It will be a long and gloomy day of rain as the crew removes twine, although this hardly affects their spirits. Wearing a uniform of foul weather gear even on sunny days, they hardly notice the additional water falling from above.

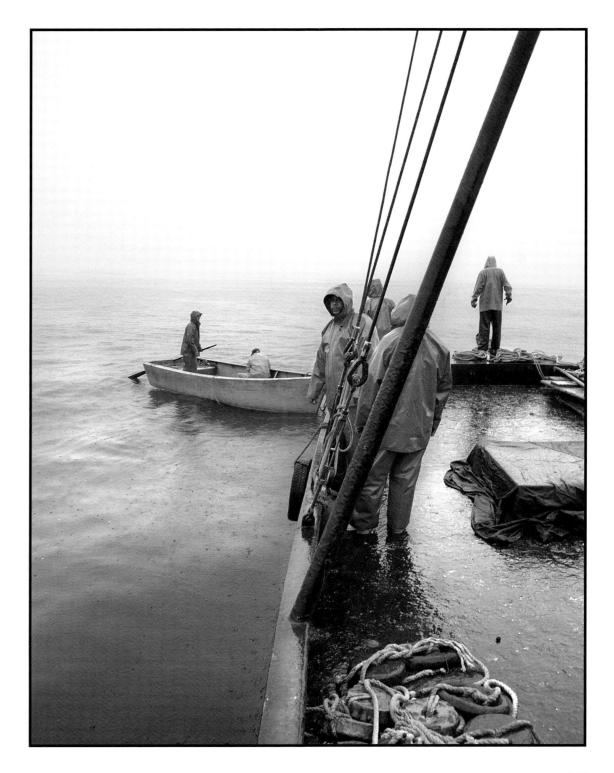

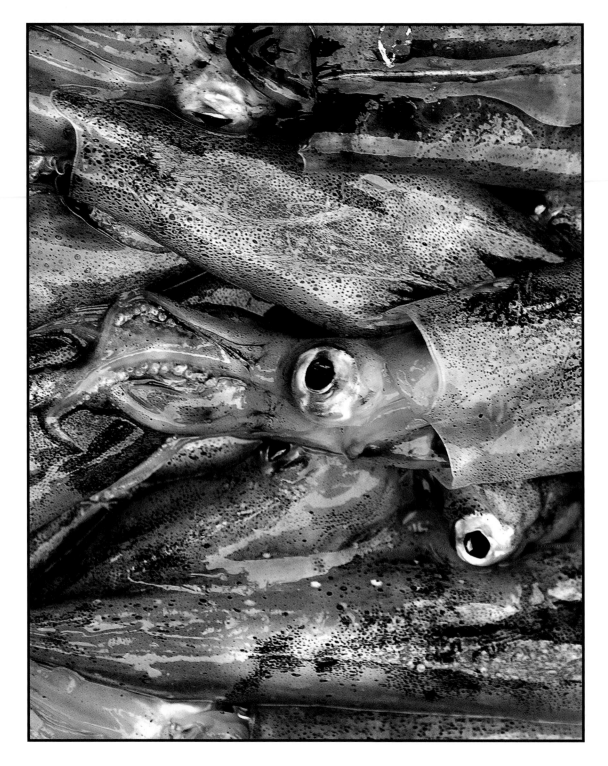

Left: Squid on deck. These cephalopods have enormous eyes, the giant squid having the largest of any animal alive. Propelled by jets of water, they capture their prey within their eight arms and twin tentacles before tearing them apart with a sharp, beak-like mouth. Not only can squid blend into their surrounds by varying the color and patterning on their skin, they also generate clouds of black ink to help them elude predators.

Right: Fishermen remove twine from the frame. Hauling the net vertically using the ship's winch, crewmen pin it to the rail while the portion above is lowered to the deck, allowing another bight of netting to be raised from the sea. As the twine is brought aboard, the cast weights that held the lower edge of the net to the ocean floor are removed.

Early on, fishermen used stones to keep twine in place, although these were quickly replaced as weights cast in metal became cheaper. While iron became the standard, even lead was used when economical. Today, when older weights are lost, substitutions are made with ready-made objects such as links from navy anchor chain. Cast concrete weights are occasionally used, but they "float" more than their denser counterparts and are relegated to sections near rocky beaches where they are more likely to be lost.

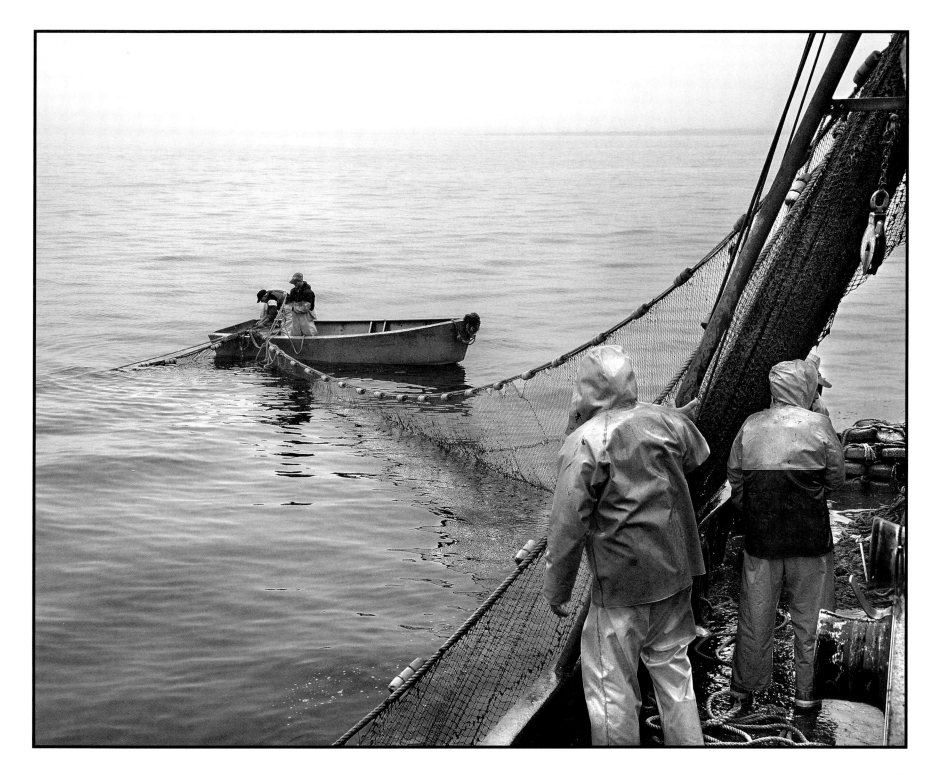

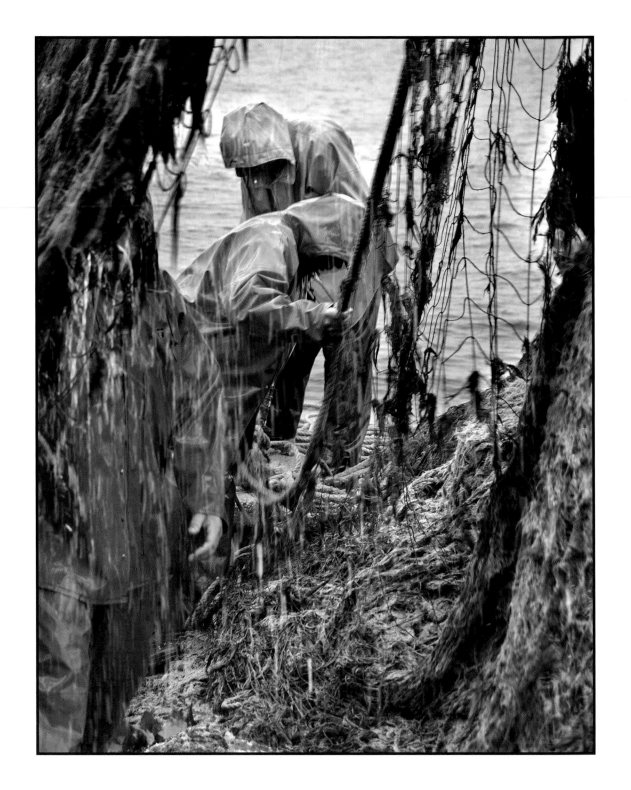

The marine growth fouling this net is obvious, as is the rather wet nature of the day's work. It will take the crew several hours to bring aboard all of the trap's twine.

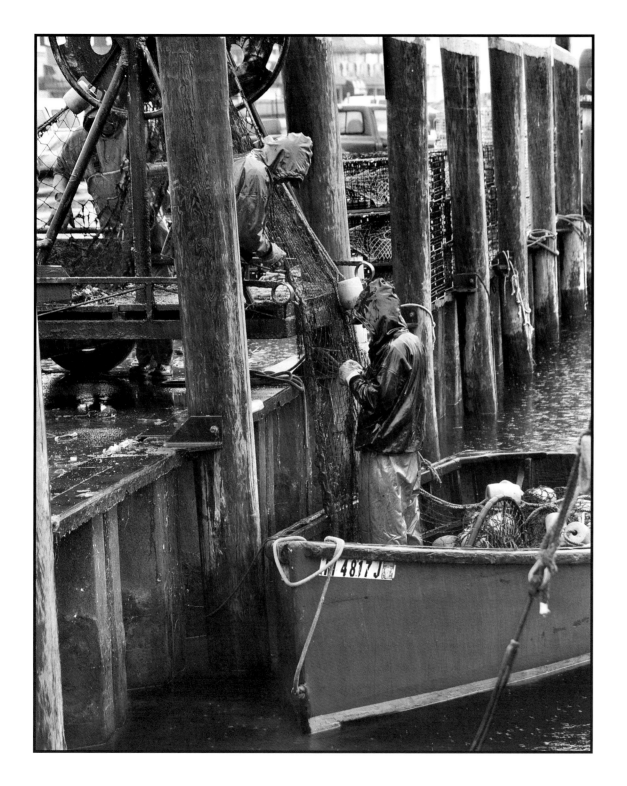

The crew from the *North Star* loads a leader net into a skiff on yet another dreary day. Twine is usually pulled for inspection and cleaning during lulls in the fishing or if threatened by hurricanes. Ian and Sam pull spider crabs from the mesh as they go, a job far more tedious than one might imagine.

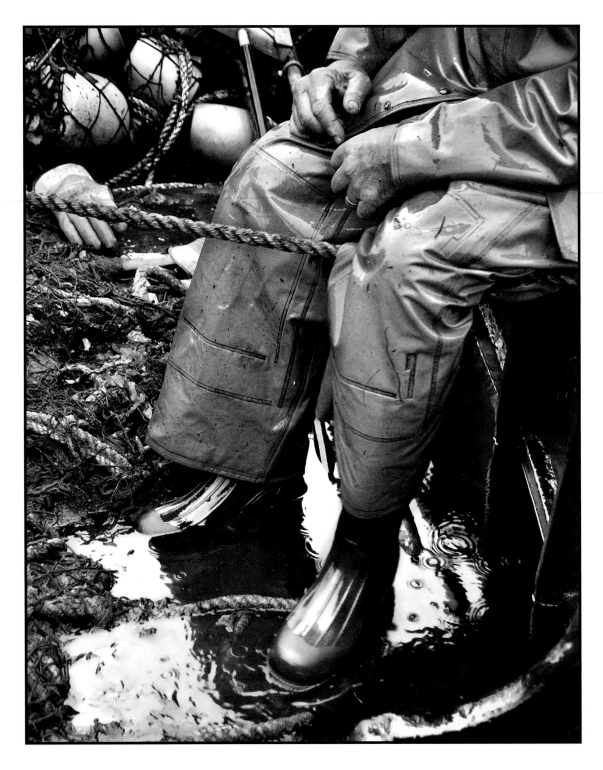

Tom Hoxsie secures the leader line as Sam and Ian work to reattach the twine. Tom's traps have provided meals of fresh seafood, bait for other fishermen, and live fish for aquariums around the country. Additionally, a local artist gathers subjects for his Japanese fish prints from Tom's traps because each specimen is undamaged when caught this way.

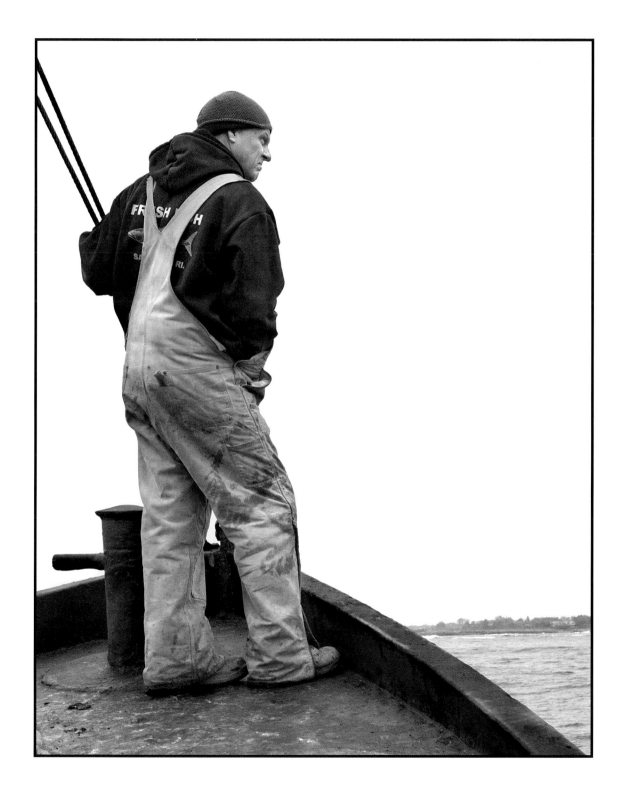

Adam Lotz overlooks the crew as they latch onto the twine. Adam, a partner in the company, is responsible for the marketing end of the business as well. Beyond their skills as fishermen, a detailed knowledge of when and where to sell their catch is required to assure financial success. The company's product may travel the Eastern Seaboard, and Adam decides when and where it will go.

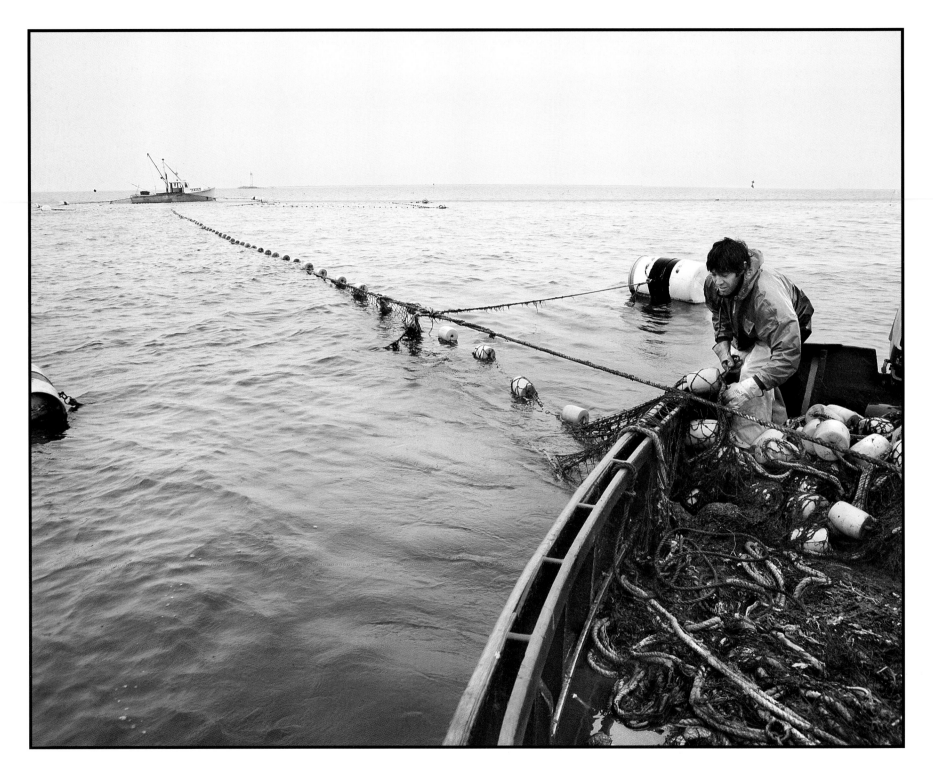

Left: Sam Willis works to reattach the leader's twine to the Breakwater Village trap at the east end of the harbor. While Tom's traps may be the smallest, this image provides a feeling for just how big they are still. The skiff is only two-thirds the distance to the shore end of the leader.

Tom hires Joe Whaley, a retired local fisherman, to do much of the repair work on his nets, although many of his own hours are spent at this task off-season. The twine itself represents a significant expense, not only for the inherent material costs, but for the labor involved when constructing a trap. Anthony Parascandolo estimated building a full-sized trap from scratch would now take two men nearly six months, working six days a week at that.

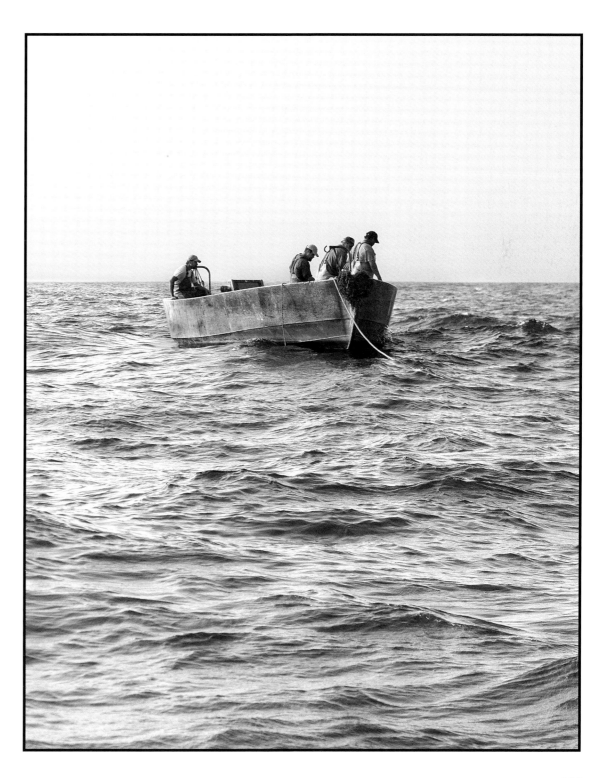

Right: A longboat from the *Christine Roberta* stops to repair a cut leader. Inexperienced yachtsmen, flooding the coast during the summer months, represent a continuous problem for trap fishermen. Although each trap's exact position is marked on charts and hundreds of floats, barrels, and radar buoys make them visible, both sail and speedboats manage to run afoul. Yachtsmen cut their way out of their mistakes, leaving extra work and lost profits in their wakes.

Left: Alan Wheeler supervises the deck work as a section of netting comes aboard. Concern over getting this task done safely left him uncharacteristically tense throughout the day, but having done it hundreds of times before, the job ran smoothly and without incident. Among the many other things to think about in the course of a day's fishing, all captains worry over the safety of their crew.

Right: Dan MacDonald and Sammy Peters remove twine from the frame. Sammy, 87 years old, was the most senior man working traps during this particular season. Despite heart problems and several bouts with cancer, he drove to Sakonnet Point from Massachusetts to arrive at 5:30 each morning, usually the first of the crew on the scene.

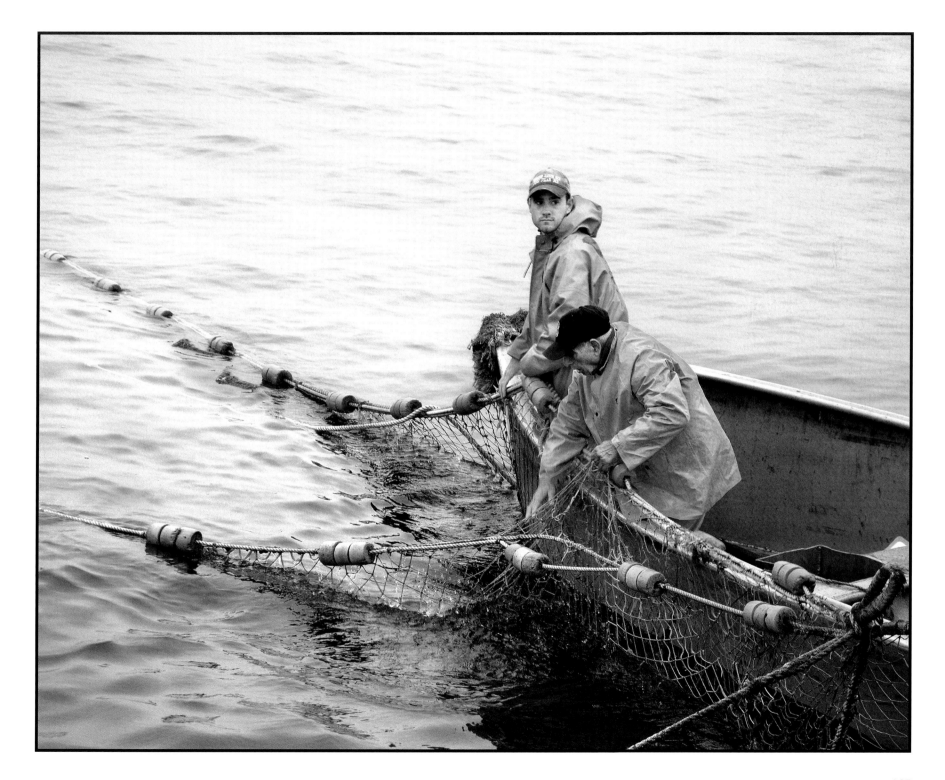

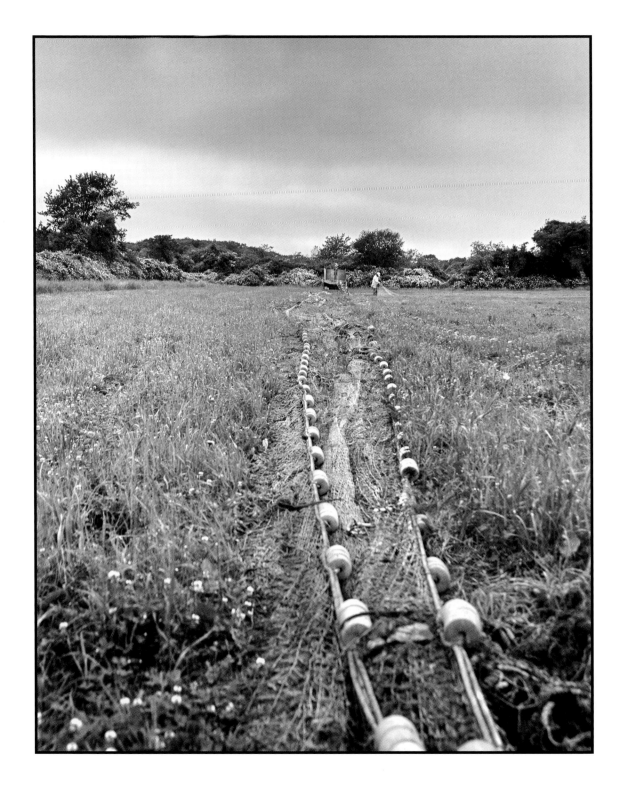

View of a trap net stretched in an open field for cleaning and repair. John Sousa works at a point almost exactly in the middle of the leader, which stretches to the truck at the far end of the field. Because the loss of twine during the summer can mean financial ruin, each trap company maintains spare twine that can replace netting catastrophically damaged during the fishing season.

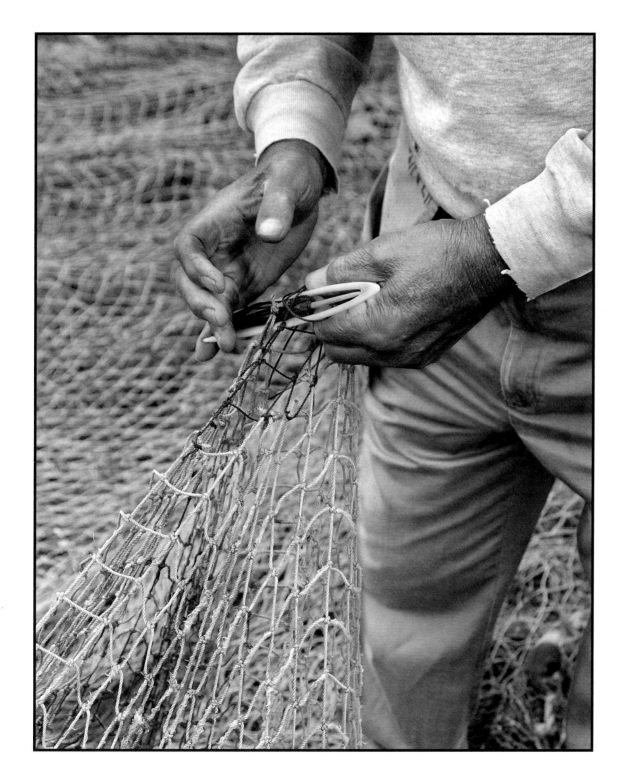

John's hands have built and repaired untold thousands of yards of netting throughout his long career. This is one of the important skills young fishermen no longer learn, as companies can no longer afford to employ them throughout the year. Corey Wheeler Forrest has learned many of these skills by working with older fishermen and also spends time repairing twine in the hot summer sun.

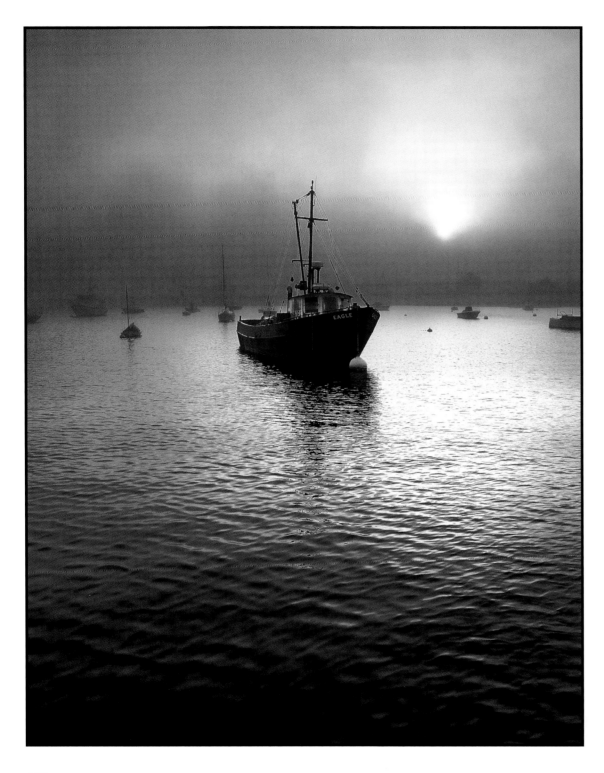

The *Eagle* rests at her mooring as the sun begins to burn through the early morning fog. As with most harbors, the number of working watercraft continues to dwindle, with pleasure boats filling the moorings left behind. This harbor is no different, as evidenced by the large yacht club just completed next to the trap companies' operations.

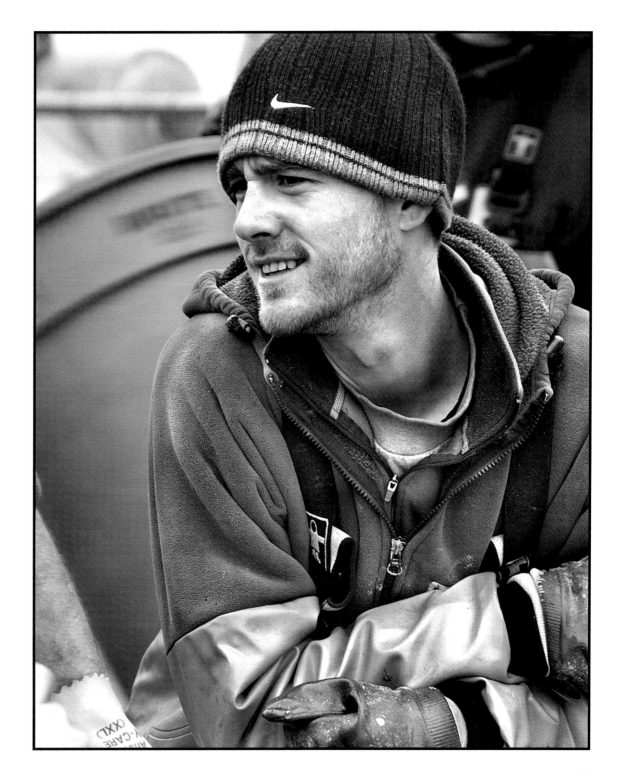

Portrait of Dan MacDonald. Alan Wheeler loves to ski and works at a resort in the winter months up north. Dan is one of the snow-makers Alan brings south for the summer to work as crew on the *Maria Mendonsa*. For men and women who prefer to work outside, trap fishing provides the opportunity to fish without having to go offshore on extended trips.

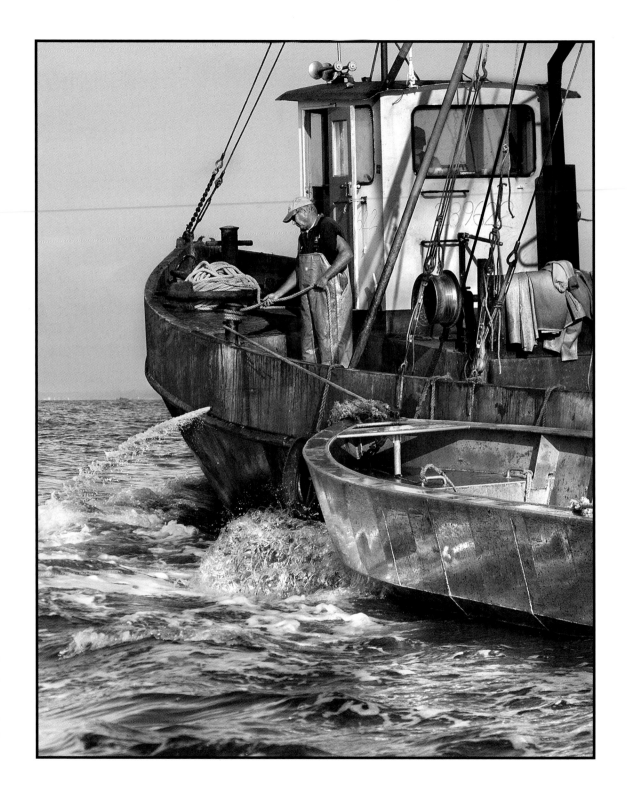

Sully holds the longboats alongside the *Mendonsa* as she steams to the next trap. The water jetting from the ship's hull was used as coolant for the vessel's power plant. In this closed system, cold seawater passes through a heat exchanger mounted on the engine block before it is discharged back overboard.

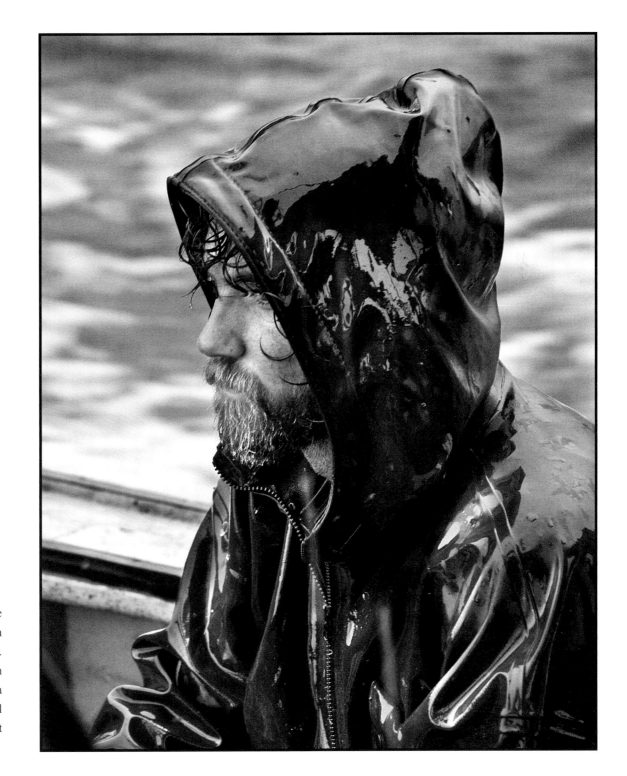

Ian Campbell sits in the rain as the boat heads to the East Wall trap. Two of *North Star's* leaders begin on the massive stonework forming the Harbor of Refuge. Construction on these breakwaters, nearly 13,000 feet in length, began in 1891 and finished in 1914, providing a safe haven for vessels traveling the coast. Using several million tons of stone, the breakwaters are 20 feet wide at the top and rise in places from waters 34 feet deep.

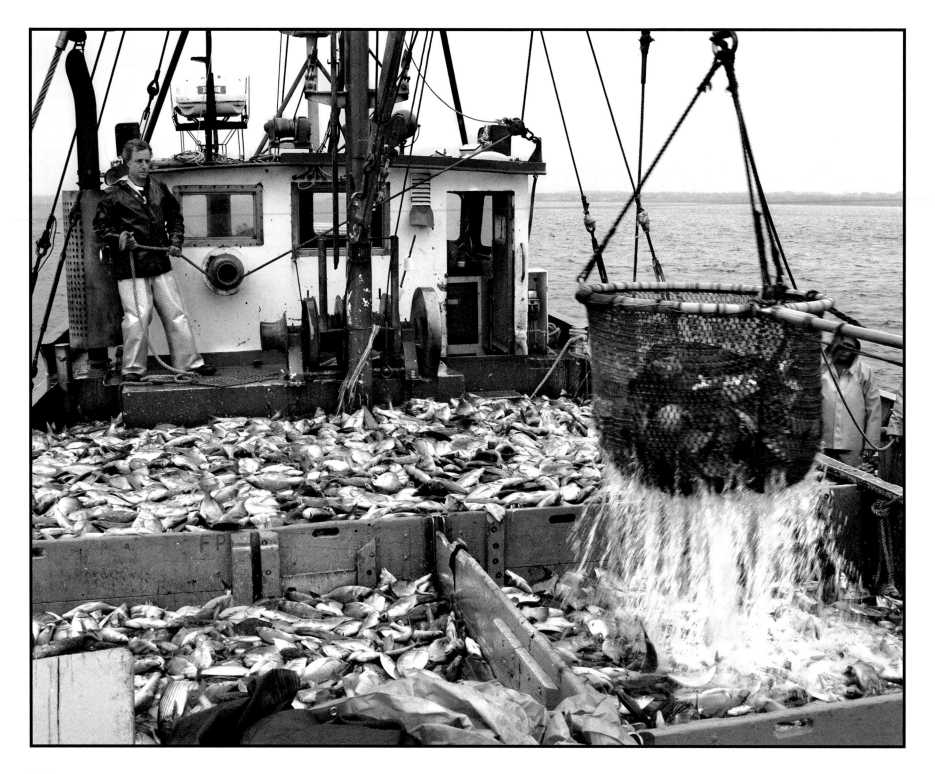

Left: Anthony Parascandolo operates the ship's winch, lifting another load of scup from the sea. In many ways, fishermen are much like farmers, even ignoring the obvious parallels in food production. Weather and other elements beyond their control often affect their livelihoods. In a few critical summer months, drastic changes in environmental conditions can seriously impact their ability to make a living. As with New England's farmers, fishermen are dependent on specific and expensive equipment to make thin profit margins work, and maintaining that equipment adds much to the overall cost. Finally, trap fishermen and farmers were once major food producers for the area, and both are rapidly disappearing from the Northeast.

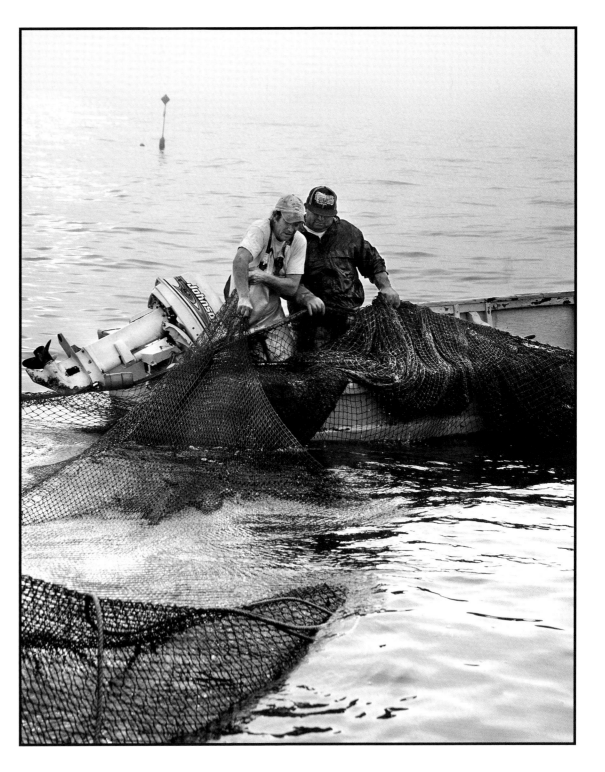

Right: Tom Hinckley and Saul Umana work together to keep their side of the parlor's twine above water. The netting used in traps is dipped in liquid tar, giving it a distinctive black color. Early on, tar preserved the cotton fibers from which twine was made. While twine made of nylon won't rot, this added layer of protection helps to reduce physical wear as well as UV damage from sunlight.

Right: Portrait of Rick Cambio. A career fisherman, Rick has worked on traps and as a draggerman far out to sea. This summer, after finishing the morning's work, Rick went to work cutting apart a wooden dragger that was no longer commercially viable. Point Judith's fleet has dwindled significantly over the course of the past ten years.

Far Right: Adam and Sully clean the deck while James rests in the longboat. While younger crewmen generally chat on the way to the site, the more experienced members on deck seem always in motion, taking care of little details that assure a smooth day of fishing.

Fish species appear at the same time each year with great predictability, as a trap fisherman of 1871 relates:

In the remarks of Mr. E. W. Whalley, of Narragansett Pier, we find a statement of the usual sequence of fish at Point Judith, and are presented at the same time with a most charming fragment of folk-lore. In reply to the inquiry as to whether fish were not earlier arrived at that point than usual, he replied: "About the same. They expected them in February and got the seines ready. They had them in the water in March. I always judge by the dandelions. When I see the first dandelion, scup come in; I watch the buds, and when the buds are swelled full then our traps go in; when the dandelion goes out of bloom and goes to seed, the scup are gone. That is true one year with another, though they vary with the season. I am guided by the blossoms of other kinds of plants for other fish. When high blackberries are in bloom we catch striped bass that weigh from 12 to 20 pounds. When the blue violets are in blossom—they come early—you can catch the small scoot-bass. That has always been my rule; that has been handed down by my forefathers." [8]

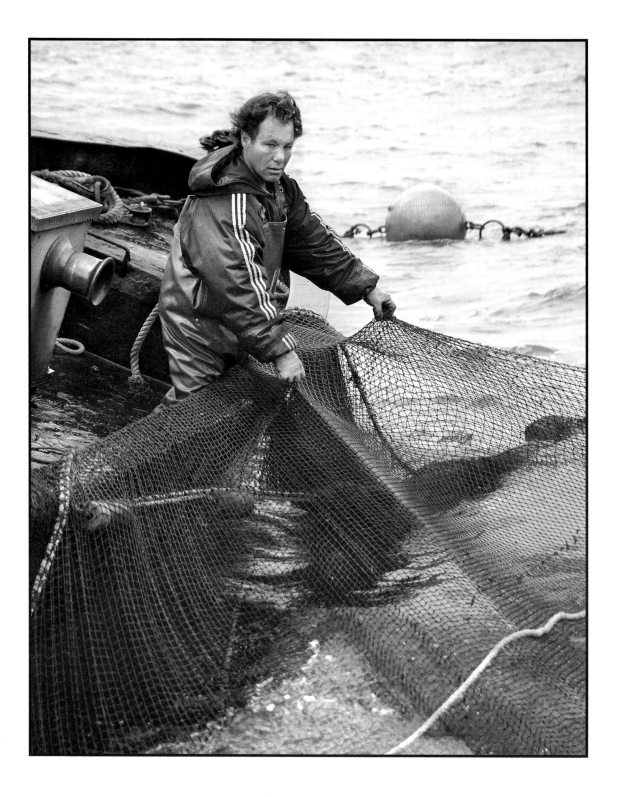

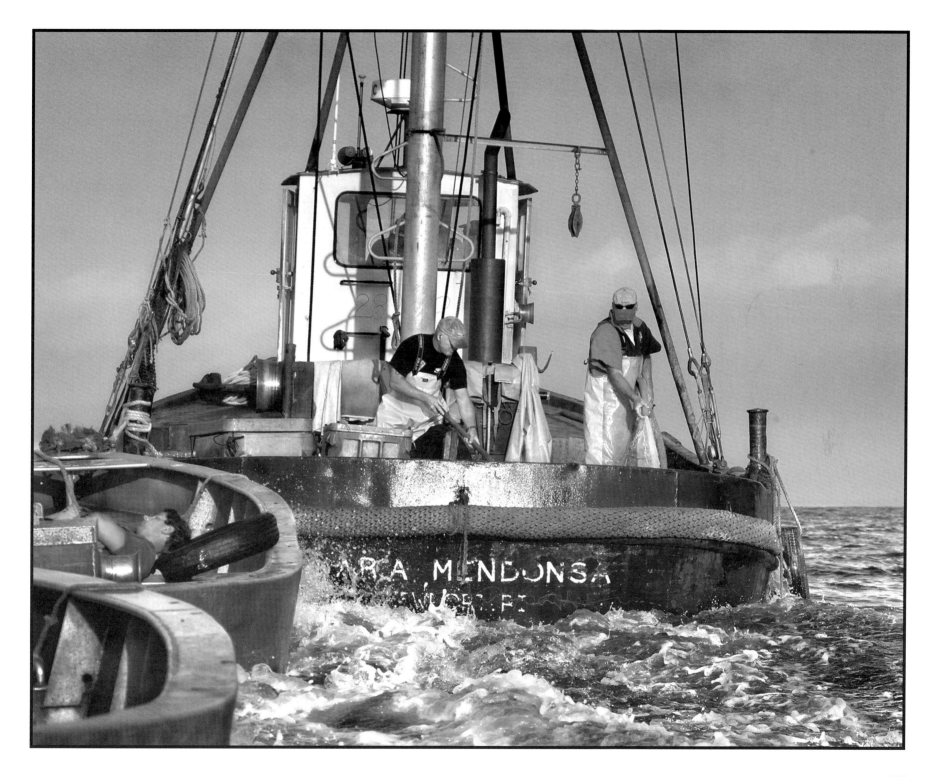

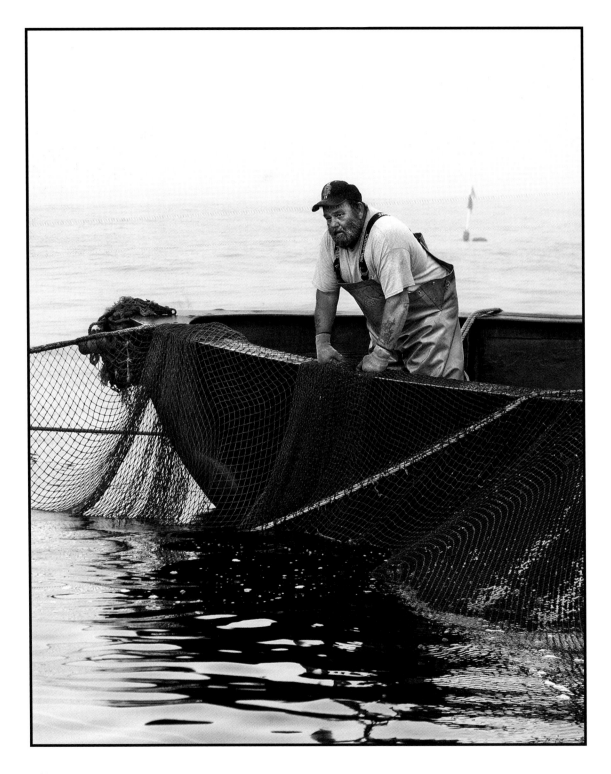

Left: Bucky Smith holds the twine in place as he waits for the signal to begin hauling. Commercial fishing is a rigorous game, better suited to the young and strong. With an average age of 55, a significant portion of New England's fishermen are now approaching retirement, leaving the industry with challenges in this arena as well. Captains often complain the trade is no longer passed to younger generations; finding young men or women with even the most basic skills has become nearly impossible.

Right: *Christine Roberta* at her dock with thousands of pounds of scup in her pens. A conveyor will lift these fish into the packing building on the right. Trap companies in Rhode Island do not process their catch beyond simply packing them with ice into waterproof boxes. Others clean and fillet the fish later in the process of getting them to consumers.

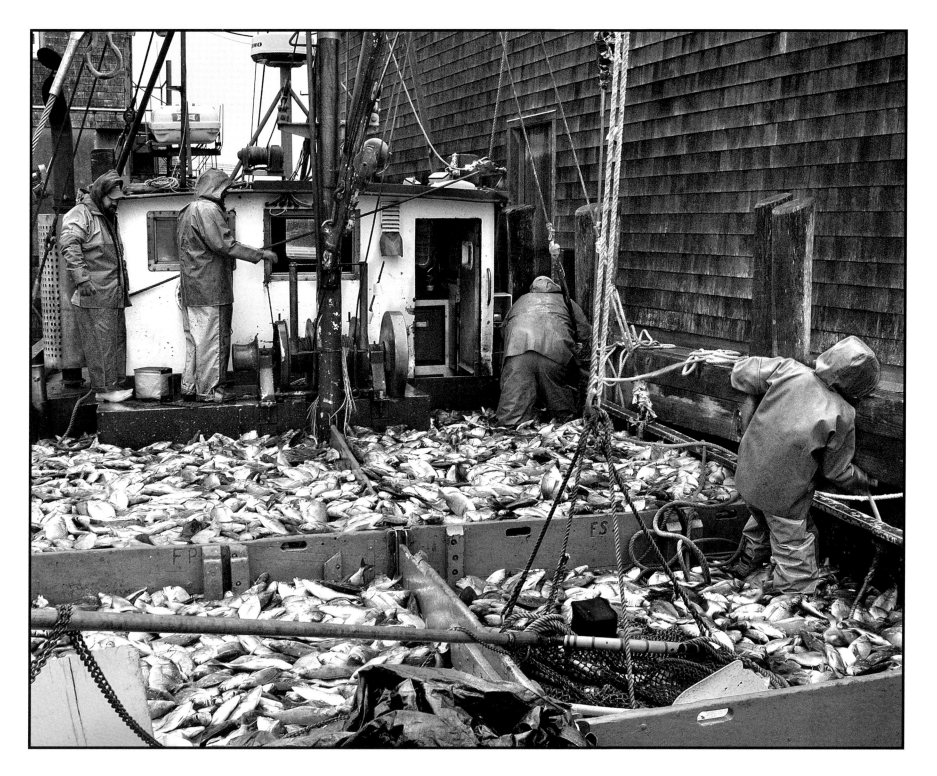

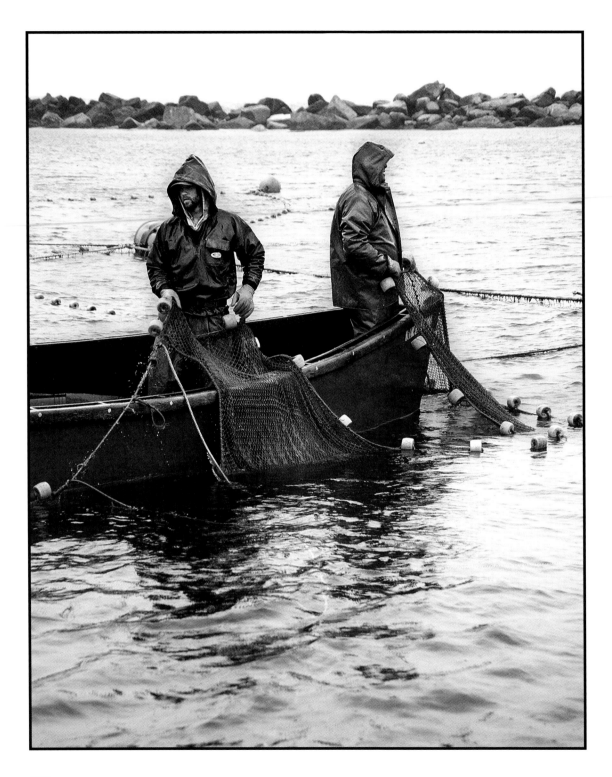

Ian Campbell and Tom Hoxsie pull twine on the East Wall set. Tom, who has been trap fishing for more than twenty-five years, feels there may be a better future in harvesting fish by trap than by trawler. Low overhead and a green footprint could help revive the industry.

A lone sea robin swims towards the light, seeking a path out of the entrapping web. A primitive-looking fish with a bony skull and sharp spines, they are beautiful when they spread their wing-like fins.

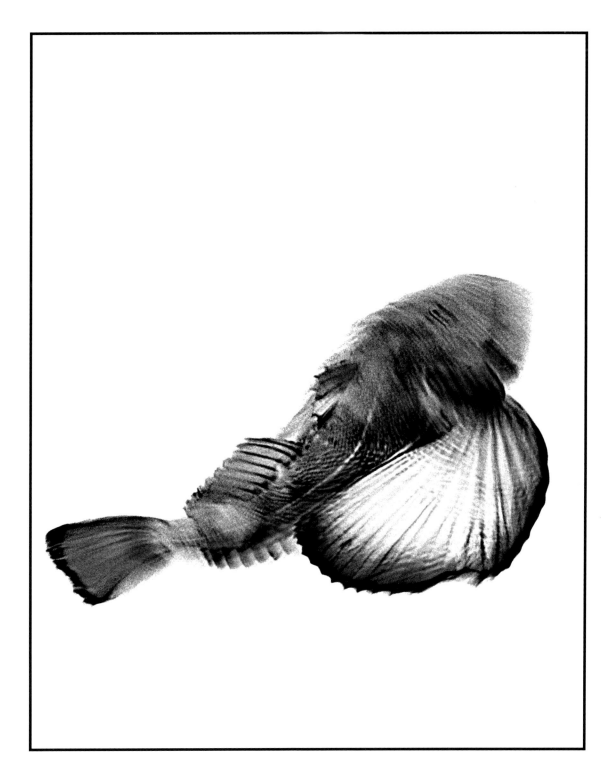

Previous Page Left: The *Amelia Bucolo* returns to Point Judith after hauling her trap. Both the *Bucolo* and the *Maria Mendonsa* were built by Gladding and Hearn on the Taunton River in nearby Somerset, Massachusetts. Begun in 1955, the shipyard still builds steel and aluminum vessels, a rarity on the East Coast. The *Bucolo*, built in 1965, is still powered by her original Caterpillar 342 engine. Alan Glidden estimates her fuel consumption at five gallons per hour, burning a few hundred gallons every three weeks.

Fishing, unlike many careers today, has always been a trade passed down by one generation to the next. Age and experience has taught youth and enthusiasm. While there are a few schools still offering some training in the business, most fishermen start on the back deck of a fishing boat willing to take them to sea. The fishing industry is democratic by nature. As a fisherman once told me, who you were, where you came from, or what you had previously done wasn't important. What mattered was how you did your job, and any fisherman who put in effort could expect to see results over time. Young workers once entered the trade dreaming of the vessel they would eventually command, and the majority of Rhode Island's fishing captains began their climb to the pilothouse from the lowest rung on the ladder.

Previous Page Right: Gear once again covers the wharf at the summer's end. Anchors, buoys, nets, line, and the vessels themselves are retired for winter. The season ends abruptly when quotas for the year are filled. Once over, the crew's last job before dispersing is to gather back this gear. The twine is removed from the frames and brought ashore for drying and storage. Frames come next—the thousands of yards of line and the buoys that kept the trap afloat throughout the summer months. Finally, the 1,000-pound anchors are swung aboard for the trip back to their winter home along the waterfront.

In the past, companies employed trap crews of hundreds of men on a year-round basis. They often fished a longer season when weather allowed, and when fishing ended, there were still new traps to build and twine to repair. Today, small crews disband and look for new work to tide them over the long winter months. Some stay within the fisheries while others go ashore to jobs with no ties to the sea. Yachts moored in the harbor begin to disappear as the winter intrudes, and Sakonnet Point settles into the role of icy gatekeeper at the mouth of the bay, quiet and deserted until spring arrives once again.

Right: A Parascandolo & Sons Trap Company truck sits at a barn located a few miles from Sakonnet Point. The barn stores trap gear through the winter months. These stainless steel trailers are in big demand on the waterfront, not subject to the quick decay modern aluminum trailers face when exposed to the saltwater environment. Used not only to transport and store gear, many of them are refrigerated and hold daily catches until ready for shipment. As with any product, market prices vary with the demand for any particular species and the available supply. While allowed to catch fewer fish than in the past, higher prices in the marketplace for smaller quantities have helped offset some of the financial loss brought about by regulations.

As waterfront property over the course of the last thirty years became more desirable, fishermen have been forced to move parts of their operations away from the ocean to more affordable locations, again increasing their costs. Housing for the wealthy continues to envelope the working waterfront and its supporting infrastructure. Newport, once a major fishing center, now caters only to yachtsmen and tourists. Even the loss of local hayfields to developers robs the trap fisherman of important space. Only time will tell how much longer this industry can survive.

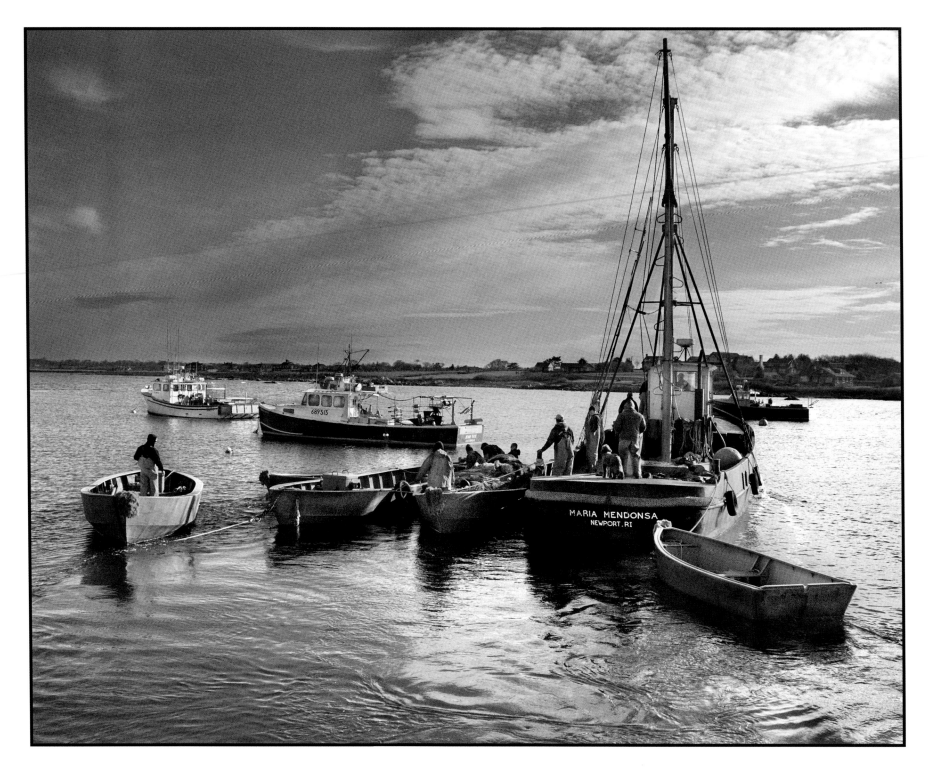

The *Maria Mendonsa's* crew gathers the boats once again shortly after the morning's promising sunrise. The future of fishing in New England remains uncertain. As regulations pile upon the fisheries in the few ports remaining on the Eastern Seaboard, fishermen leave the work of generations to head inland in hopes of earning a living with a more certain future. What we lose as a society when they leave goes beyond the ability to buy fresh seafood from local sources. While we can, for now at least, buy seafood farmed or fished from countries located around our shrinking globe, there will come a day when we can no longer afford to freight our dinners from a spot on the ocean 6,000 miles distant. Beyond these considerations, however, is the loss of yet another industry, another working culture, and the people who once toiled to provide food for the rest. Over the past thirty years, our country has shed these types of jobs and skills in a relentless quest for cheaper products, and as we now begin to discover, without work to do ourselves, we can no longer afford the products we now import. When a few large corporations finally control the industry, the small businesses that each boat represents will fade away, as will the jobs they provide. These are the type of men and women who built our country: independent, hardworking, and self-motivated, and we will all share in the loss when they no longer work our coastlines.

Janet circles her offshore trap during her last season as a working vessel. Built in 1954 in Deltaville, Virgina, her previous owner attempted to sink her off Block Island. Forgetting to empty two large fuel tanks, *Janet* remained partially afloat and was towed back to shore. Ronnie Fatulie purchased her and after she was rebuilt, the *Janet* went on to fish traps for the Coast Canning Company for nearly 40 years.

With opportunities fading in a sea of regulations, young fishermen no longer see possibilities. They are less and less the masters of their own fates, now subject to the bureaucracy that oversees them. Despite the many hurdles, fishermen remain an optimistic lot, and their enthusiasm for the work they do carries them through new challenges. While lifelong fisherman Joe Whaley sometimes feels he won't return to fishing, he nevertheless manages to leave the door open:

But after you did what you wanted all your life, without being told what to do, and all of a sudden somebody is trying to tell you what to do, where to go, how to do it, who to sell it to, what you can catch, when you can go, when you can come back, I said "Nope—you're not tellin' me." But I'd love to go. I might get back in yet, I don't know. I still keep my Rhode Island permit... .

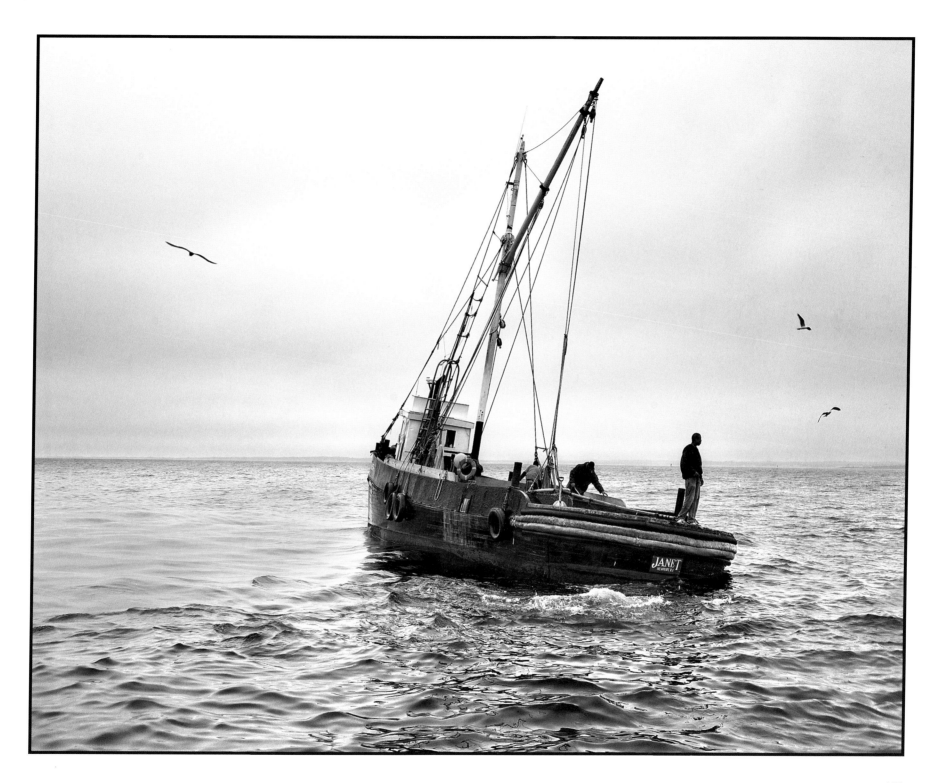

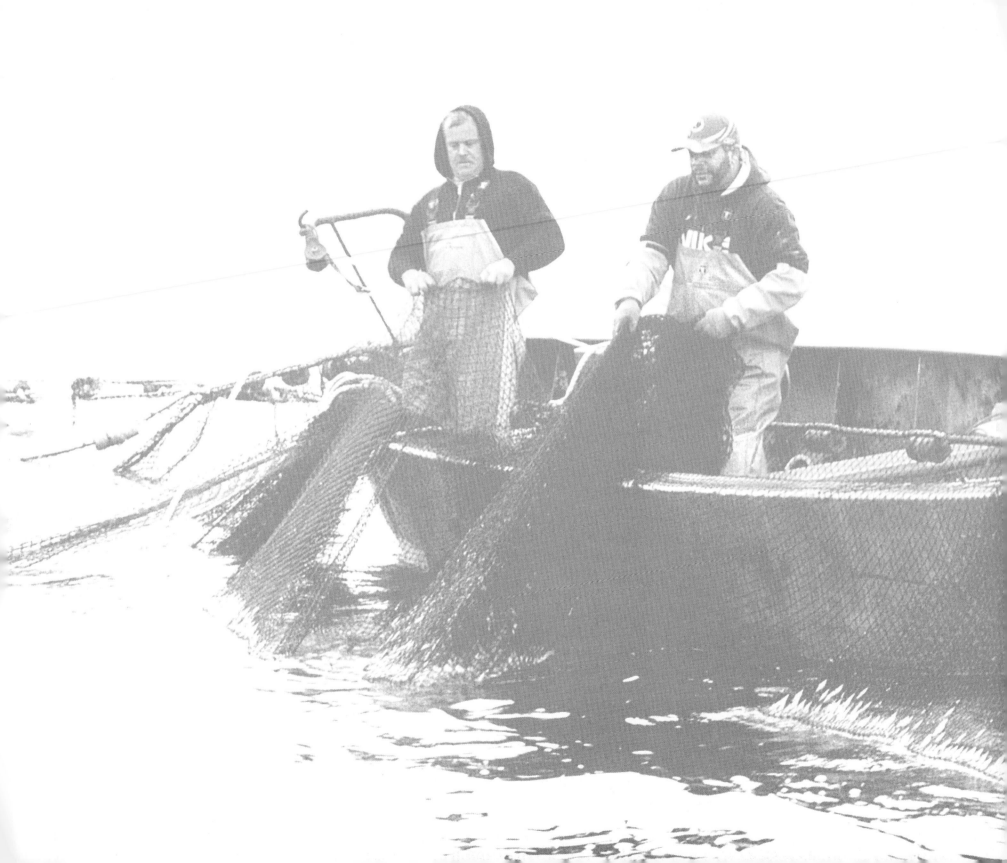

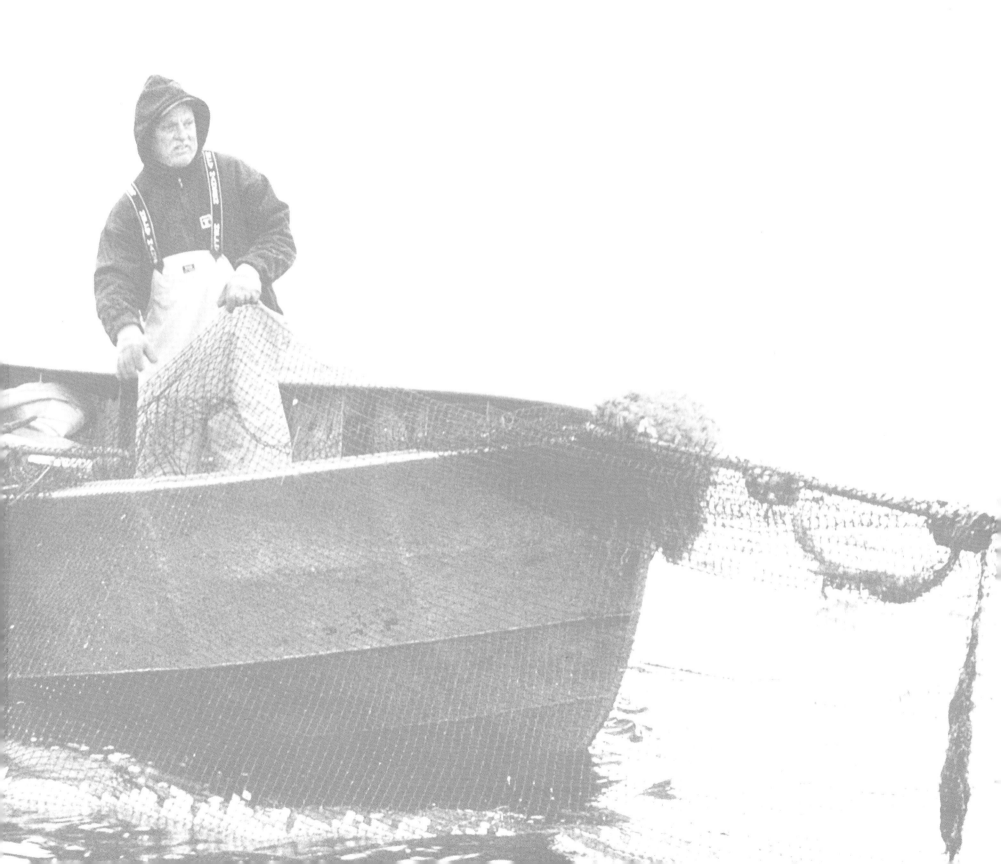

Acknowledgements

First and foremost, I thank all fishermen appearing in this book. Without their generosity and understanding, this project would not have been possible. I would like to extend special thanks to the owners of each of the four trap companies. They gave me complete access to their business and helped me better understand the nature of their work. I was truly honored by their trust and the opportunity they placed in my hands, and I hope this book accurately reflects the admiration and respect I feel for each of them.

I thank my wife Sue for understanding why I do the things I do and for standing with me as I do them. To this day, I remain surprised by my continuing luck in having her by my side. I know I could not live without her, and I hope she never figures she can live without me.

Despite their busy lives, everyone involved in this book gave generously of their time and expertise, and it was a real pleasure to be given the chance to see what they do and hear of their experiences. Despite their best efforts to teach me, however, I fear errors may have crept into this text. Any and all mistakes are of my own making, and I apologize in advance to my patient teachers along Rhode Island's coast.

Sincerely,

Markham Starr

Bibliography

Note: All italicized interview material, unless noted below, is from personal interviews conducted with fishermen and transcribed in 2008.

The naturalist's drawings of the different species of fish heading and ending each chapter in the main body of the text were drawn by H. L. Todd and come from G. Brown Goode's *The Fisheries and Fishery Industry in the United States, Volume II.*

1. G. Brown Goode, *The Fisheries and Fishery Industry in the United States*, 7 Volumes, Government Printing Office, Washington, 1887. Section II, 299.

2. Ibid. Section V, 604.

3. Ibid. Section II, 294.

4. Ibid. Section II, 297.

5. Ibid. Section II, 295-6.

6. Ibid. Section V, 606.

7. Ibid. Section V, 606.

8. Ibid. Section V, 605.

9. Theresa Maggio, *Mattanza: Love and Death in the Sea of Sicily,* Counterpoint, 2000.

About the Author

MARKHAM STARR is a documentary photographer and author of eleven books such as *End of the Line: Closing the Last Sardine Cannery in America, Barns of Connecticut,* and *Swab Summer: Transformation at the United States Coast Guard Academy.* He lives and works in New England, documenting traditional working cultures now fighting for their very survival. His photographs have been featured in magazines such as *Yankee, Rhode Island Monthly, LensWork, Vermont Magazine* and others, and reside in the collections of many regional historical museums throughout New England. His images are also part of the permanent collection at the Library of Congress.